Valparaiso Public Library 103 Jefferson Street Valparaiso, IN 46383

P9-DHQ-405

DISCARD Porter County Library System

The Perfect Wedding Dress

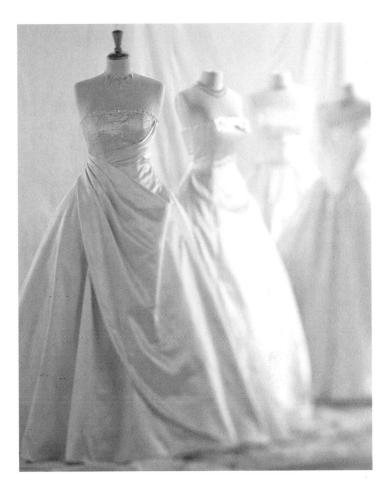

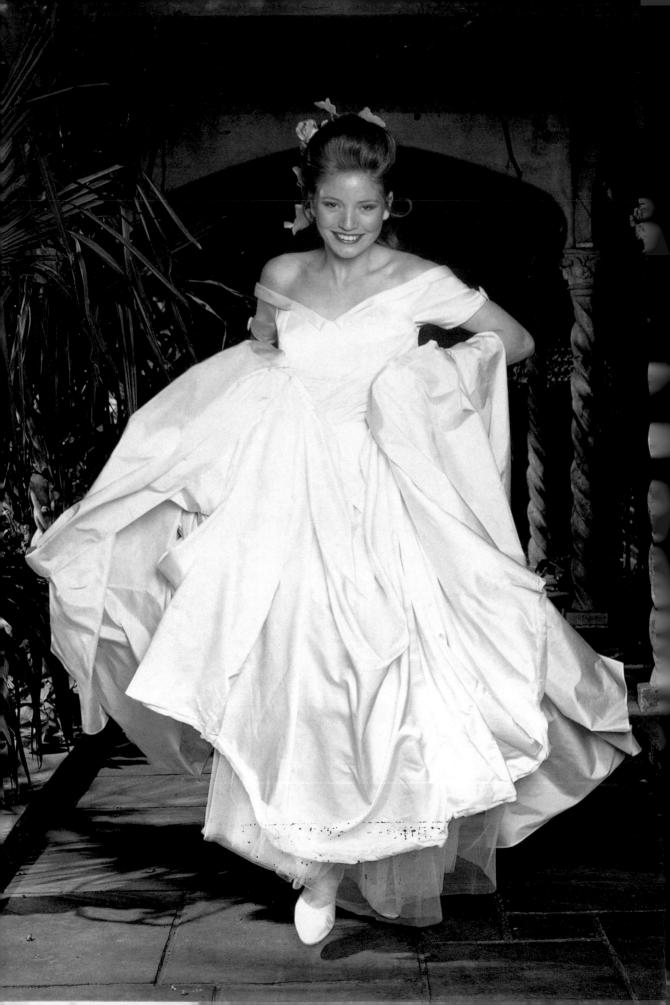

THE Perfect Wedding Dress

PHILIP DELAMORE

PORTER COUNTY LIBRARY Velparaiso Public Library 103 Jefferson Street Velparaiso, IN 46383

NF 392.54 DEL VAL Delamore, Philip. The perfect wedding dress / 33410008729172 MAY 0 4 200

A Firefly Book

Published by Firefly Books Ltd. 2006

Copyright © 2005 Pavilion Books

All rights reserved. No part of this publication may be reproduced, stored in a retrieval system, or transmitted in any form or by any means, electronic, mechanical, photocopying, recording or otherwise, without the prior written permission of the Publisher.

First printing

Publisher Cataloging-in-Publication Data (U.S.)

Delamore, Philip. The perfect wedding dress / Philip Delamore. [224] p. : col. photos. ; cm. Includes index.

Summary: Complete guide to designer and off-the-rack wedding dresses, including information on styles, cuts, materials, necklines, sleeves, veils, trains and accessories.

ISBN 1-55407-131-3 ISBN 1-55407-130-5 (pbk.) 1. Wedding costume. I. Title. 392.5/4 dc22 TT633.D453 2005

Library and Archives Canada Cataloguing in Publication

Delamore, Philip The perfect wedding dress / Philip Delamore. Includes index. ISBN 1-55407-131-3 (bound).—ISBN 1-55407-130-5 (pbk.) 1. Wedding costume. I. Title. GT1752.D44 2006 392.5'4 C2005-903928-0

> Published in the United States by Firefly Books (U.S.) Inc. P.O. Box 1338, Ellicott Station Buffalo, New York 14205

Published in Canada by Firefly Books Ltd. 66 Leek Crescent Richmond Hill, Ontario L4B 1H1

Designer: Isobel Gillan Illustrator: Camilla Dixon Cover photo: SaraSusa/Virgin Bride; Back cover, from top: www.carolineparkes.com; www.carolineparkes.com; SaraSusa/Virgin Bride; Collection of Stuart Parvin; Spine: AFP/Getty Images

> ISBN 13: 978-155407-130-2 ISBN 13: 978-155407-131-9 (pbk.)

> > Printed in Thailand

CONTENTS

- INTRODUCTION 6
 - BALL GOWN 12
 - PRINCESS LINE 32
 - EMPIRE LINE 52
- MERMAID AND FISHTAIL 68
 - A-LINE 92
 - COLUMN 108
 - MINI AND MIDI 120
 - THE SUIT 130
 - NECKLINES 140
 - BACKS 152
 - SLEEVES 164
 - VEILS 174
 - TRAINS 184
 - DETAILS 194
 - INDEX 220
 - DIRECTORY 222
 - ACKNOWLEDGMENTS 223

INTRODUCTION

The wedding dress is such an evocative symbol of the bride. It has romantic and historical associations with the ritual of dress and the rites of ceremony, from countless princess brides encountered in fairytales as a child, to the televised and endlessly photographed weddings of royalty and celebrity that have punctuated our adulthood.

Today the wedding dress occupies a unique moment in your life. As ritual and ceremony is all but removed from our everyday experiences, the idea of wearing a special dress for only one day of your life imbues it with the significance of its symbolic heritage. While fashion may affect the silhouette, the white dress and

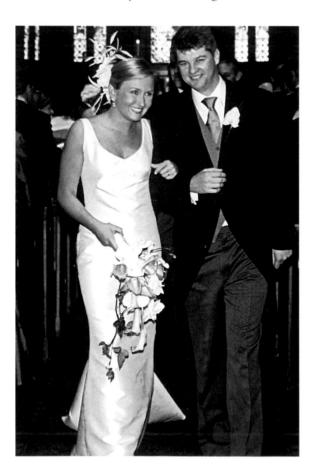

veil have remained virtually unchanged in over 150 years.

The variety of styles, details and fabric combinations available to today's bride may, however, seem a little bewildering. If you do not know an A-line from a princess line, or a sweetheart neckline from a picture collar, then read on.

This book is intended as a sourcebook for you and a helpful guide for inspiration, ideas and visual reference, not only to help with your choice of wedding dress, but also to help communicate it to others. That picture/thousand-word analogy is never more true than when trying to communicate the abstract ideas of design and the emotions of romance to others. Use this book, along with the other reference material you've gathered from bridal stores and magazines, to build a picture both of yourself and your dress. This will help the other people involved in the process, from the shop assistant to

INTRODUCTION

"I chose my wife, as she did her wedding gown, for qualities that would wear well." OLIVER GOLDSMITH, c.1760

the caterer, have a better idea of your vision. Even if you don't feel like you have much vision yet, this book will help you develop one.

First, you will need to know three things:

KNOW YOURSELF

Unless you're Jennifer Lopez, who, let's face it, must know what kind of dress suits her best by now, you need to start with a little self-analysis. If you have never done anything traditional in your life, now is not the time to start just because you feel it is expected. The diversity of wedding experiences available are limited only by your imagination, but if you have lived a life of expectation that you would sweep down the aisle in a fairytale ball gown, then don't compromise.

You might want to think about what your favorite dress is, and if you don't have one you might like to consider that there are other options, such as a suit or more casual two piece outfit. Do you have a personality that you tend to express by the way you dress, or do you dress to blend in? Trying a few dresses at a bridal store or boutique with an honest friend can also be a good start to see what does and doesn't suit you, especially if you are not used to dressing up (*listen* to the honest friend). Try on a range of styles and colors, and use the experience of the staff to help you make some initial decisions about what you look good in and feel comfortable wearing. Once you have an idea of what works for you, then you can be more confident in your choice.

KNOW YOUR BUDGET

The dress is one of the biggest purchases for a wedding, so you need to budget for it whether you are buying a simple suit or dress off the rack, or having a couture dress made for you. Like house buying this can tend to go out of the window when you see something you like, but remember that if you are having a dress made for you there is lots of flexibility, and you can discuss how to get what you want for the budget you have. The idea of couture being the expensive option is not necessarily true.

Remember not to rush into ordering, and look at the options available to you not only at the department stores and specialist bridal stores, but also vintage

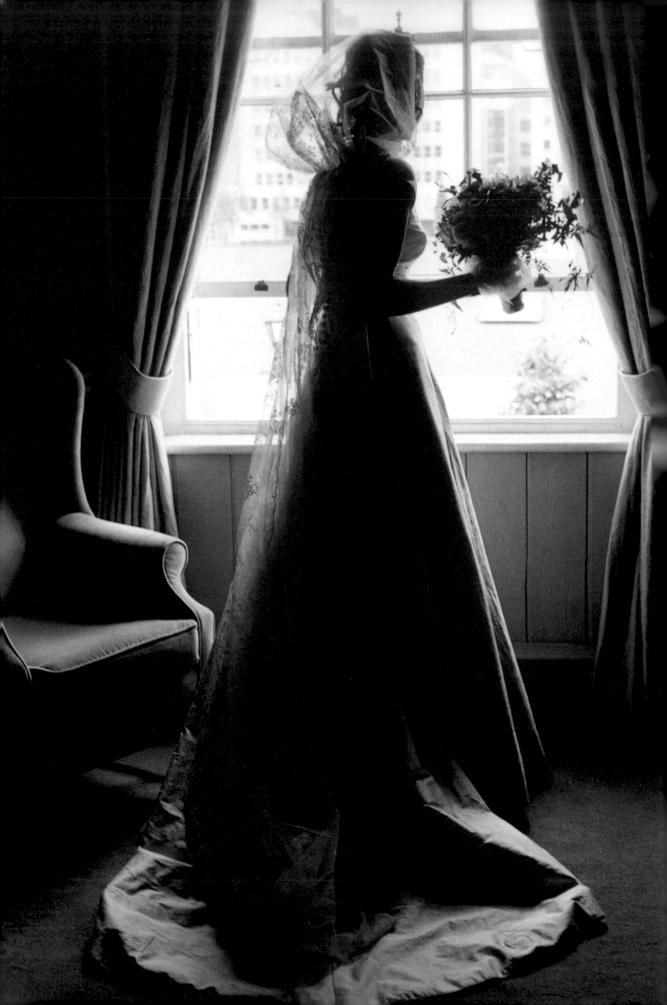

"A dress should never overpower the wearer. It should merely be an appropriate frame for a charming picture, bringing out the beauties of the picture, but never distracting attention from it. So few women understand this."

CHARLES WORTH, HARPER'S BAZAAR PERSONAL COLUMN, DECEMBER 15, 1877

and antique clothing stores, costume and period hire specialists, and individual dressmakers. Ask friends for personal recommendations and make use of the internet to view designers' collections or even bid for a vintage piece.

KNOW YOUR LIMITATIONS

I don't mean you shouldn't do anything unexpected, but rather consider all those external factors that you may have no control over. For example, are there any religious restrictions on what you may or may not wear for the ceremony? (Jewish weddings require a veil for example.) Will your cathedral train fit in the motorcycle sidecar you are arriving at the church in? If you are getting married abroad, on a beach in Hawaii for example, there may be simple practical issues of transporting your dress. Perhaps that white bikini is a better option!

USING THIS BOOK

While I have included a brief historical resume of each style—along with suggestions for whom the style may be better suited to and classic examples of the style and fabrics used—this is by no means a historical work on the wedding dress, and should not be taken as such. Many of the styles fall into several categories and it is arguable as to where to draw the boundaries between them. Some styles belong to specific periods in time, while others refer to specific constructions or cuts.

Don't be fazed by the almost overwhelming choice there appears to be out there. At the start of the 21st century you simply need to remember that a lot of "Talk six times with the same single lady and you may get the wedding dress ready." LORD BYRON

weddings have preceded yours. As each bride has expressed herself through personal, religious and fashionable desires, so a myriad of styles and combinations of dresses have evolved.

Each of the chapters of this book will guide you through the basic silhouettes—some enduring classics, some fashion *faux pas*—and some of the details you will want to consider when embellishing.

Finally, perhaps it is worth remembering the words of this ancient rhyme when planning your color scheme:

Married in white, you have chosen right, Married in green, ashamed to be seen, Married in gray, you'll go far away, Married in red, you'll wish yourself dead, Married in blue, you'll always be true, Married in yellow, ashamed of your fellow, Married in black, you'll wish yourself back, Married in pink, of you he will think. OLD ENGLISH RHYME

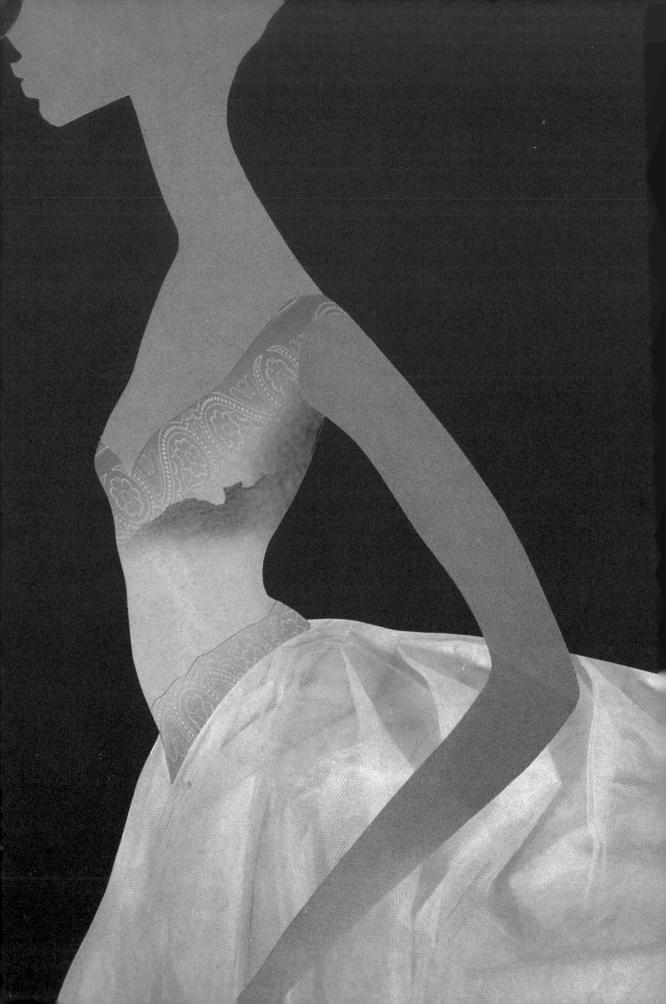

BALL GOWN

STYLE

As the enduring image of the archetypal wedding dress, the ball gown epitomizes the romantic idea of the fairytale princess bride. The fitted bodice and voluminous skirts, petticoats, train and veil in diaphanous layers seems to be the definitive bridal statement. Ball gowns have fitted bodices and full skirts. They tend to be one piece, but may comprise of a top and separate skirt. The skirt usually skims the floor, with petticoats or hoops resembling the original Victorian crinolines to give the required fullness. The distribution of this fullness can vary—so consider whether you want a ballerina style with circular skirts, or whether a bustled style with fullness at the back that allows you to keep a flatter front profile is better suited.

Bodices come in many variants, from strapless basque or corseted types, with straps or sleeves, to off-the-shoulder picture collars and fully fitted high necks.

HISTORY

It is interesting to consider that the elements of shape and color that define the classic white wedding dress did not really come together until the middle of the 19th century, with the wedding of Queen Victoria and Prince Albert. Perhaps it is the romance of a royal wedding that was for love rather than in the tradition of political and financial convenience, where the bride and groom would have rarely met prior to the ceremony, which has endured.

The Victorian era was pivotal in the development of fashion as an industry, where the dressmaker turned into the designer. The invention of the domestic sewing machine, the industrialization of textile production for fabrics such as lace, and the establishment of the first couture houses in Paris during the reign of Victoria created a consumer market for fashion to an aspirational *nouveau riche* and a burgeoning middle class. Journalism and an opening up of international markets, particularly in the New World, saw illustrated journals describe in detail every aspect of the court seasons and events, including numerous fashion plates and patterns, which could be recreated by the home dressmaker if a couturier was beyond your means.

It is easy to forget that this style of dress was actually not far from the normal everyday dress of the period, and dresses were often altered to be worn again for other formal occasions. Queen Victoria herself set the example by frequently using the lace overskirt from her wedding dress—wearing it over black silk for her Diamond Jubilee celebrations over 50 years later.

5 3 -1

Today it is more rare that the bride considers wearing her dress for another occasion, unless perhaps it is a more contemporary style of dress or a suit.

CLASSICS

As it is a perennial favorite, you will have plenty of choice in this style. The precedent has been set in a century of royal weddings, both real and on screen: think of Liz Taylor (first time around) and Grace Kelly as the ultimate Hollywood royalty-turned-princess bride, and none were more evocative and overblown than Diana Spencer's fairytale Emanuel creation (see page 17). More recent celebrities to return to this style statement include Mariah Carey and Victoria Beckham.

More casual, modern variants on this style include the 1950s-style quilted skirt and cardigan, and simple crossover wrapped blouse worn over a full skirt.

WHO SHOULD WEAR IT

Strapless is great if you are of tall, slim build and tend to be broad shouldered. If you have the height but are narrow on top, or feel uncomfortable exposing so much, then opt for a more covered up version with straps or sleeves and a high neck. This style can still work if you are of medium height or tend toward a pear shape, as you can emphasize the waist and disguise broader hips with a full skirt. The corseted style can also work for a fuller bust by placing emphasis at the waist. Higher-heeled shoes and hair worn up can help emphasize a lean silhouette. Remember, long opera gloves can look great with a strapless gown, adding drama while reducing the amount of exposure, especially if you are unsure about baring your arms.

If you are planning on having a train, then the ball gown is the style of dress to do it with. Consider whether you want the train to be attached or detachable, and how grand a statement you want to make with it (see Trains, pages 186–193).

FABRICS

Lots of options here, and often the bodice and skirts will have variations. Satins and taffetas, with lace overlaid or as trimming, are a classic look. Be aware that silks like this will always crease, especially the more papery silks like dupioni, which should be avoided. If you want something that looks clean and unwrinkled there are some good synthetic alternatives available now. Many layers of tulle petticoats may be added under the skirt to give volume, or indeed may compromise the whole skirt, encased in sheer swathes of chiffon or voile, in the more 1950s-style gowns. The bodice may be of a contrasting fabric to the skirt, or have elaborate beading, appliqué or embroidery that cascades from the bodice and scatters across the skirt.

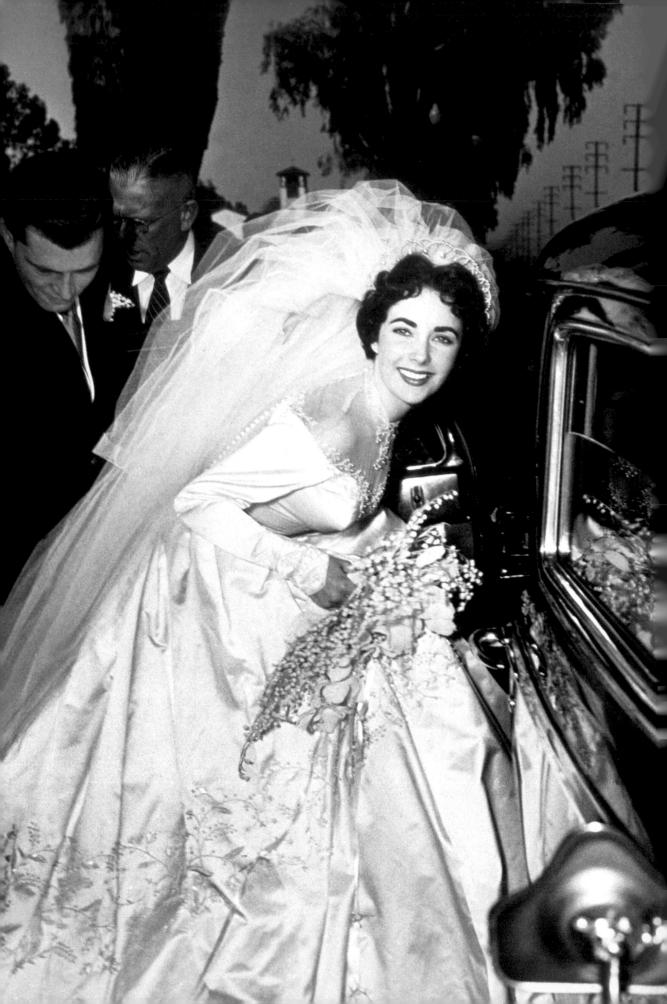

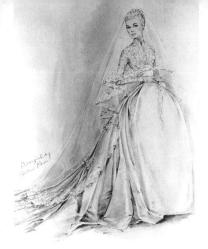

LEFT Elizabeth Taylor weds Nicky Hilton, 1950, in a white satin dress by MGM studio designer Helen Rose.

ABOVE AND RIGHT Grace Kelly wears a Helen Rose dress in a renaissance style, with a bell-shaped skirt and rose point lace bodice, for her wedding to Prince Rainier of Monaco, 1956.

BELOW Lady Diana's iconic Emanuel gown for her wedding to Prince Charles in 1981.

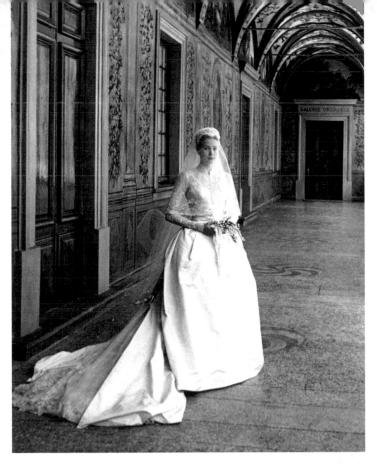

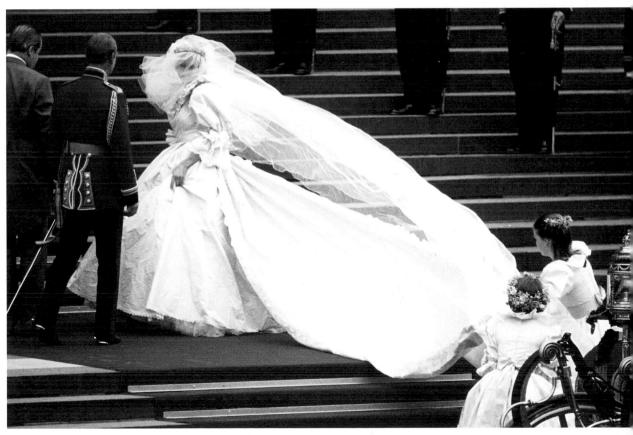

ABOVE Phillipa Lepley's strapless silk zibeline design is cinched at the waist with a silk rose and feather corsage, and features a delicate, hand-beaded trim.

RIGHT Flowers make a bold statement in this full-skirted design with a corsage at the hip trimming a long fluid train, and balanced by a beautiful hairpiece.

BALL GOWN

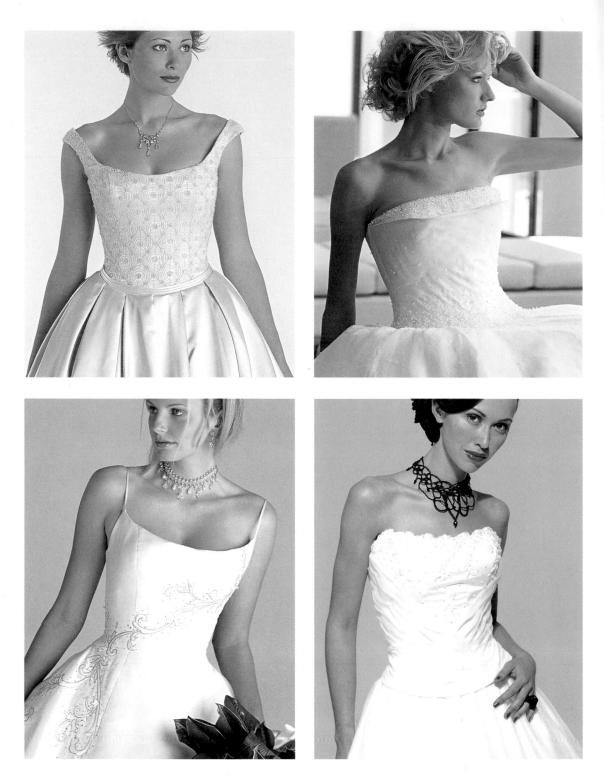

ABOVE, CLOCKWISE FROM TOP LEFT Cobweb lace bodice with crystal dewdrops on a silver base; clusters of beads in a two layered bodice divide the body at the widest and narrowest points; scalloped edges trimmed with beads and a wrap over effect add interest while narrowing the silhouette; spaghetti straps and cascading embroidery draw the eye across and down the dress. OPPOSITE This sweetheart neckline is softened with floral appliqués to the bodice, which scatter onto the skirt of this prom-style dress.

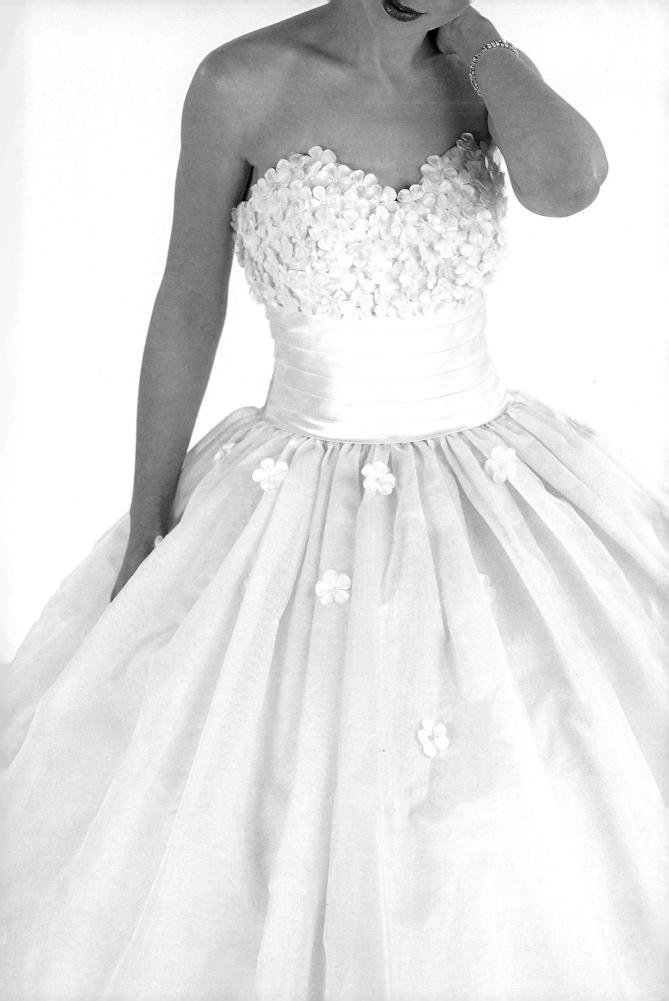

TOP RIGHT The swathed bodice of this dress is echoed by the skirt, swept back into a bustled train. Diamante straps appear to fall from the shoulders.

BELOW RIGHT A *fin de siècle* aesthetic is evoked in this dress by Elizabeth Todd, which combines a provocative low-cut corset bodice with the soft clouds of a multilayered tulle skirt.

FAR RIGHT Another daring corset top—winged sides and asymmetrical embellishment unfold into a bellshaped satin skirt.

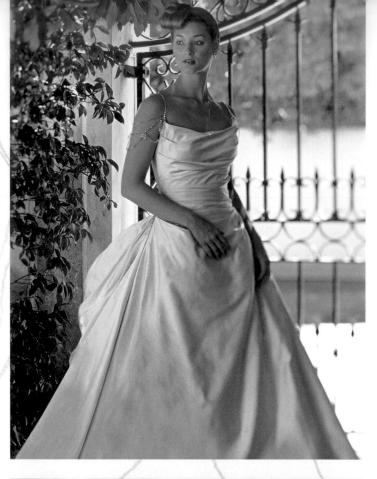

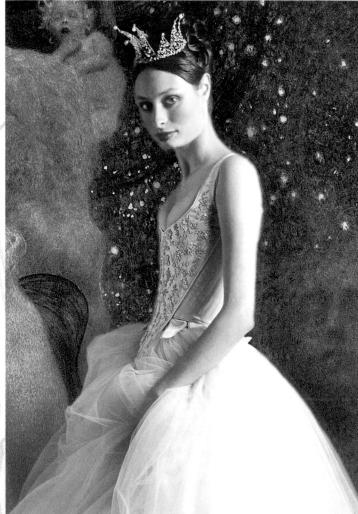

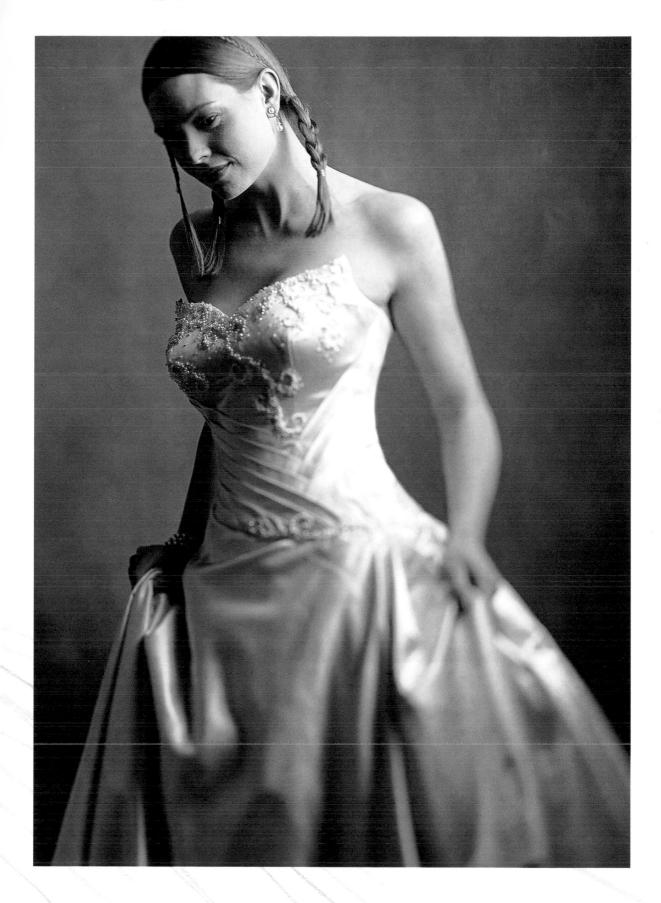

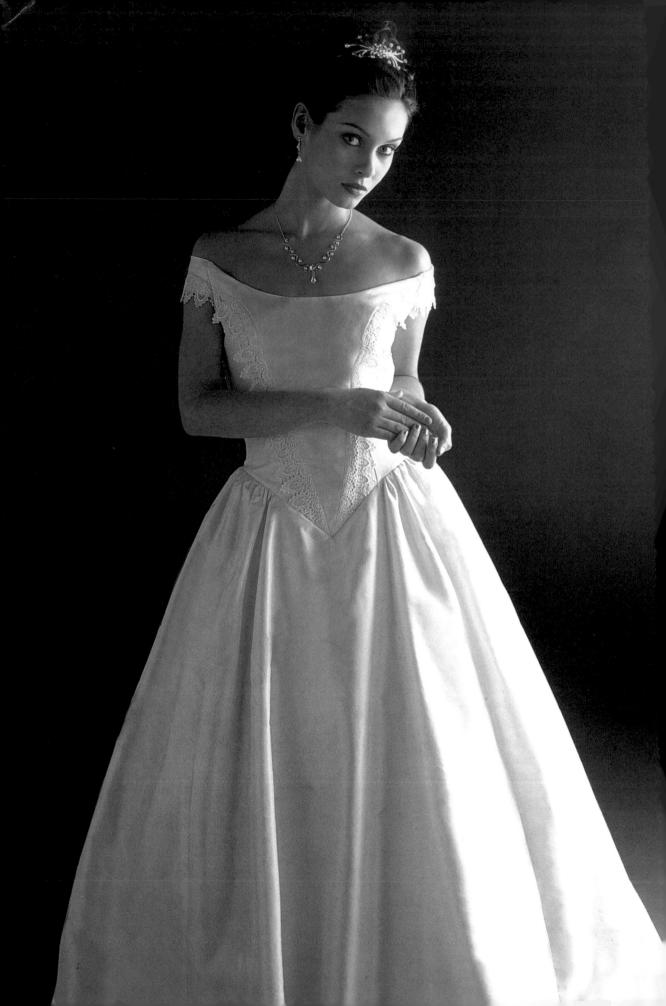

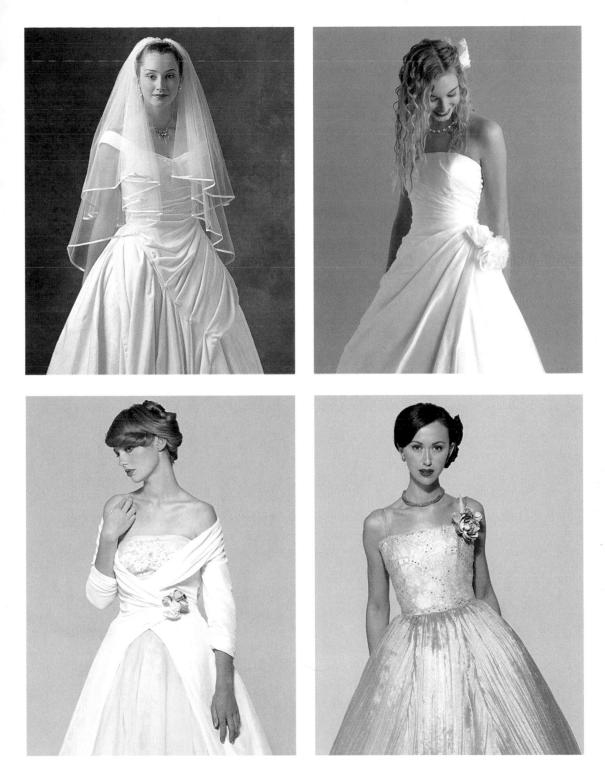

LEFT Innocent looks—lace inserted from the neckline to the point of this basque-bodiced dress is simple and pretty. ABOVE, CLOCKWISE FROM TOP LEFT Asymmetric details in these dresses create focal points. A cascade of fabric swathes softens the silhouette; a simple strapless dress is gathered at the hip with a silk corsage; a tea rose dress is accented with lace overlay and a pleated skirt; a white coatdress over a strapless foundation gives contrast in texture and tone.

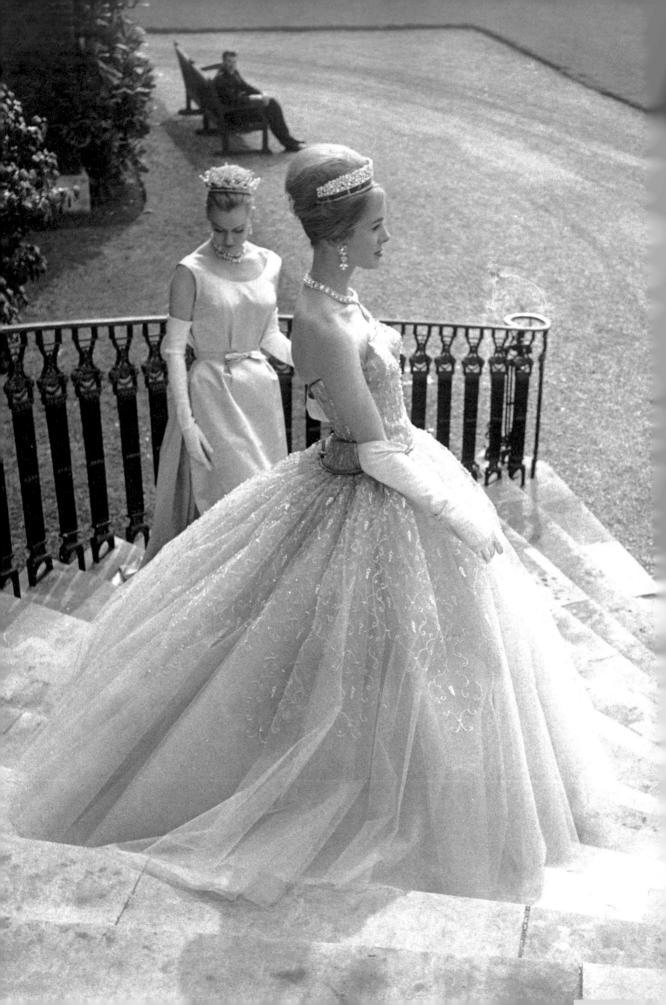

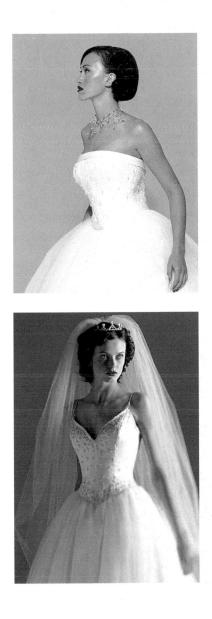

LEFT The simple column dress in the background is upstaged by the voluminous tulle skirts of the dress being photographed by Hardy Amies—both are his own wedding dress designs, 1960.

ABOVE Two more modern examples of tulle ball gown skirts, showing the striking emphasis to the waist (TOP), and a soft matching veil (BOTTOM).

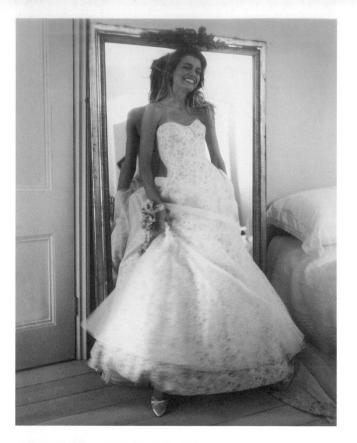

LEFT The "Godiva" dress—a strapless, Italian floral print gown with silk organza overlay, designed by Phillipa Lepley. It features a "cupped" bustier bodice and a flat-fronted full skirt.

BELOW Daring colored highlights make this low-cut dress stand out from the crowd. A sheer green overskirt is scattered with silk hydrangeas in gold, lilac and blue.

RIGHT Subtle combinations of color complement different skin tones. This SaraSusa ivory and cream satin dress with rose details is good for fair skin.

BELOW RIGHT "Married in blue, he will always be true"—this color looks good on olive and darker skin tones.

BELOW FAR RIGHT A rose tint on the bows and crossover bodice and train of this SaraSusa dress complements pinker tones.

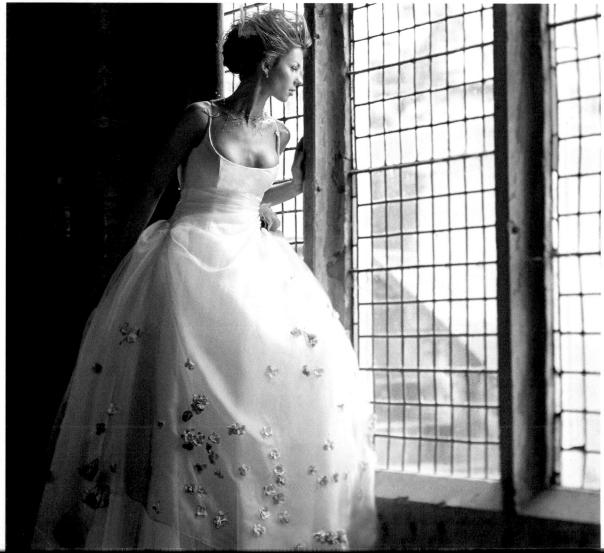

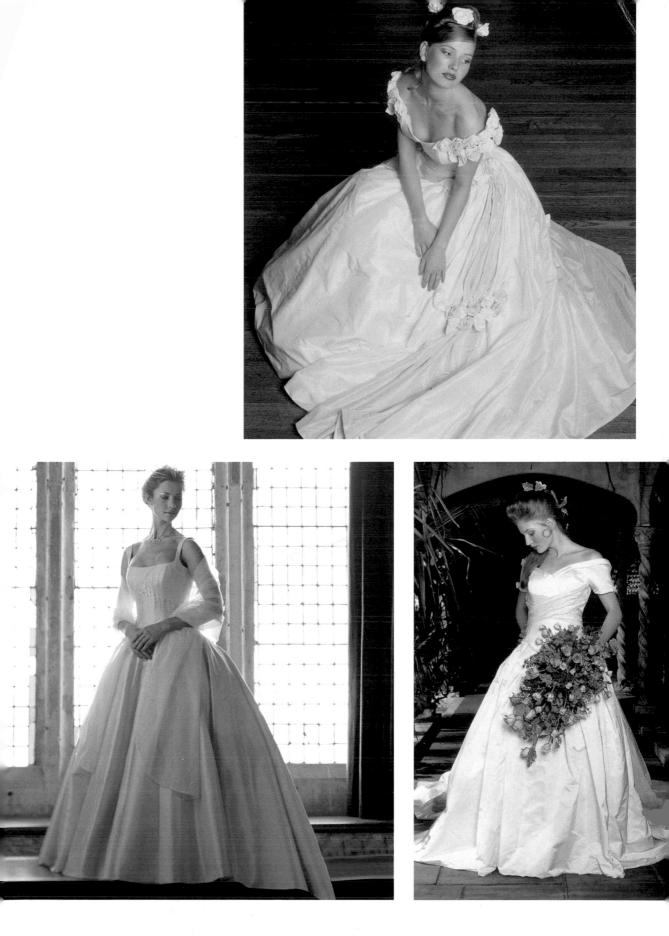

RIGHT A seamed bodice is echoed in the pleats of the bell skirt in this subtle gold gown.

BELOW An ivory strapless dress with large, pleated, bell-shaped skirt is striking in its classic simplicity.

30

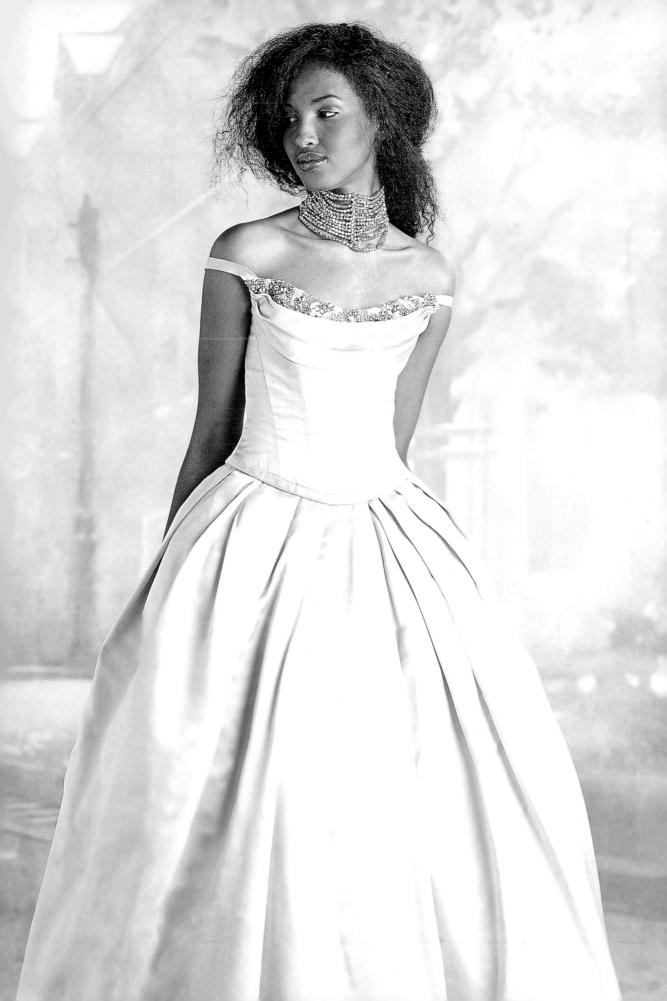

PRINCESS LINE

PRINCESS LINE

STYLE

A very flattering and useful style, the princess line is not so much a silhouette as a cut. It tends to be closely associated with the fit and flare of the A-line, but for the purpose of establishing the different dress styles within this guide, the princess line flows unbroken from top to bottom, dividing the dress into vertical panels, while an A-line style may have horizontal seams to define the waist. The princess line is characterized by vertical lines straight from the shoulder or curving from the armhole to the hem of the dress. These lines incorporate the fit, and shape the dress so no other darts or pleats are necessary. Consequently the style is clean, minimal and most importantly slimming. Not only used for dresses, you will also find the princess line used for jackets and coats, and it is a favorite cut for women's tailoring.

Ultra versatile, the princess line can be used to create a number of definitive styles from mini and shift dresses, elegant sheaths and columns, to bell skirts, circular hems and fishtails. It is also a cut often used to create bridal coats and coatdresses, like the one worn by Sophie of Wessex at her wedding to Prince Edward (see page 72).

HISTORY

The princess line is generally attributed to Charles Worth, the 19th century couturier who created the wedding dress for Princess Alexandra for her marriage to Edward VII. Worth was an English designer who established the first couture house in Paris, in 1858, and was responsible for many innovative styles adopted during the latter 19th and early 20th centuries.

The princess line was named after Princess Alexandra and was developed from a desire to eliminate the need for a separate bodice and skirt in the construction of the dress. It set a standard that has been universally adopted, and is a perennial favorite with designers such as Yves Saint Laurent and Marc Jacobs.

In combination with an A-line silhouette, this cut was definitive of the 1960s styles from designers like Courrèges, Cardin and Mary Quant (see also A-line, pages 92–107), who used the cut to create clean space-age designs. In the 1980s, designers like Jean-Paul Gaultier used the contouring effects of the style with corsetry fabrics to create sexy curves on celebrity clients like Madonna.

CLASSICS

As I have already described the versatility of the princess line, once you start to look for it you will see it everywhere. The classic example is a "fit and flare silhouette," which may be strapless or with sleeves like the one worn by Queen Elizabeth II. As Princess Elizabeth she wore a Norman Hartnell satin dress with lace décolletage in this style for her wedding to Prince Philip in 1947 (see page 36). Half a century later, Lady Helen Windsor chose a modern take in Catherine Walker's dress of the same style.

If you are considering a winter wedding then a high neck, long-sleeved, princess line coatdress with a hat and muff is a great look. This style can also look stunning in lace and allover textures where the silhouette remains uncluttered and elegant. Ivory or metallic laces over subtle base colors can work well, and black lace over cream if you want to turn heads. Embellishments tend to be placed at the neck or hem, so as not to interfere with the clean lines, but a cascading motif can add interest, and a bold print can give it wow factor (see page 50).

WHO SHOULD WEAR IT

Ideal for creating a statement that is sculptural and uncluttered, the strong verticals add height and reduce the visual impact of a large expanse of uninterrupted fabric. With so many possibilities on offer, this style will suit most body types and heights. Particularly good on tall curvaceous figures, this cut can also give the illusion of curves where they are in fact wishful thinking. Teamed with the right underwear, the shaping effect at the waist and fulness of the skirt can also disguise wide hips and bums. In shift and shorter incarnations, it is ideal for petite and boyish, straight up and down figures. If you have a long body and relatively short legs, the high waist and shape and flare of the skirt can help re-proportion you. There are lots of neckline and collar options that work well with the princess line. If it is cut straight from the shoulder seam, then it works well with a high neck; while the curved princess line from the armhole complements round, bateau and scoop necks (see also Necklines on pages 142–143).

FABRICS

Sculptural shapes tend to benefit from unfussy fabrics, and the classic princess line would be in duchesse satin, peau de soie silk, raw silk or similar fabrics that have weight and structure, while the skirts can be given extra volume with petticoats. If you are going for a bolder statement, such as the textured, lace or two layer constructions, then you might want to consider damasks.

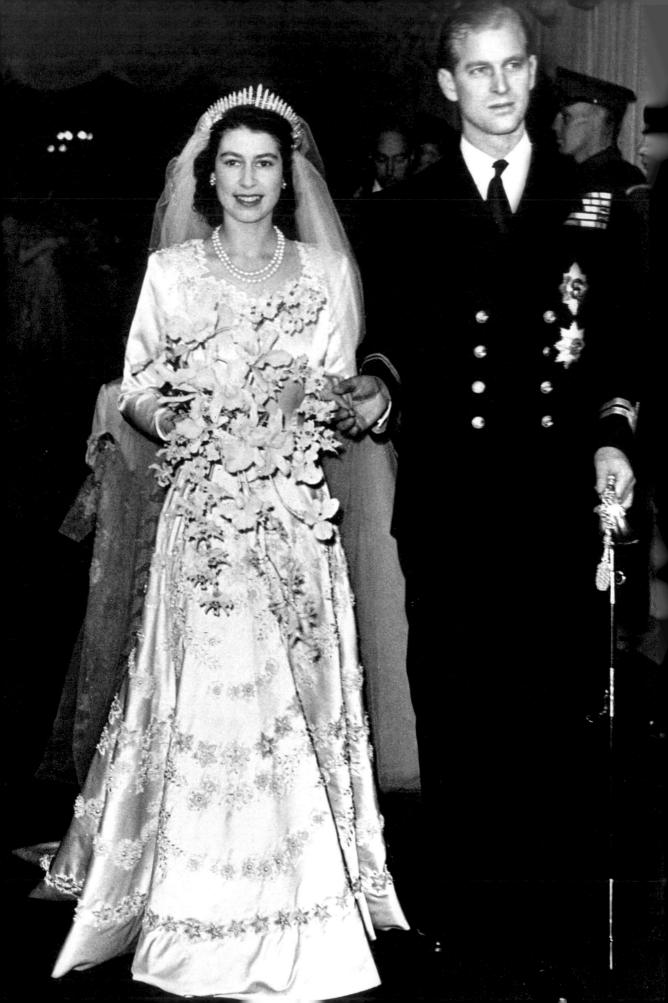

ABOVE Carmen Electra in an ivory Badgley Mischka dress, 2003.

RIGHT Roses clustered along a sweetheart neckline add interest to the classic simplicity of this SaraSusa designed gown. This is a replica of the style chosen by *Little House on the Prairie* star Melissa Gilbert.

LEFT Royal Princess, Elizabeth II wears Norman Hartnell for her wedding to Prince Philip in 1947. The dress was inspired by Botticelli's *Primavera*, and the white satin dress was embellished with seed pearls and 10,000 crystals in the form of white York roses, orange blossoms, lilacs, jasmine and wheat.

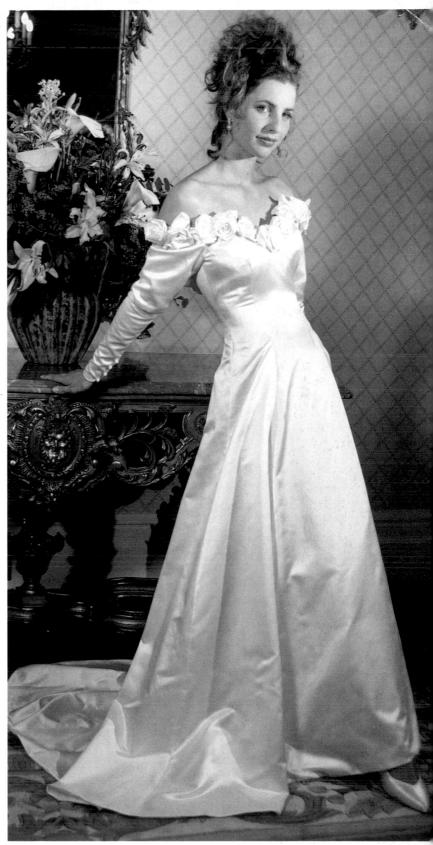

RIGHT A dramatic entrance in a square-neck princess-line dress with symmetrical embroidery on the bodice and stylish opera length gloves.

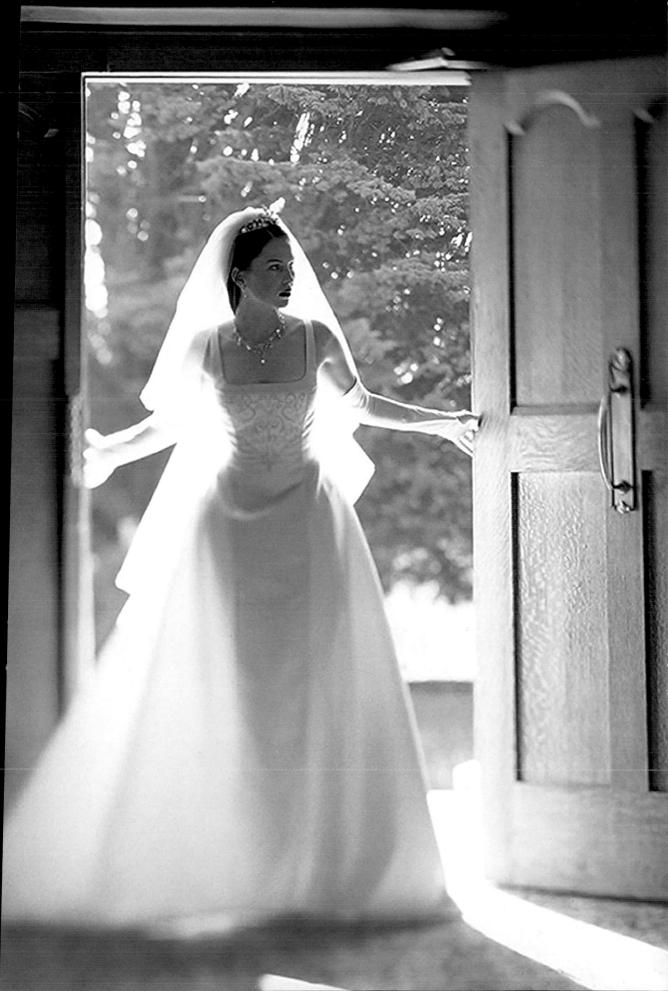

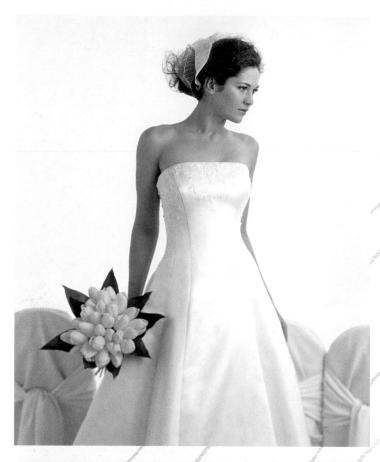

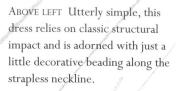

BELOW LEFT This Caroline Parkes design in silver lace needs no other detail to make a statement.

RIGHT Layers of silk ruffles on this stunning Caroline Castigliano Collection dress add textural interest while the line of the gown remains unbroken.

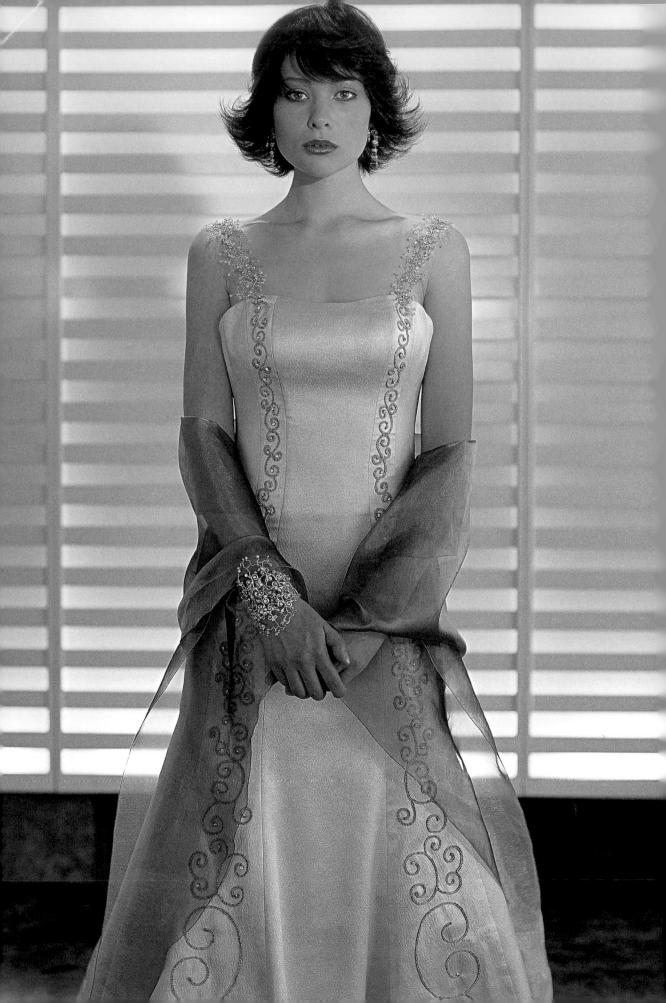

LEFT The embroidered details on this silver dress follow the princess line contours of the gown culminating in decorative straps

RIGHT Delicate embroidered floral motifs cascade down a white satin dress.

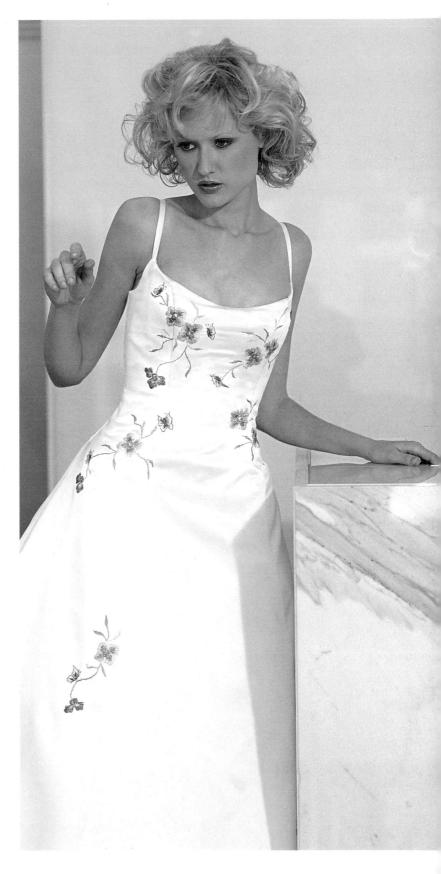

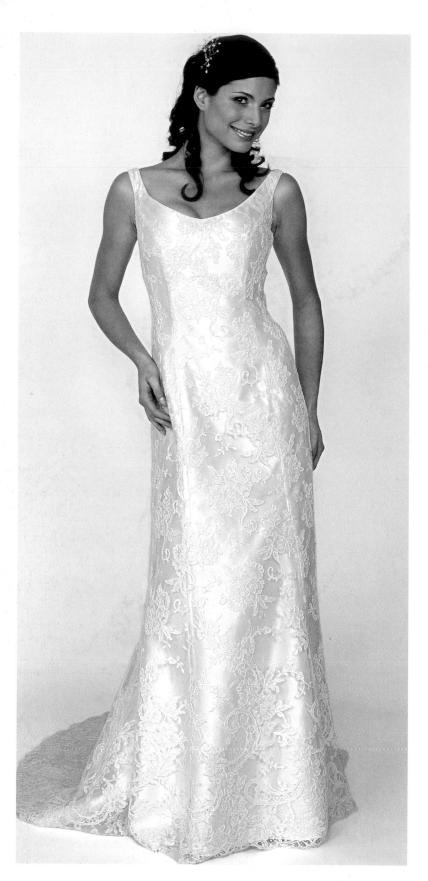

LEFT A Caroline Parkes gown with lace overlaid on satin, which is cut straight-through into a small train. A simple, fluid design.

OPPOSITE Colored lace and beaded appliqué create a very different effect with asymmetric detailing on this fullskirted dress.

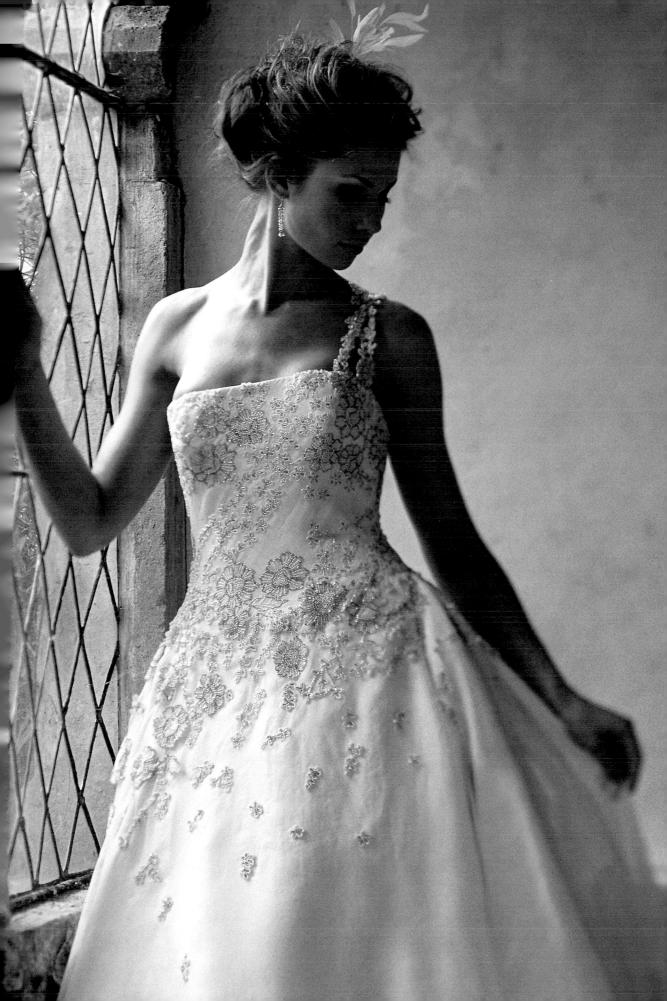

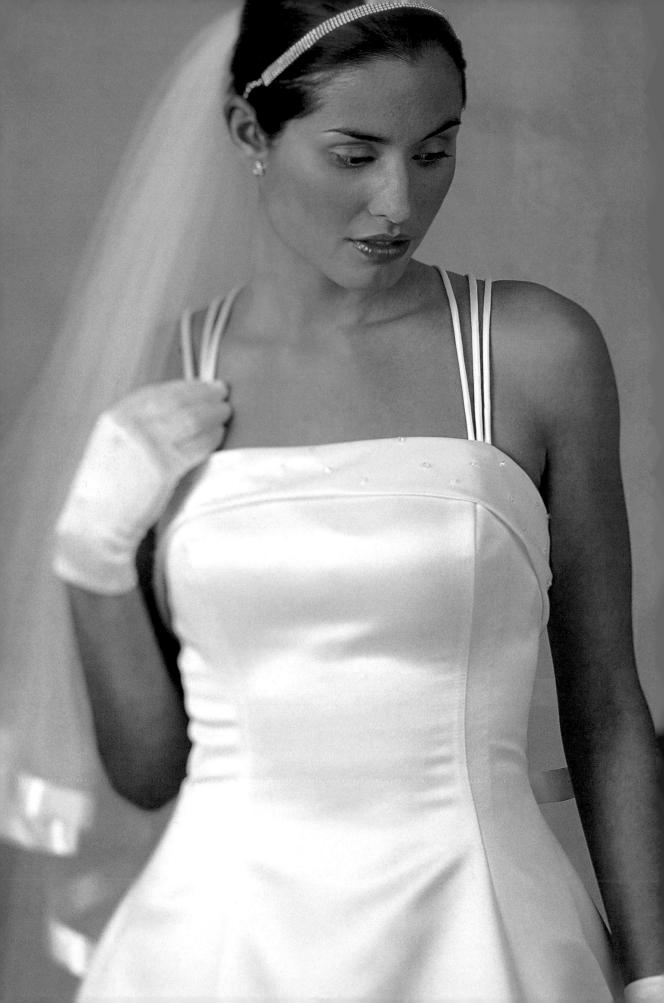

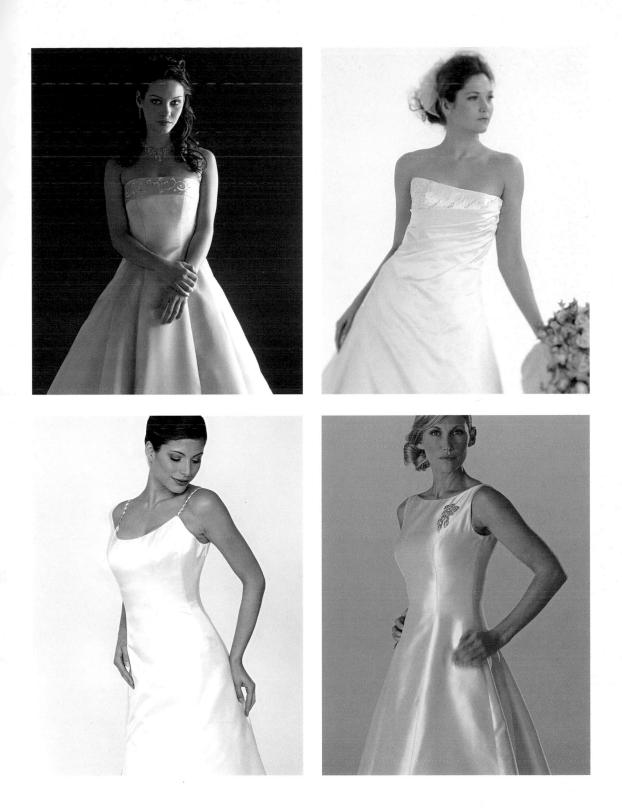

LEFT Spaghetti straps suspend a white satin dress sprinkled with crystal beads, which echo the diamanté headband. ABOVE, CLOCKWISE FROM TOP LEFT Embroidered border trim adds interest to this uncluttered design; an asymmetrically draped bodice is subtly sprinkled with beads; a brooch sparkles on a simple gold Stewart Parvin design; jeweled straps set off the clean lines of this white dress by Caroline Parkes.

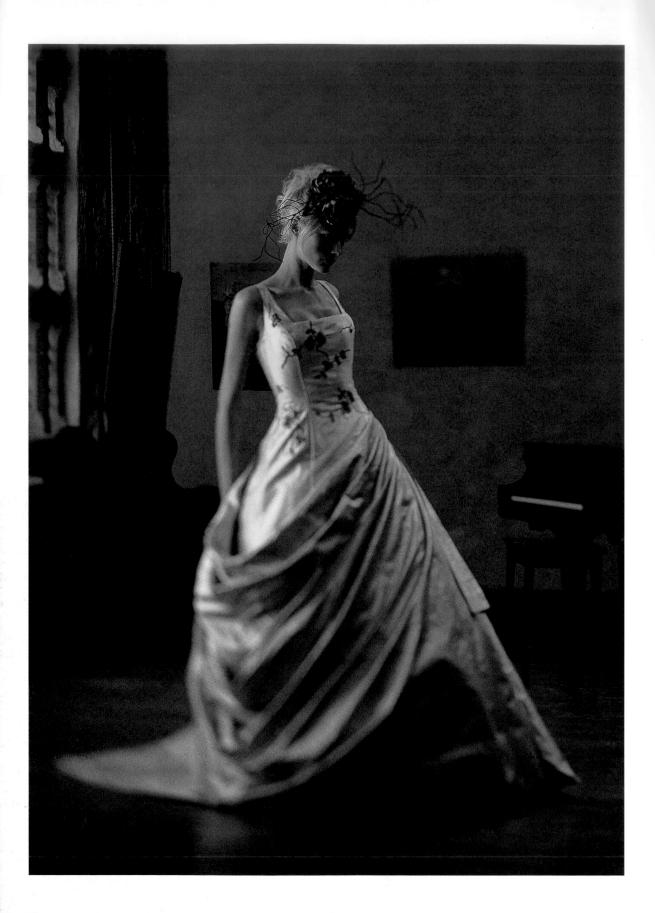

PRINCESS LINE

LEFT A striking floral headpiece is echoed in the embroidery of this draped and full-skirted gold dress.

ABOVE RIGHT Wing-fronted bodice with beads on a dress with trumpet-style train.

BELOW RIGHT This gown features an inverted V detail on the bodice and a deep inverted pleat skirt.

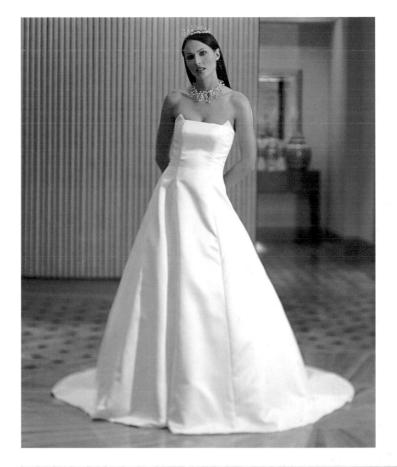

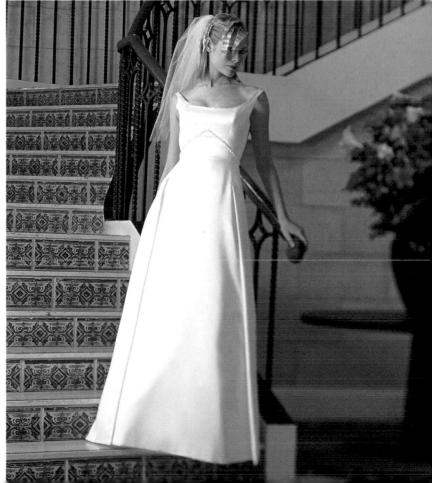

BELOW A Caroline Parkes strapless design with bold rose print—a dress that begs to be noticed. RIGHT This pretty off-the-shoulder gown features a gathered bodice and radial beaded details.

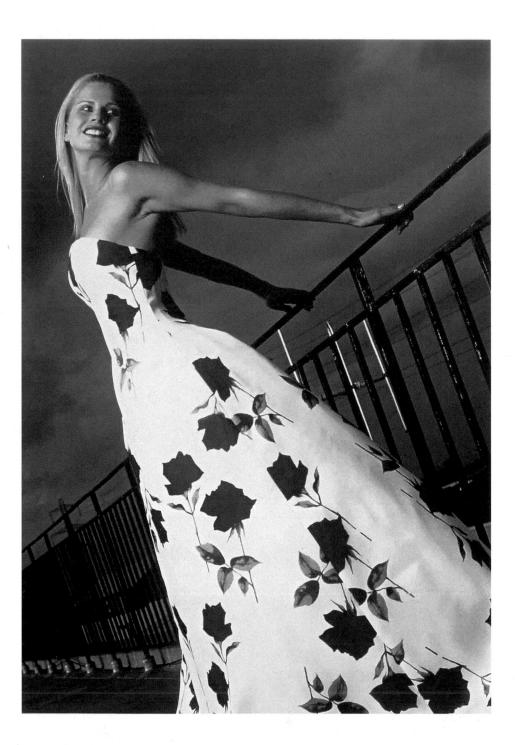

PRINCESS LINE

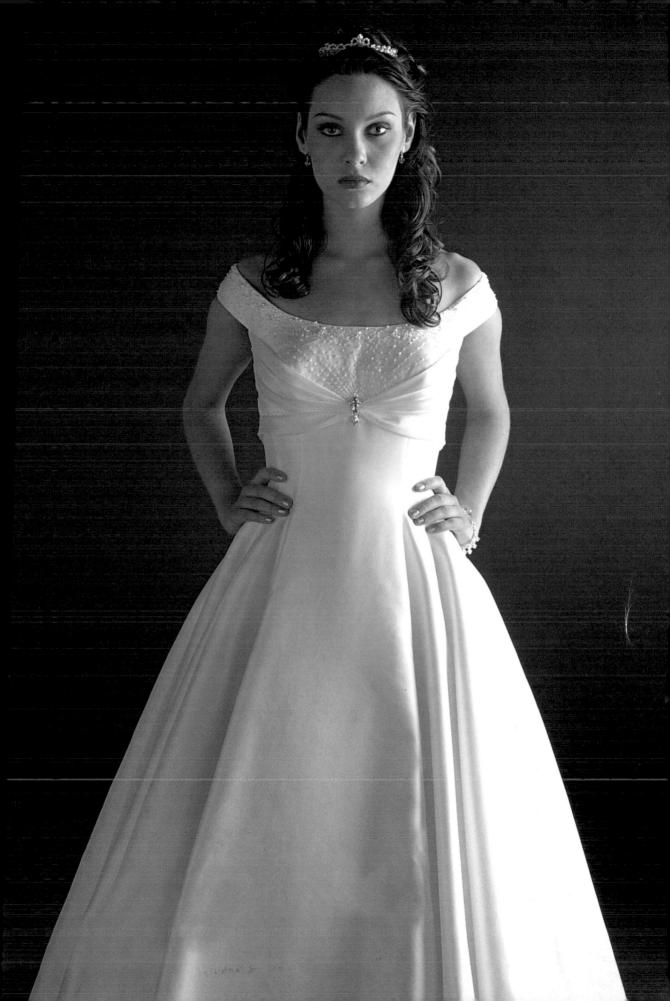

EMPIRE LINE

STYLE

The empire line is defined by a raised waistline cut just beneath the bust, often gathering a full dress, which drops to the floor to give an elongated silhouette. The neckline is traditionally a deep square décolletage, which is either worn with straps cut wide on the shoulder, or with capped or long sleeves. Dresses often feature a short round train at the back, as the fabric falls smoothly from the high waist to the floor. Sometimes a small pad similar to a bustle is used to separate the dress from the body. Historically, this style of dress was often worn with a cropped bolero, a spencer jacket in velvet or brocade, or a pelerine (a shaped wrap). Alternatively, a long matching coat called a pelisse could be worn over the dress. This has the same high waistline, at which it is fastened, falling open to the floor to reveal the dress beneath.

More contemporary takes on the empire line include strapless versions, and freeflowing A-line and mermaid skirts. A variation on the empire is the trapeze line, which is not waisted but flares directly from the underarm to the hem.

The empire style is often embellished with embroidery, lace appliqué or beading to the bodice (see Kate Winslet's fine example on page 56). The emphasis of the raised waistline is often highlighted with ribbon, bows or contrasting fabric to the skirt of the dress.

HISTORY

This style became fashionable during the Regency period (1790–1825), when it originated in France. It was inspired by the Greco-Roman style of draped tunic worn by classical figures, which became popular as the Napoleonic Empire spread across Europe into the Middle East. The fashion, which was relatively short lived, symbolized a period of classical enlightenment and unrestrained dressing for women, and it was epitomized by the heroines of Jane Austen's novels, such as Elizabeth Bennet in *Pride and Prejudice*. Subsequently, the heavily constructed and corseted clothing that became fashionable throughout the remainder of the 19th century actually encumbered women.

Its short-lived popularity may have been due to the French influenza epidemic that swept England during this time, branded the "muslin disease" after the flimsy style, which was at odds with the often inclement English weather. Added to this was the fashion for the empire-style dress to cling to the curves of the body, and it is recorded that women would actually dampen their petticoats to allow the fabric of the dress to do this.

Revived at the beginning of the 20th century by the French couturier Paul Poiret, the style had much in common with the dress reform of the period, and many designers were influenced by this classical silhouette. It has subsequently remained a popular style throughout the last century—in the early 1970s revival for Deco with designers such as Barbara Hulanicki for Biba, and in the late 1980s with John Galliano and Romeo Gigli. It is perhaps testament to the romantic associations with the many film and television adaptations of Jane Austen's novels that the style has recently become popular for wedding dresses once again.

CLASSICS

Classics can range from an authentic recreation of the period style, perched on a *chaise longue* with an ostrich feather fan, to Audrey Hepburn as Holly Golightly in *My Fair Lady* in a sparkling Hollywood version of the empire line, gathered at the bust, with sheer beaded capped sleeves and opera length white gloves. You can choose from a number of interpretations from the decades described to pick the perfect incarnation for you.

WHO SHOULD WEAR IT

The empire style is a good all-rounder, suitable for most physiques, as illustrated in the following pages: famous actresses Kate Winslet, Liv Tyler and Emily Mortimer (pages 56–57) show the versatility of the style for flattering different body shapes and sizes. The high waist elongates the body and hides lumps and bumps. It is ideal for those with a small bust, short legs, a long body or a pear-shaped figure. It can also help minimize a large bust if cut correctly, and it makes a natural maternity style.

FABRICS

The style is traditionally made from light cotton fabrics, such as muslin and lawn, with details in eyelet lace (broderie anglais) or embroidery of classical motifs. It works equally well in sheer silk chiffon, georgette or voile laid over a base fabric. Color variations in pale shades and metallics with delicate beaded embellishment can update the look.

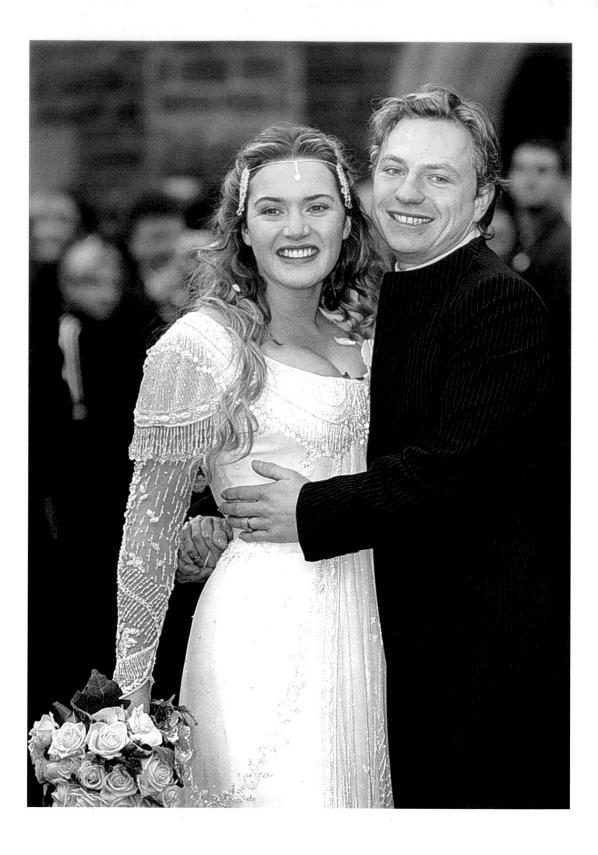

LEFT Kate Winslet marries Jim Threapleton in a stunning white beaded dress by designer Alexander McQueen, 1998.

ABOVE RIGHT Actress Emily Mortimer's delicate pale yellow empire line dress was a vintage find in London antique emporium Virginia. It featured traditional sheer capped sleeves and a front buttoning detail.

BELOW RIGHT Liv Tyler weds in a simple, ethereal empire line dress by Alexander McQueen, with draped sleeves and a deep scoop décolletage. A band of gold brocade adds interest and her shoes match the groom's tie.

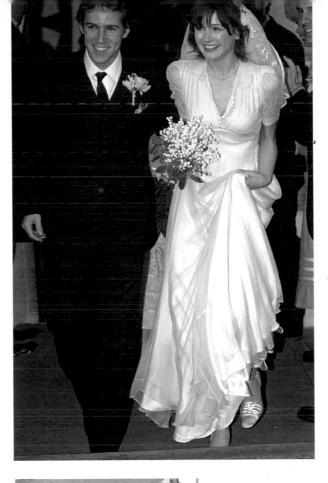

BELOW A pretty damask train is trimmed with a daisy border, hem and headband in this vintage empire line dress.

RIGHT A full-length trapeze-style dress by Jeanne Lanvin in ribbed voile with high-waisted sash and matching widebrimmed floppy hat, 1968.

EMPIRE LINE

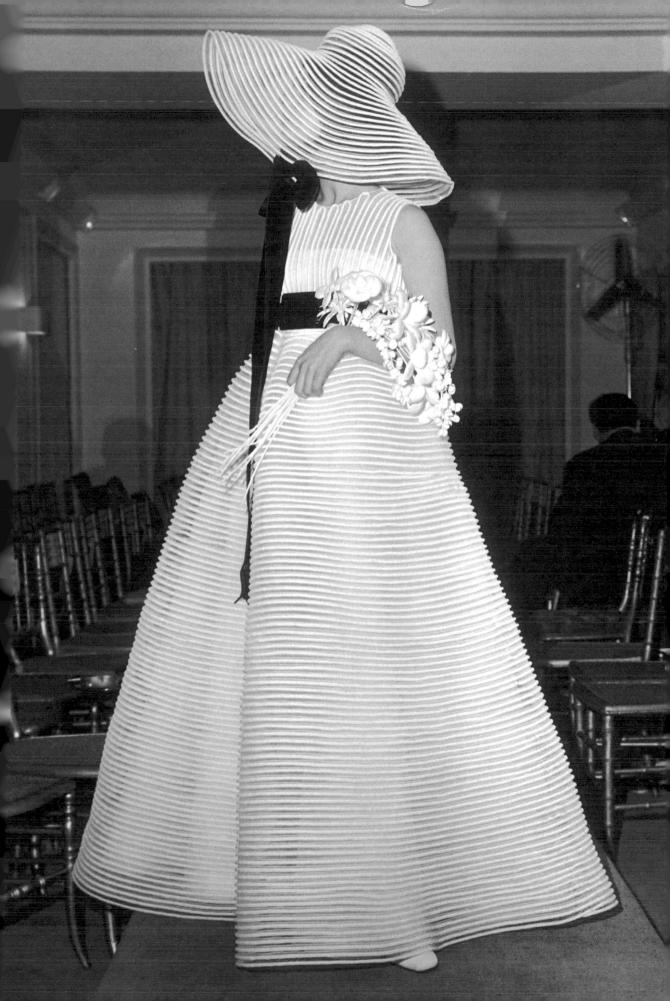

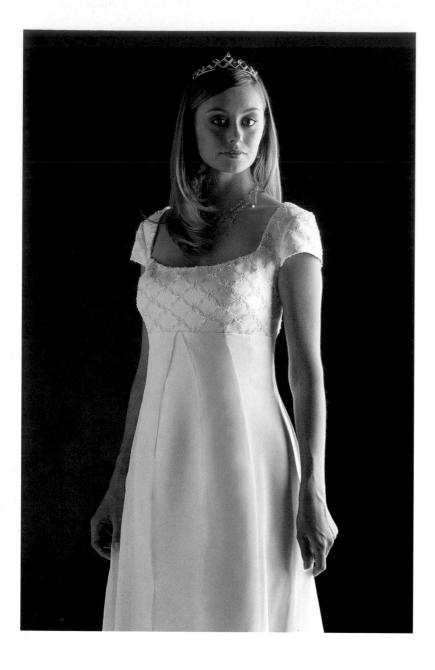

ABOVE Latticework appliqué adorns the bodice of this cap-sleeved dress with sheer, split skirt overlay.

 $R_{\rm IGHT}\,$ Sheer simplicity—a chapel-length veil and pearls set off this elegant dress with spaghetti straps and lace appliqué detail.

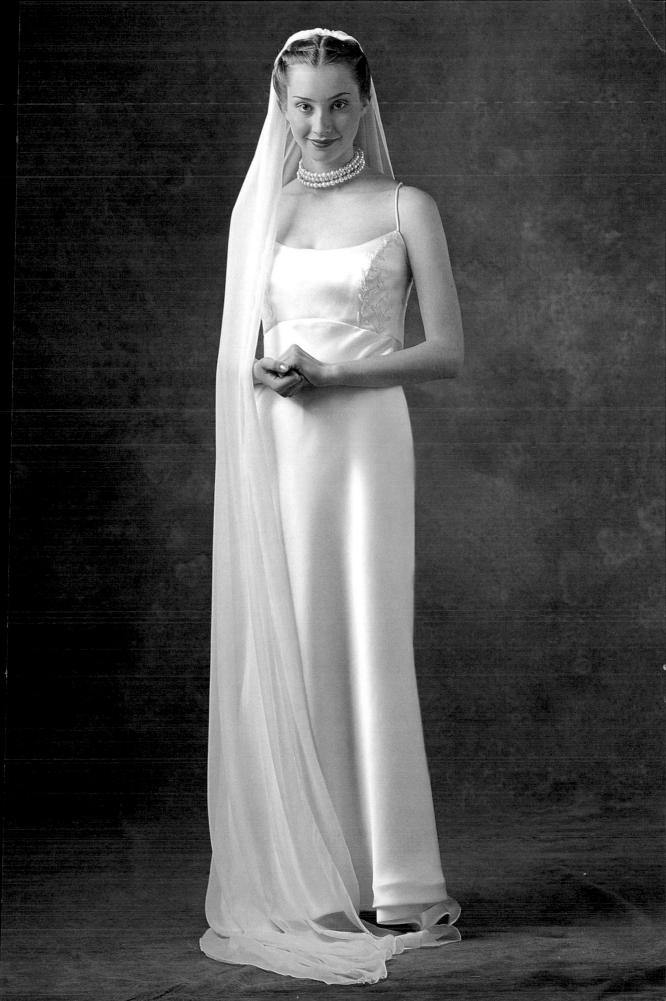

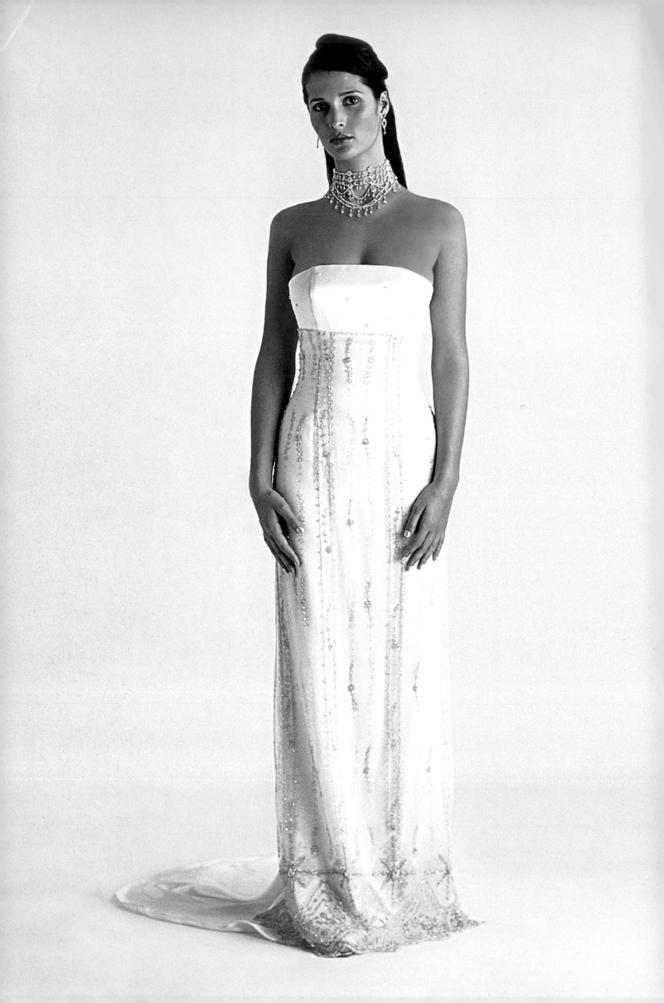

LEFT Crystal-beaded and silverembroidered sheer skirt over a strapless empire-line dress with chapel train is set off by a sparkly choker.

BELOW Lace-trimmed petticoats are pretty under organza ruffles on the hem and bustier of this off-theshoulder Caroline Parkes gown.

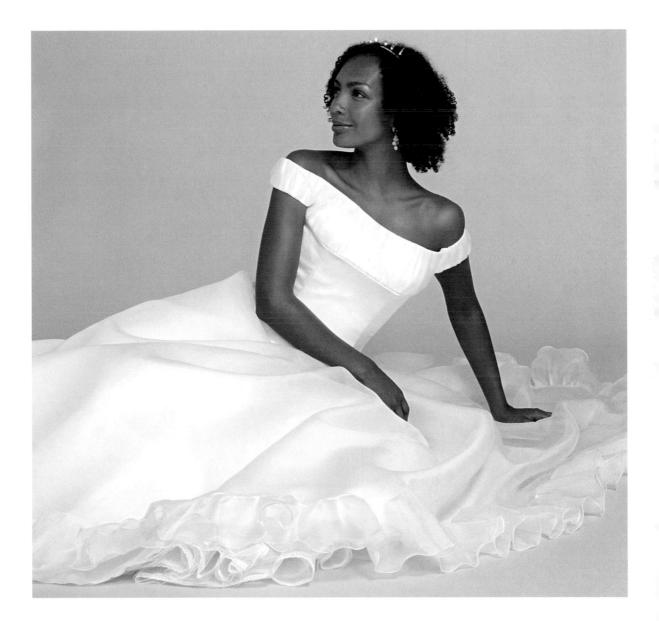

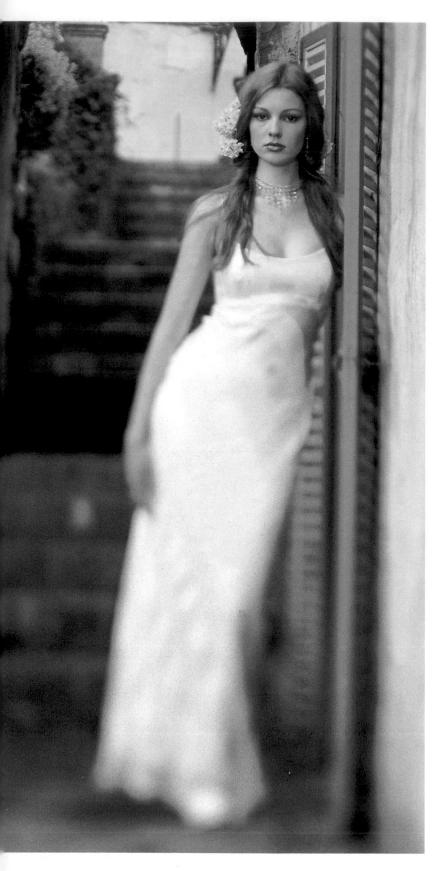

LEFT Pre-Raphaelite looks in a simple low-cut dress with crystal spaghetti straps.

RIGHT Romantic and sophisticated, an ivory dress with pearl details and embroidered overskirt that flows into a train.

FOLLOWING PAGE, LEFT "Elliot"—a Phillipa Lepley design in duchess satin, with a crepe and chiffon bias-cut skirt and a flower and streamer ribbon corsage to adorn the bust.

FOLLOWING PAGE, RIGHT Modern elegance in a fluid, bias-cut crepe dress with empire line and pin-tuck chiffon sleeves by designer Sarah Owen.

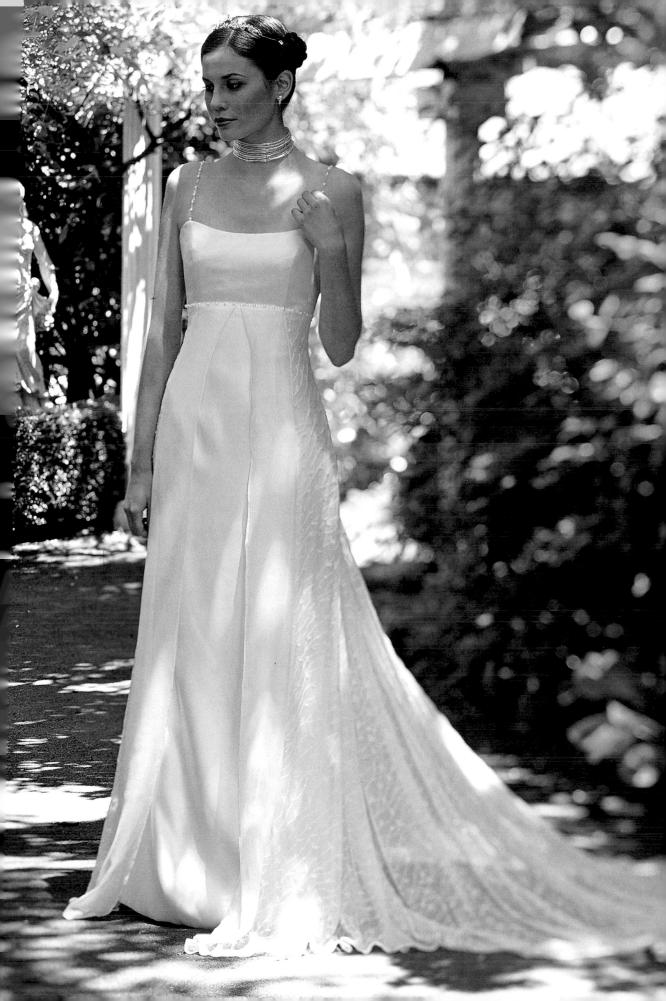

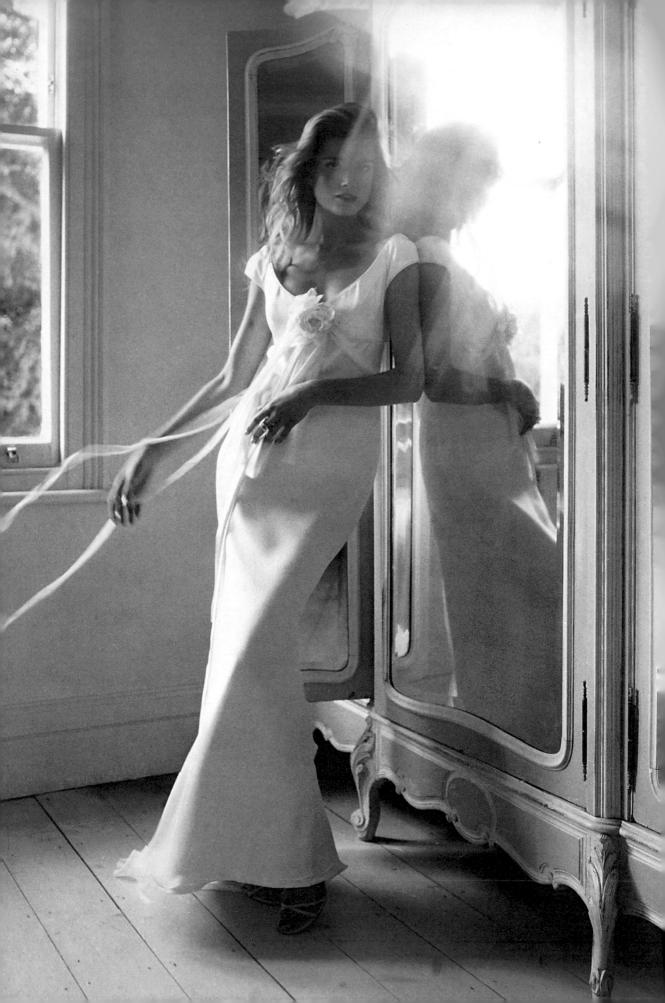

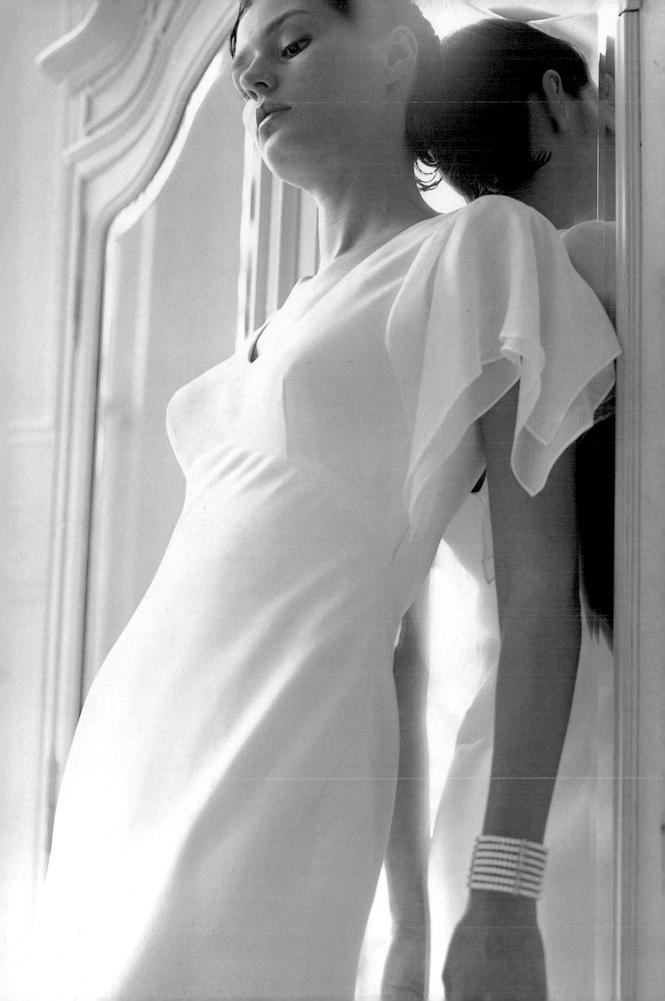

MERMAID AND FISHTAIL

MERMAID AND FISHTAIL

STYLE

The mermaid or fishtail dress is usually associated with a bias-cut style typical of the 1930s Hollywood siren, a quicksilver sheath that seems to collect in a pool as it hits the floor. A fluid alternative to the constructed column style (see also Column, pages 108–119), it is a sheath that fits where it touches the body. The fabric is cut diagonally to the grain, allowing it to drape around the body so that dresses often require no fastenings or openings and can be slipped over the head, much as if you were wearing a knitted jersey or stretch Lycra dress (which is of course an option, but only for the physically and emotionally confident!).

Most dresses in the bias style tend not to actually be cut on the bias, but give the same visual effect, as bias cutting involves quite a lot of diagonal seaming within the construction. True bias-cut dresses in the 1930s tended to have circular hems in trumpet or fishtail shapes.

The mermaid dress is typically figure hugging to the knee then flares to the hem. This can be achieved in a number of different ways: by adding godets (triangular inserts) to give fullness, or by adding volume evenly through the vertical panels of a princess line. Alternatively a circular panel can seam horizontally at or above the knee to add a lot of volume. The distribution of the "fishtail" can vary dramatically, it can be a trumpet or circular hem, a hem that is only apparent from the back, as a train, or even gathered to the front in a flamenco style.

HISTORY

Madeleine Vionnet was a pioneer of bias cutting in the 1920s and 1930s, and like Fortuny's pleated columns, the fluid cling and drape of fabric cut in this way was evocative of classical Greek dress (see page 110). The style was immortalized by Hoyningen-Huene in a photograph of a Vionnet dress as a *bas-relief* for *Vogue* in 1931, reminiscent of the Elgin marbles. Vionnet was, and still is, revered as an extraordinary talent whose designs transcend her era, with Dior, Alaia, Galliano and Miyake all citing her influence on their work. Actresses of the period such as Marlene Dietrich, Joan Crawford and Katherine Hepburn wore Vionnet both on and off screen. This was also the time when the influence of Hollywood really began to challenge Parisian couturiers as the arbiters of taste, with designers such as Adrian of Hollywood establishing retail businesses from dressing many of the stars of the silver screen. This relationship with the media still endures, and can be seen on the red carpet at the Oscars, as well as the film and television successes that influence what we wear today.

The slip dress, rather than a true bias-cut dress, can be traced back further. As an item of underwear, a silk slip was favored with the early 19th century empire styles, but has only more recently become an item of outerwear. Since the 1970s, the slip has evolved to become one of the most popular styles of dress, particularly with U.S. designers like Calvin Klein and Betsey Johnson.

CLASSICS

The style is typified by the slim sheath dress to the knee with a draped or cowl neck and flowing trailing skirt. Think of Jean Harlow or Mae West and 1930s Hollywood, with a figure-hugging dress and circular cut fishtail inserted asymmetrically at the knee. A contemporary take on the Vionnet classic bias dress for brides can be found at Catherine Walker, who has dressed many famous brides and celebrities.

The coatdress worn by Sophie Wessex in her wedding to Prince Edward shows a good example of the classic mermaid skirt, cut flat to the front with volume at the back, allowing the skirts to flow in a train behind her (see page 72). American film actress Denise Richards wears a slip dress for her wedding to Charlie Sheen for a more relaxed and modern take on the style (see page 73).

WHO SHOULD WEAR IT

You don't have to be tall to wear a bias cut, but you need to be slim or athletic to carry it off. The rule goes that if you are not confident about wearing a bias dress without underwear, then perhaps you shouldn't wear one. Unsightly straps and fittings can mar the cling of the dress. If you are really skinny or very flat chested you may be better advised to go for a slip dress or a more constructed style, which will also suit tall, curvaceous shapes, as the volume at the hem can balance hips and bust.

FABRICS

The mermaid skirt will work with many of the other styles covered in this guide, particularly the princess and column style of dress, and it works equally well in stiff, constructed fabrics. Contrasting fabrics can work well too, for example, velvet inset with a contrasting fabric for the fishtail gives textural interest. Other silks such as crepe, georgette, mousseline, organza and gazar work well for this type of dress. Slip-dress styles tend to be in satin, crepe de chine and lace, or for something more dramatic, in fringed, beaded or sequinned fabrics.

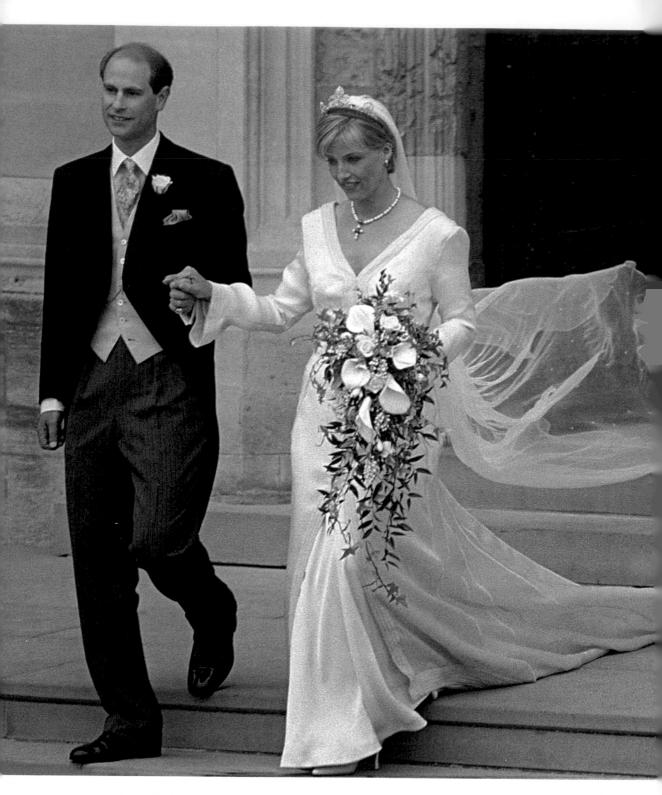

ABOVE Sophie Rhys-Jones marries Prince Edward at St. George's Chapel, Windsor, in a fishtail coatdress designed by Samantha Shaw, 1999. TOP RIGHT Actress Anne Heche poses with her new husband in a scoop neck dress with capped sleeves, 2001.

BELOW RIGHT Denise Richards wears an antique-white slip dress by designer Giorgio Armani for her wedding to Charlie Sheen, 2002.

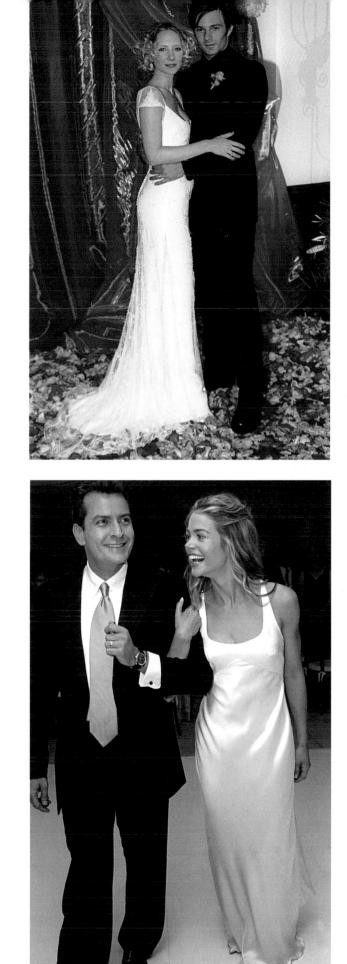

ABOVE LEFT This shaped ivory zibelinesilk sheath dress with puddle train creates the classic structured mermaid silhouette. It is set off with the addition of a rabbit fur bolero jacket.

BELOW LEFT On the lawn, the bride wears an empire line fluid mermaid dress by Antonia Pugh-Thomas with pearl beaded neck and armhole trim.

RIGHT Spiral-cut dress with square neck, silver beaded floral motifs and edge trim.

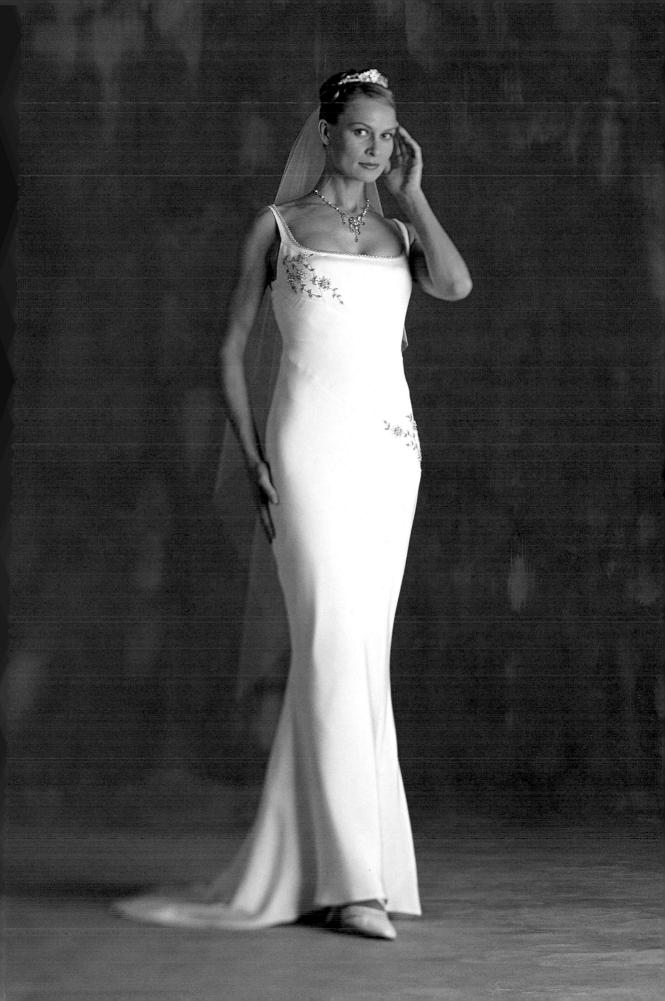

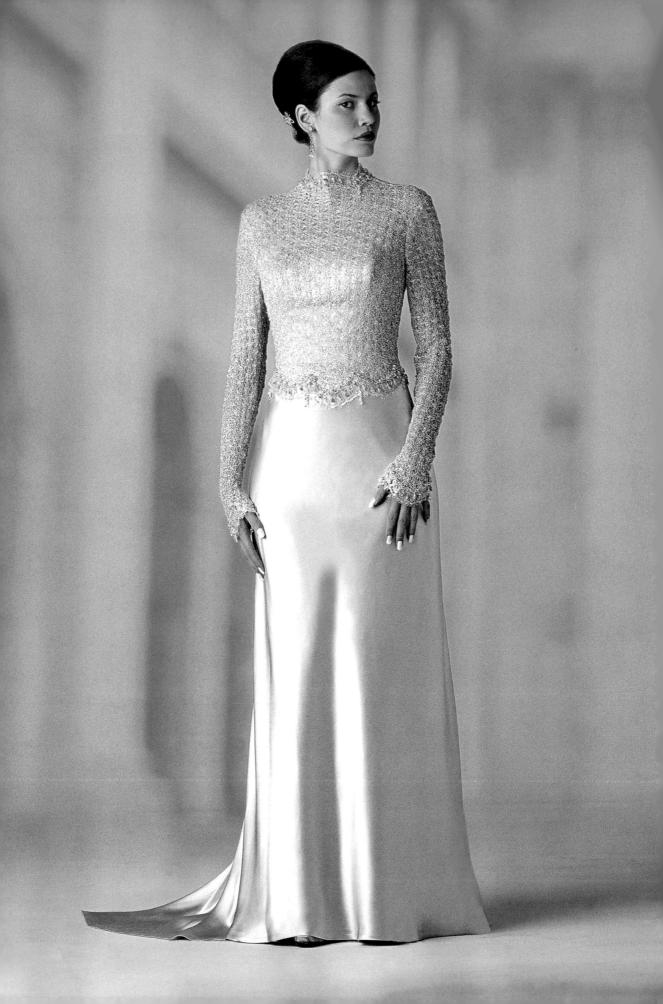

LEFT A striking chainmail effect is created on this silver satin dress by a silver crochet knit top trimmed with lace and crystal.

RIGHT Sheer simplicity—this apparently seamless sheath has a soft chiffon layer over satin, the perfect backdrop for some statement accessories.

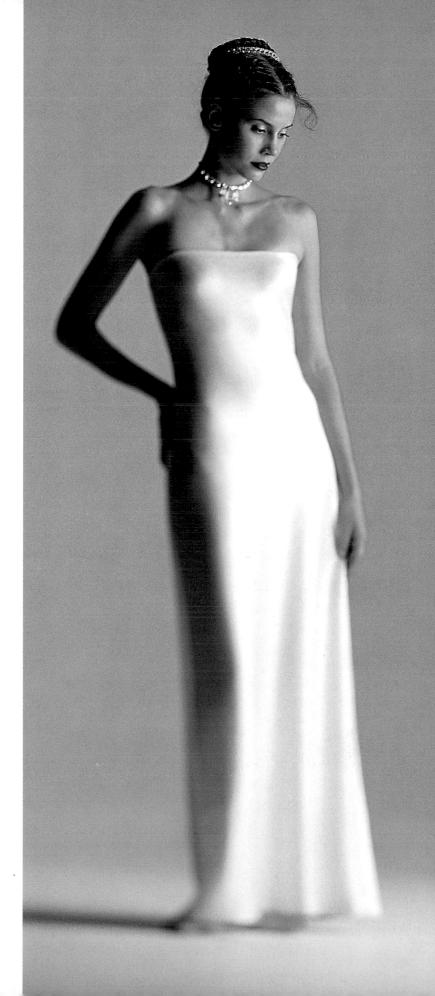

FAR RIGHT Antique-white bias-cut mermaid dress with spiral cutwork lace appliqué and halter neck.

BELOW LEFT White strapless dress with lace sheathed bodice. BELOW RIGHT A Stewart Parvin design in cream crepe satin with empire waist and cowl neckline.

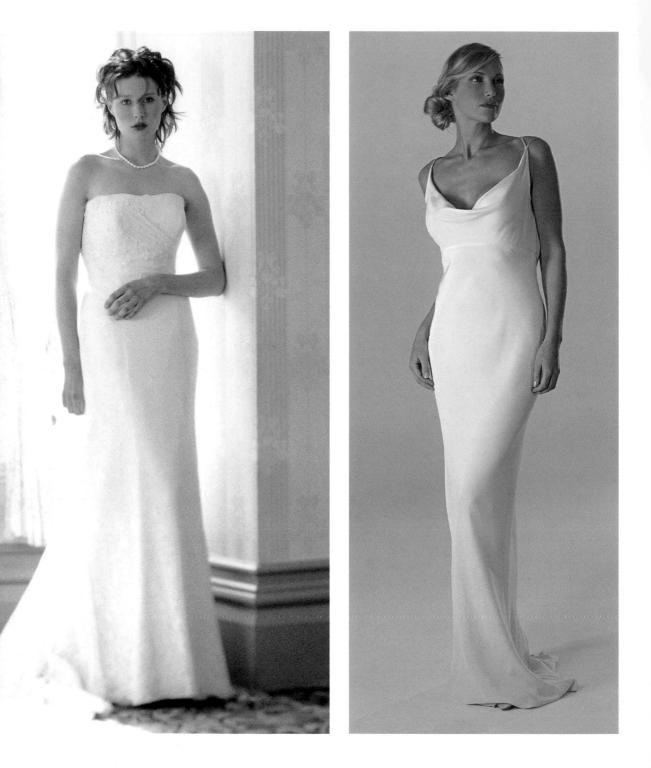

MERMAID AND FISHTAIL

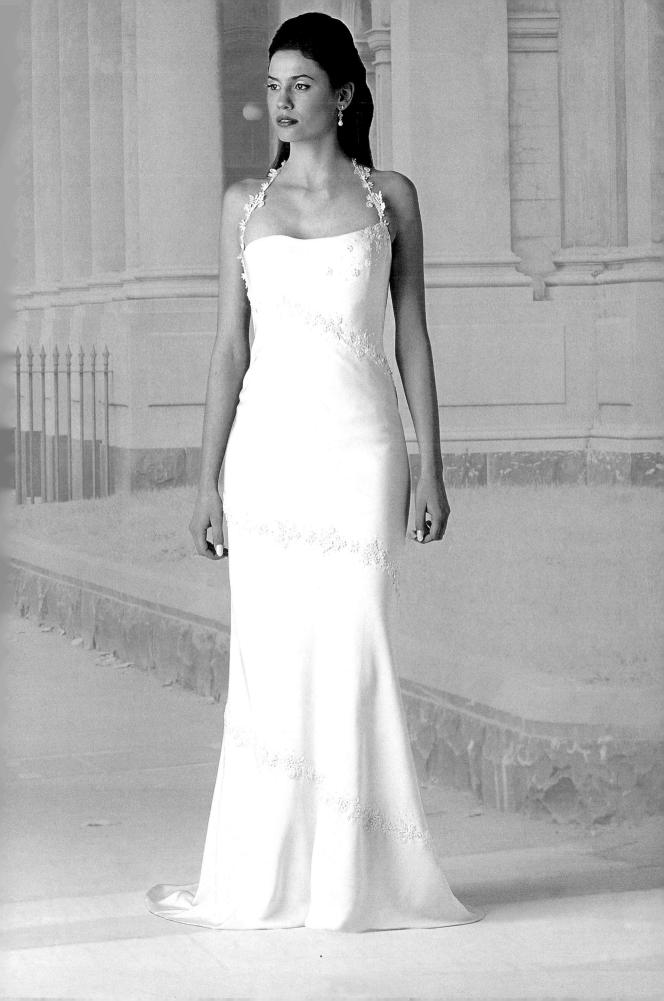

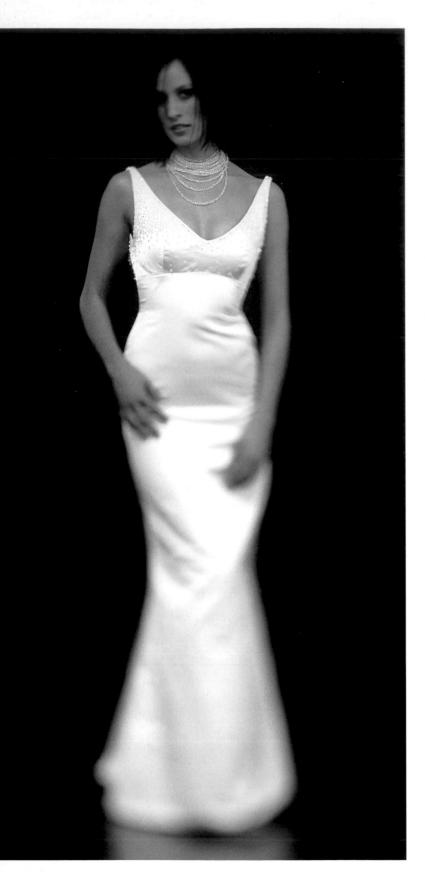

LEFT A deep V-neck scattered with crystal beading adorns a figurehugging fishtail dress.

RIGHT The classic, understated, flowing lines of this mermaid dress, with draped cowl neck and sheer bellshaped sleeves, are injected with a touch of humor with the addition of the striking Cozmo Jenks headpiece.

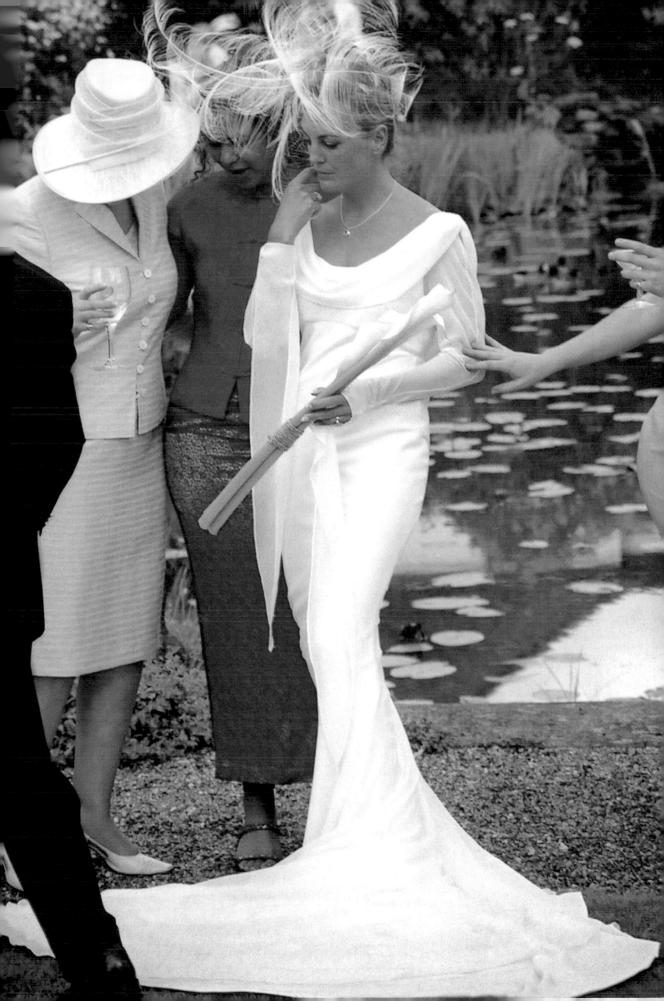

LEFT Rites of Spring—a simple biascut gown with halter neck and an allover embroidered spiral design.

ABOVE RIGHT Champagne structured bodice with lace appliqué over a satin base. The appliqué continues down the two-tiered skirt, which is hemmed with a scalloped edge.

BELOW RIGHT This simple bodice is cut in many shaped panels and is decorated with a symmetrical motif that complements the accessories.

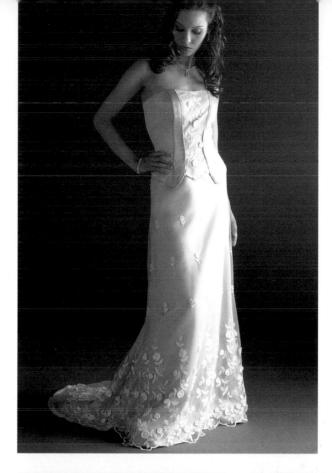

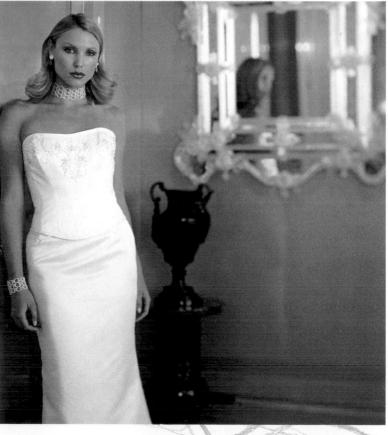

MERMAID AND FISHTAIL

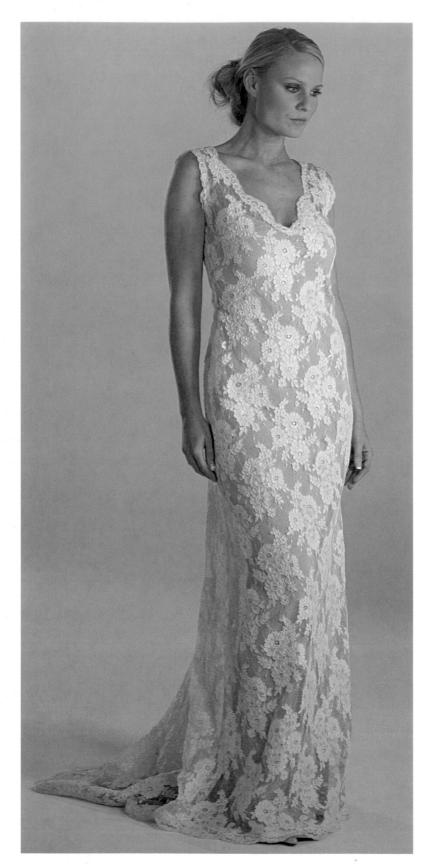

LEFT Antique-style buttermilk lace slip over a soft blue-grey bias-cut dress with spaghetti straps by Stewart Parvin.

RIGHT A beautiful bias-cut spotted chiffon dress with circular hem and tiered skirts contrasts with the lace-covered basque that encases the body.

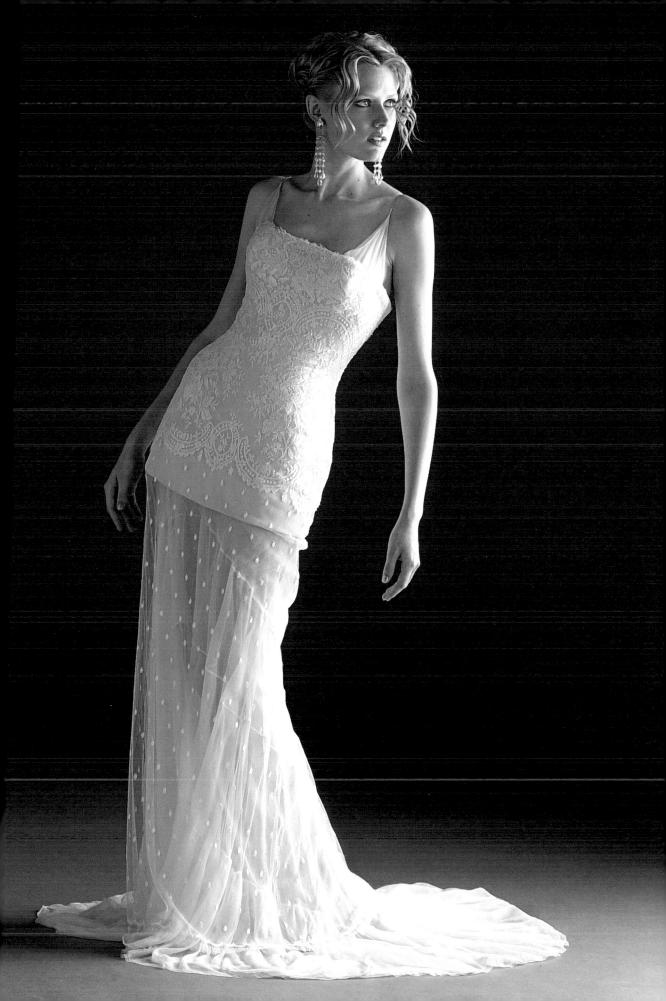

RIGHT Back views—a deep V in the back of this ivory duchess-satin column gown with covered buttons draws a line to the large trailing fishtail skirt. The bridesmaids wear narrowercut mermaid skirts.

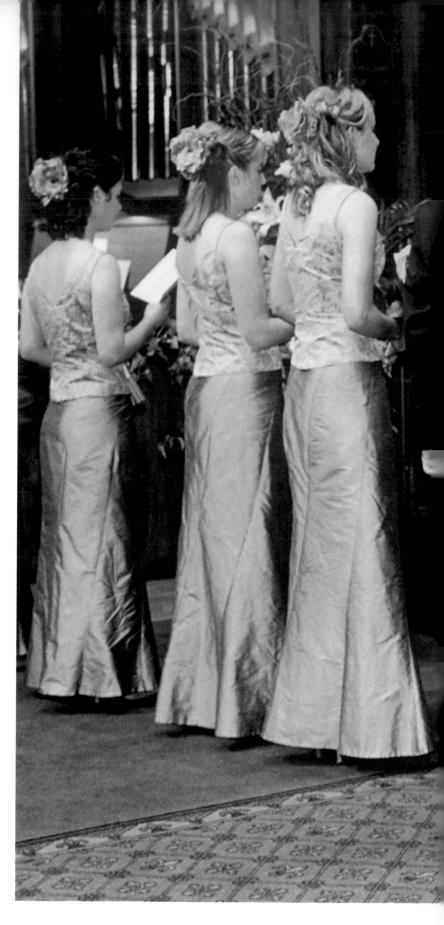

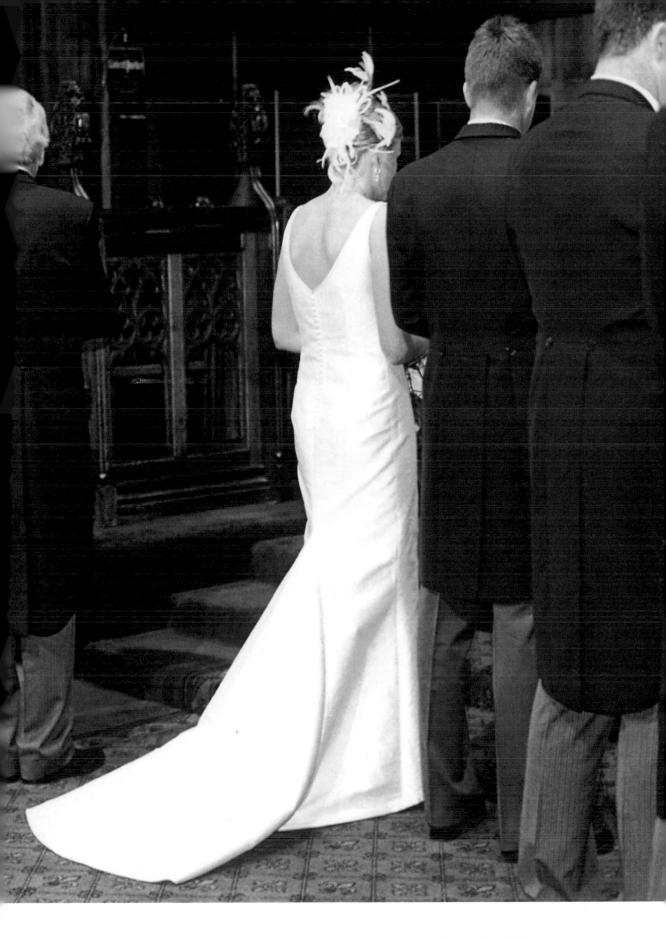

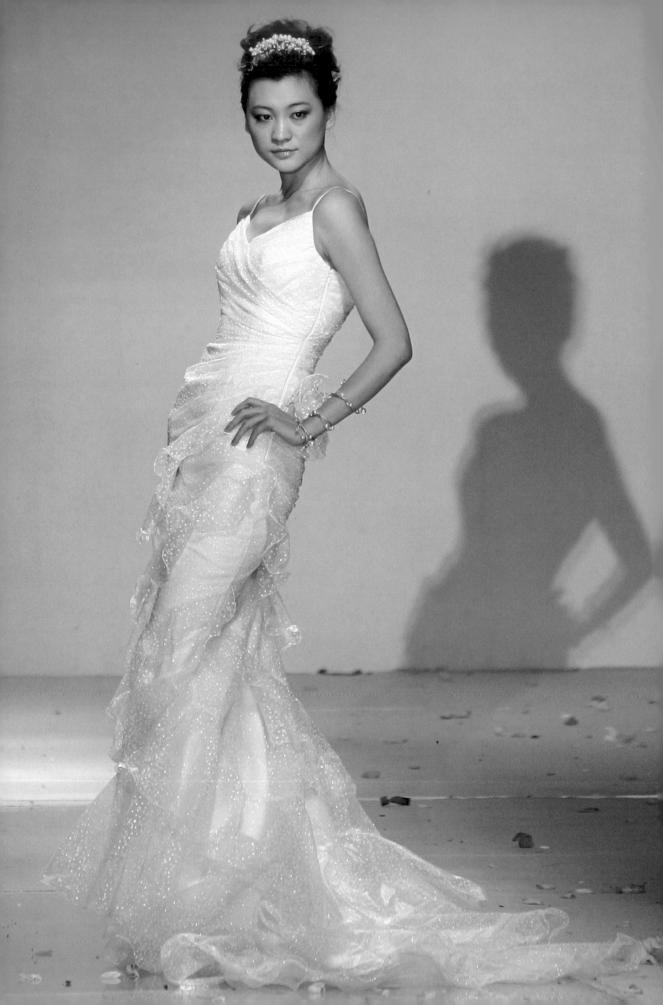

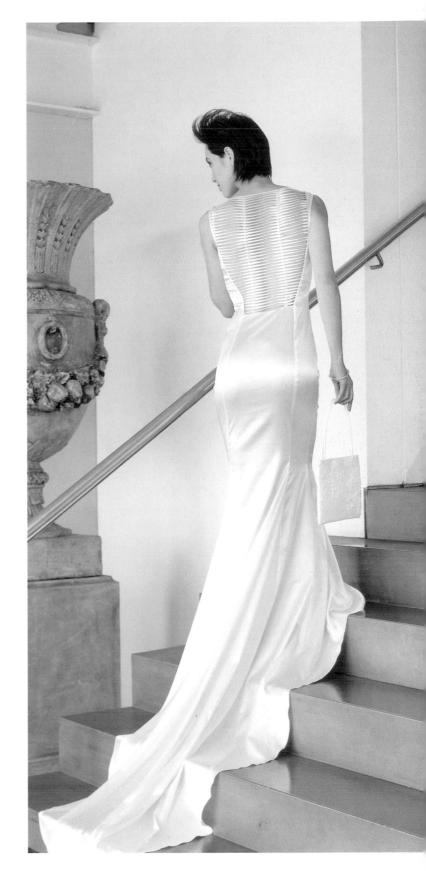

LEFT Irridescent beads flash on the ruffled flamenco skirts of this Yumi Katsura dress modeled at a wedding fashion show in Beijing, 2005.

RIGHT Pleats in the sheer back of this boat-neck dress are at once revealing and dramatic, adding strong verticals to the cathedrallength train.

MERMAID AND FISHTAIL

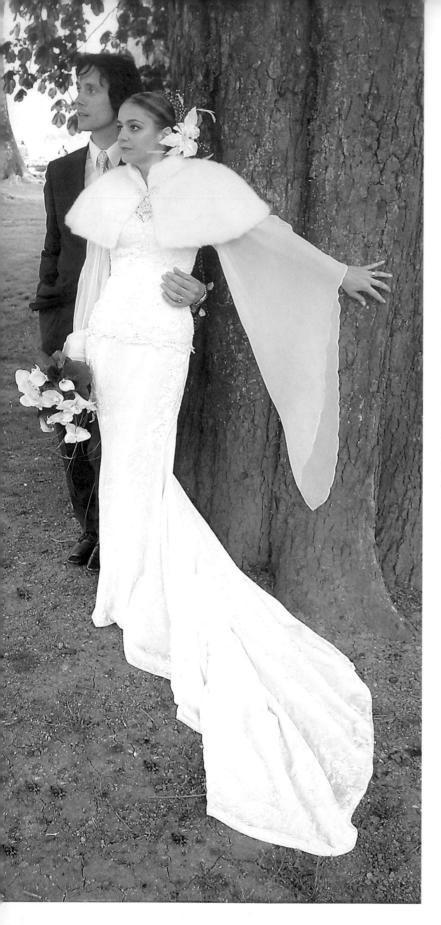

LEFT A vintage beaded 1920s dress is cleverly spliced with an ivory crushed velvet mermaid skirt and chiffon sleeves in this dress designed by the bride, Patrizia Hopkins, and made by Gussam at Fredek.

RIGHT This luxurious silk duchess satin column dress, designed by Sarah Owen, features a fishtail panel of sunray-pleated organza that gives the dress a lighter feel. The bodice is hand embroidered with pearl beads encrusted with crystals .

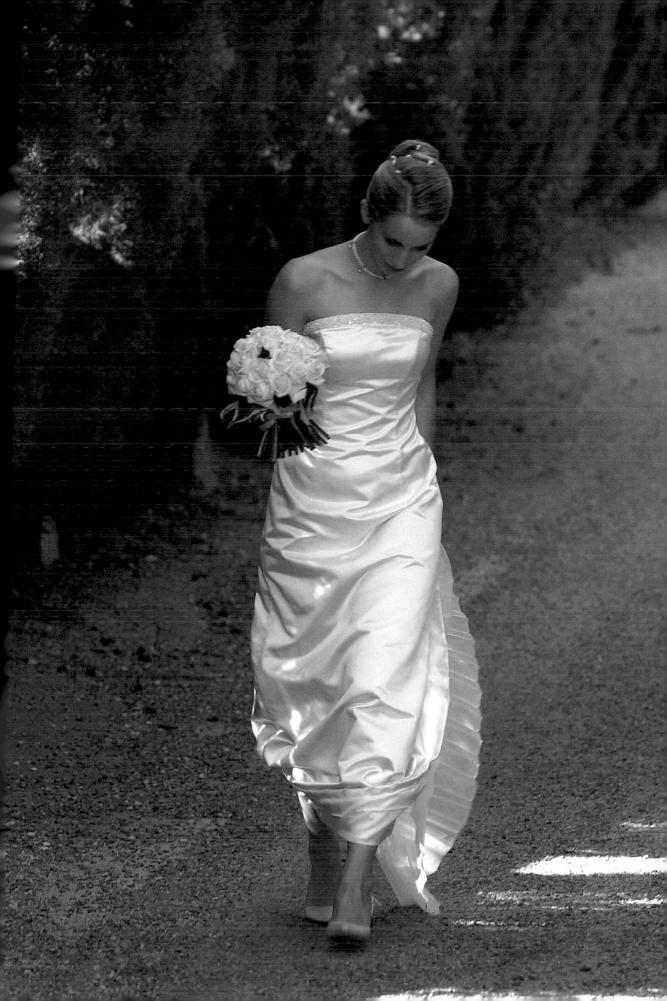

A-LINE

STYLE

As the name suggests, the A-line has a fitted bodice and flared skirt. It is a pared down and more modern take on the classic ball-gown shape, and is probably the most popular style of wedding dress seen today. We define the A-line as having a horizontal seam at the waist, and it can appear either sculptural and clean in fabrics that support the shape, or soft and flowing in lighter weights. The bodice and skirt flow together harmoniously in the A-line, but may still be in contrasting fabrics or textures, and the line is rather straighter than the curving crown of a skirt in the ball gown. A-line skirts can still be full and circular or have pleats to give added volume, but more commonly the skirt will flare gently from waist to hem. Lengths can be anything from daring mini to elegant, floor-sweeping skirts with trains.

HISTORY

The A-line is essentially a child of the 1960s, but we can see it emerge as a reaction to the utility dressing and boxy, mannish style imposed by the Second World War. Dior's 1947 Corolla collection that introduced the "New Look," a strongly feminine style with a cinched waist, padded hips and full skirt, set off the trend, and Dior is credited with the origination of the notation for this style, as each of his lines was identified by a letter, this one being the letter "A." His protégé, Yves Saint Laurent, developed the silhouette throughout the 1950s and 1960s for his own label, as did Givenchy, Courrèges and Emanuel Ungaro, who all trained at the house of Balenciaga, and were instrumental in the popularity of the A-Line silhouette throughout the 1960s, often teaming it with more experimental space-age materials. The A-line was also the shape of the mini- and maxi-dress styles popular at the end of the 1960s (see Mini and Midi, pages 120-129). By the 1970s, it was reinvented in more natural fabrics, and the silhouette softened with designers like Ossie Clarke and Jean Muir giving it a new, less structural direction in jerseys and flowing sheers. Like the princess line, which is often the partner to the A-line silhouette, it is now a staple of any designer's collection, as popular now as it was 50 years ago.

CLASSICS

A strapless A-line dress that sweeps to the floor is currently one of the most popular requests for a wedding dress, more popular now than the traditional ball gown, and a number of variations on this theme can be seen on the following pages. The bodice may be seamed into the skirt of the dress to give a clean silhouette, or in a contrasting fabric, texture or lace overlay to separate the top from the skirt visually. Balmain's 1954 wedding dress for Audrey Hepburn shows a shorter cocktail style of dress, the bound waist and full skirt reminiscent of the "New Look" style, and while the high neck and long sleeves are modest, the semi-sheer fabric hints at more. The shorter, calf-length skirt of the "prom" style dress has also become very fashionable once again with the red carpet set and these more 50s-style dresses offer a pretty yet practical style for a civil ceremony. Softer A-line silhouettes tend to be quite covered-up styles with sleeves (see page 101).

WHO SHOULD WEAR IT

This style is pretty universal, and one of the incarnations is sure to suit; it will just depend on how the dress is proportioned to your body shape. Like the empire line, this style is elongating on a petite frame, and the waist emphasis can help define a shapely figure. Tiered layers of lace on Jennifer Lopez's wedding dress by Valentino (see page 96) show how the silhouette flatters and camouflages a pearshaped body, while halter necks and deep scoops or picture collars can emphasize the Dioresque silhouette. If you have great legs then the hemline can rise as far as a minidress for the daring, or drop to the floor in a train for the more traditional. Remember, you can add height with heels under floor-length dresses, but beware of heel fatigue by the end of the day if you are not used to wearing them.

FABRICS

If you are emphasizing the simplicity of the style then more structural silks like duchesse satin, grosgrain, shantung or damask work well. Strapless styles may use contrast on the bodice, either in lace or beaded and embroidered details, or with a matte fabric that contrasts with a lustrous skirt. Sheer organza and laces layered over supporting base fabrics work well, and softer layers of voile, chiffon and even silk, viscose and wool jersey are options for a more fluid or draped silhouette.

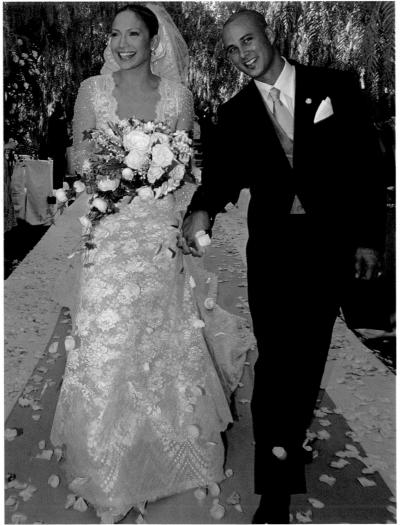

ABOVE LEFT Audrey Hepburn and Mel Ferrer leave the chapel after their wedding at Burgenstock Mountain, 1957. She wears a Balmain dress with sheer sleeves and cocktail length skirt.

BELOW LEFT AND OPPOSITE Jennifer Lopez wears Valentino for her wedding in 2001. The delicate Chantilly-lace and silk dress with plunging neckline falls in tiers with scalloped hem and matching veil. The original Valentino illustration is shown opposite.

96

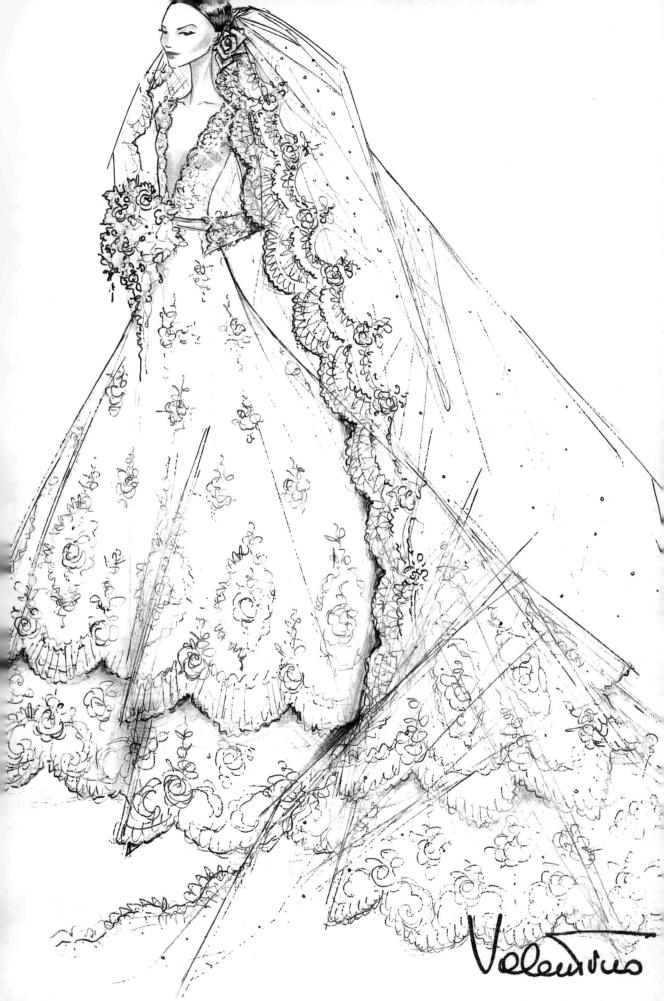

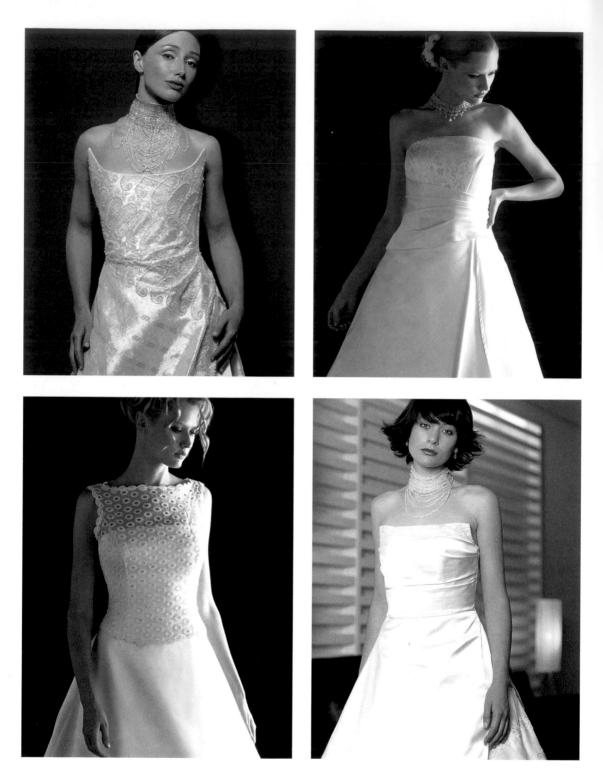

FAR RIGHT A simple belt with diamanté buckle adds the finishing touch to this strapless ivory Caroline Parkes design. Above, CLOCKWISE FROM TOP LEFT Variations on a theme with these strapless A-line dresses. Wing-sided corset bodice and skirt in silver silk sari fabric with paisley motif; ivory damask bodice with plain wrap skirt and pleated sash; deep pleated bodice with beaded border in duchesse satin; eyelet lace (broderie anglais) boat-neck overlay top, cut in a princess line.

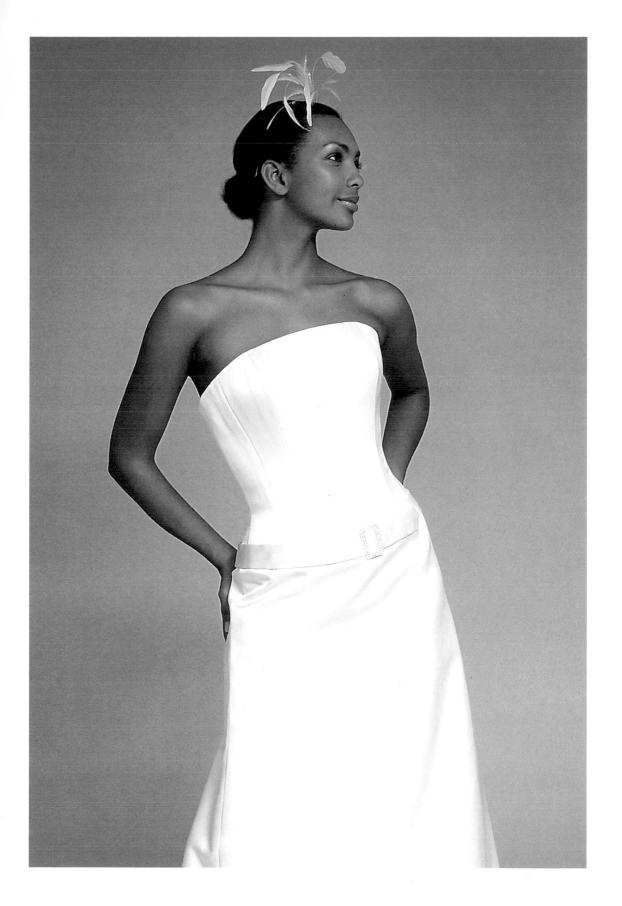

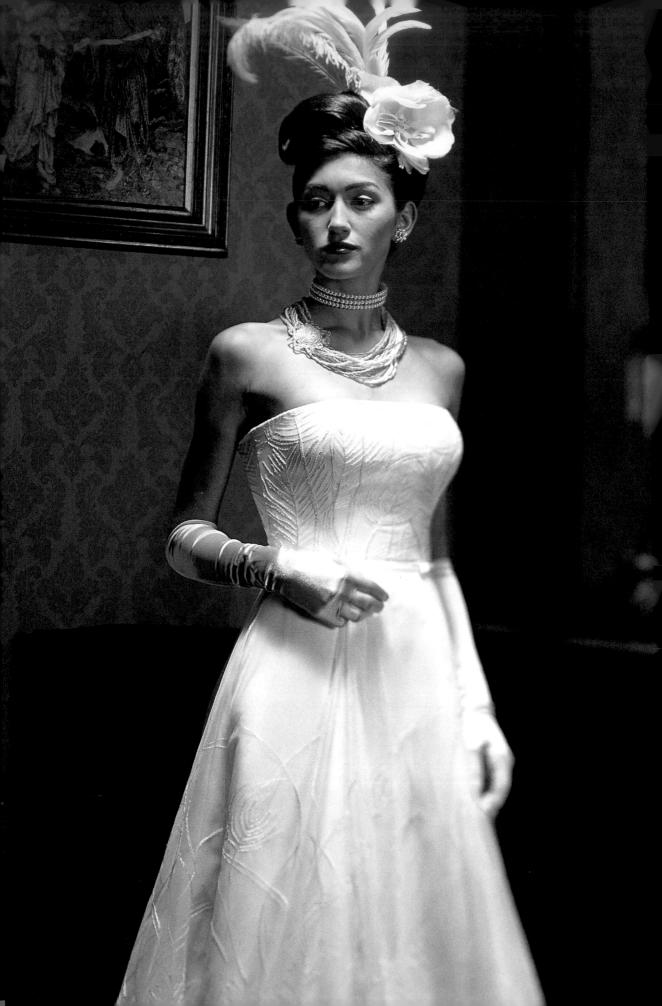

ABOVE LEFT Emily Morrison and Beth Milsom of Special Occasions designed this dress with an asymmetric overlaid sheath of embroidered metallic organza.

ABOVE RIGHT A softer silhouette in this 1960s vintage dress with puffed shoulders and covered buttons at the front.

BELOW RIGHT Asymmetrical details on a white silk gown, with organza silk flowers decorating a single strap.

LEFT Belle of the ball in striking peacock feather embroidered gown and stretch satin gloves.

101

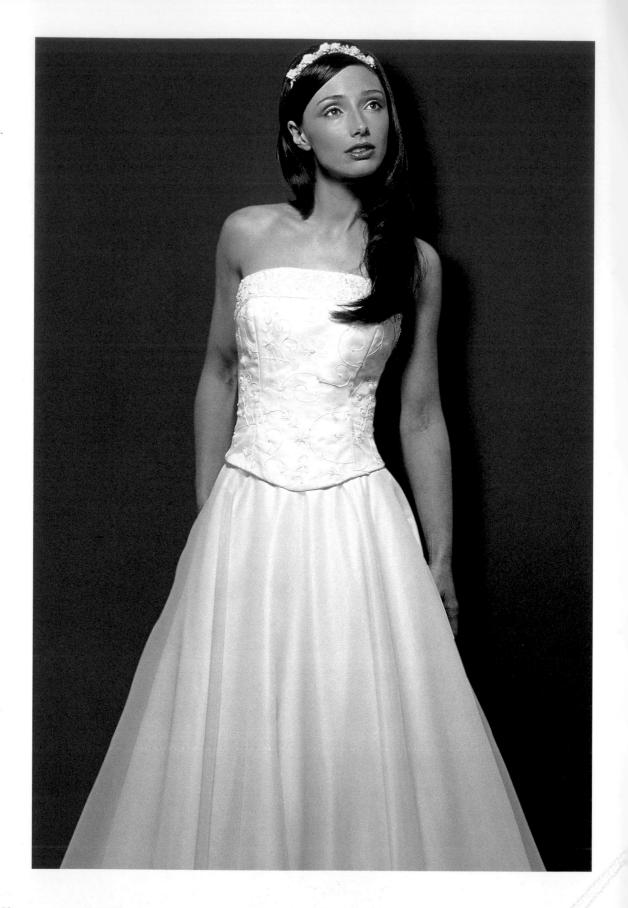

LEFT Antique-white full skirts under a beaded and embroidered strapless bodice.

ABOVE RIGHT Godets add fullness to the skirt of this square-neck dress with appliqué and beading that cascade from the bodice.

CENTER RIGHT The classic A-line silhouette of this dress has an interesting bib-bodice with crumbcatcher neckline, and a pretty satinedged veil finishes the look.

BELOW RIGHT Petticoats hold the bell shape of this *Dangerous Liasons*style dress with beaded bustskimming bodice.

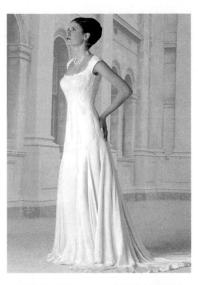

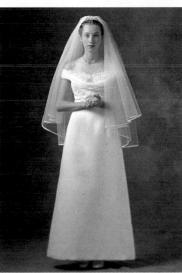

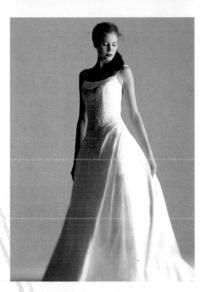

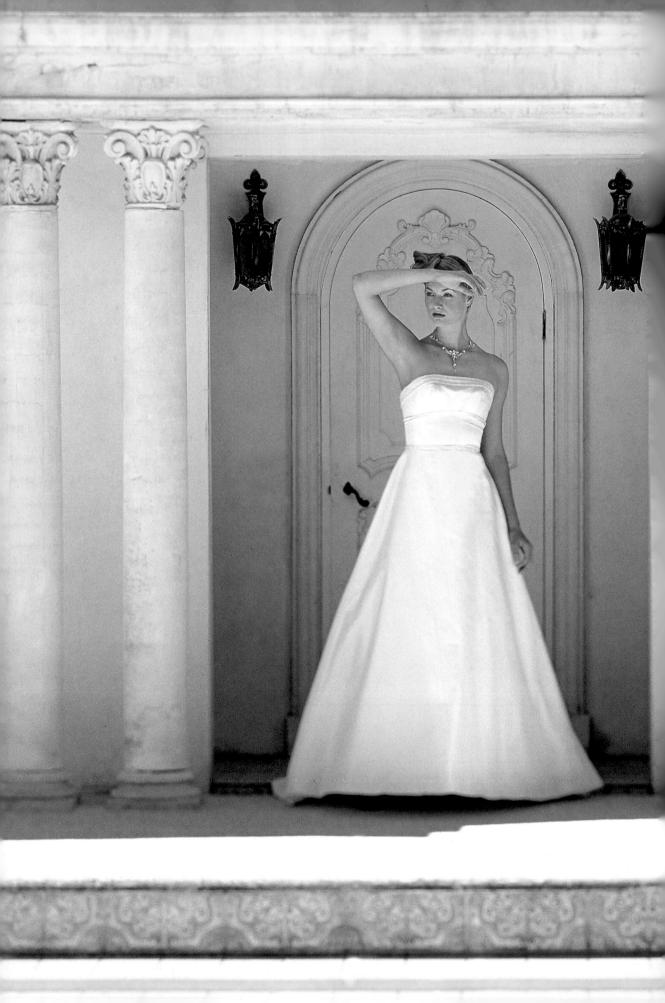

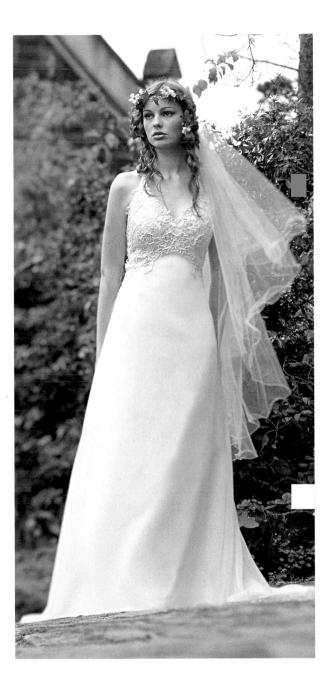

 $\label{eq:BOVE} \mbox{ Lace is overlaid on the bodice of this slip dress} \\ \mbox{ with cascading net veil and floral wreath.} \\$

 $\ensuremath{\mathsf{LEFT}}$ A simple white satin strapless dress with horizontal bands and beaded trim.

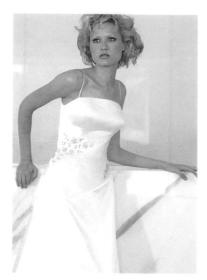

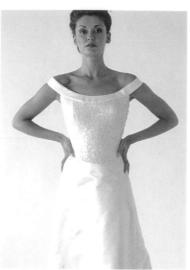

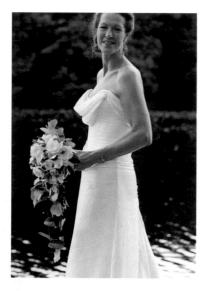

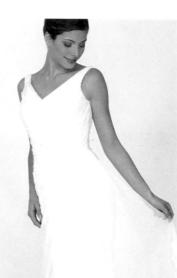

TOP LEFT Spiral-cut dress with silver beaded floral motifs.

TOP RIGHT A wide satin band emphasizes the shoulders in this Caroline Parkes dress with sequinned bodice.

CENTER LEFT Soft chiffon-draped corset bodice in a magnolia silk crepe dress by Antonia Pugh-Thomas.

CENTER RIGHT Pleated-chiffon V-neck goddess dress by Caroline Parkes

BOTTOM LEFT Bands of beading add texture to this wide scoop-neck bodice with A-line skirt.

BOTTOM RIGHT Cleverly wrapped and pleated asymmetric dress with a beaded border on an ivory strapless gown.

OPPOSITE Silk-zibeline A-line dress with asymmetrical embroidery and beading by designer Sarah Owen.

A-LINE

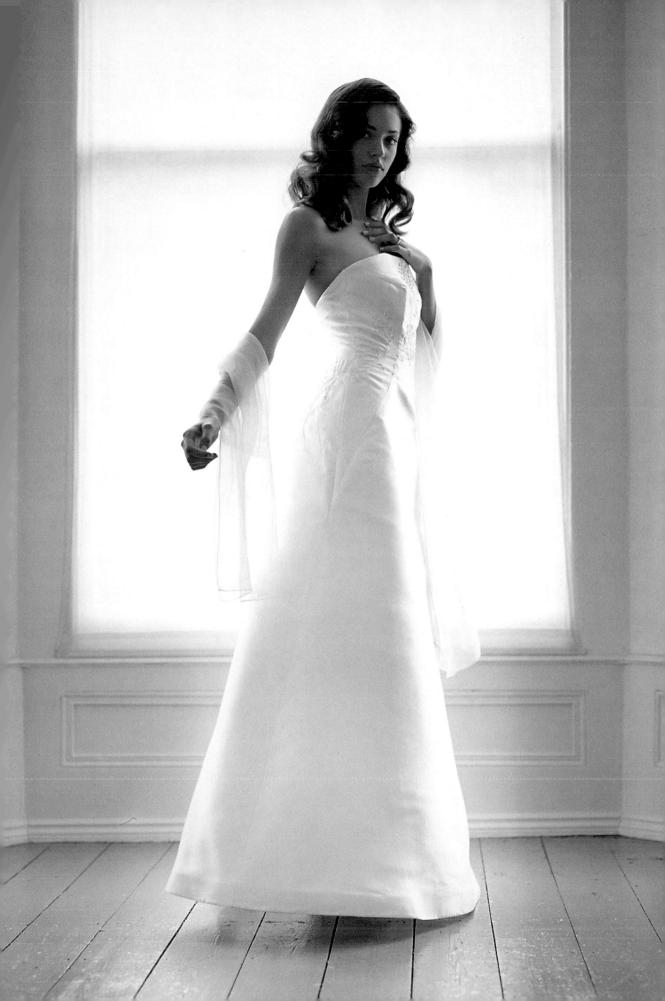

COLUMN

COLUMN

STYLE

As the name suggests, the column dress is a slim-fitted style. It can either be of an unconstructed 1920s style, with a short skirt, or a long and lean, constructed style typical of the 1950s. The constructed column dress, which may be built on a corseted bodice or foundation garment, can help control or disguise the figure, is quite different from the "flapper" style, which is about liberation and freedom of movement.

HISTORY

Mario Fortuny's "Delphos" robe, a simple column of pleated silk, was in stark contrast to the fashionable Edwardian silhouette of 1907, and was reminiscent of classical Greek and medieval dress. It represented freedom from the conventions of traditional fashion that impeded the wearer. Isadora Duncan, the dancer and advocate of dress reform, wore Fortuny gowns, and Elizabeth Bowes-Lyon married in an aesthetic style, which has medieval details and is striking in its stylish simplicity.

This style again found favor at the end of the 1960s and early 70s, as flower power turned people onto the Pre-Raphaelites and the Arts and Crafts revival. Contemporary designers, such as Issey Miyake, have skilfully updated this pleated look, using heat-set synthetic fibers to create amazing sculptural silhouettes that could make an off-the-rack alternative to the traditional dress for a modern bride.

Simpler columns, often with a chemise or camisole top, are epitomized by the Art Deco period "flapper" style, when bright young things dressed in the geometric elegance of French designers like Patou and Chanel, who brought a sportswear influence into fashion. Patou dressed many of the emerging sports stars of the 1920s, as well as silent screen icons like Louise Brooks who, with her razor sharp bob and drop-waisted dresses, embodied the spirit of the age. Again, in the 1960s, models like Jean Shrimpton, Twiggy in *The Boyfriend* and designers like Mary Quant helped revive this skinny silhouette. Galliano has more recently given us more opulent versions with beaded and sequinned columns for Dior.

Great for a boyish figure, tops tend to be strappy with square or lace-inlaid necklines and drop-waists, and hemlines can be anywhere between the knee and ankle. Fabrics for this style should be light and soft. This style is good for a more unusual color, though not too dark, and metallic or lustrous fabrics work well. The more formal, constructed style is the column dress that became prominent in the Edwardian era, as the bustle replaced the crinoline, creating a much narrower silhouette when viewed from the front, gathering the volume of the skirt at the back. Prior to the First World War, the volume decreased further to "hobble" skirts, which were such slim sheaths that the wearer could only take small steps and sitting was out of the question. This style was recreated in the evening wear of the post-war era, notably with designers like Pierre Balmain, Charles James and Jacques Fath creating swathed columns with full pleated skirts swept to the back. The advantage of this style is that the volume still allows walking, sitting and dancing without too much difficulty for the wearer, while a slim sheath dress will need to be slit or wrapped, or you could go for a fishtail style (see Mermaid and Fishtail on pages 68–91).

Remember that you will not only have to stand in your dress, but kneel, sit and dance as well, so before you plump for that skin-tight sheath make sure it won't cut you in two when you try to sit down in it.

CLASSICS

Classic sheath styles include the strapless column—think Marilyn Monroe in *Gentlemen Prefer Blondes*, in her satin sheath and shoulder length gloves, later copied by Madonna in the "Material Girl" video. It can also work with a sweetheart neckline or picture collar, and a belt can help to divide the silhouette. When teamed with a detachable train and floor-length veil, it can create a dramatic transformation from service to reception (or if you want to recycle your dress as evening wear). Another favorite style is a lace column laid over a nude lining: it hints at sensuality while remaining covered up. The lining may stop above the bust to allow a sheer neck and sleeves.

WHO SHOULD WEAR IT

Asymmetric necklines can work well with this style , and can give a lengthening effect to the vertically challenged, show off good shoulders, but are best avoided if you depend on a bra for support. Dress lengths may vary. Typically, deep inverted pleats at the back help maintain a slim silhouette while allowing movement, or volume is gathered to the back in a bustled style. If you are pear shaped it is not a good idea to draw attention to it with this style. That said, a big statement on a very clean silhouette, such as a dramatic collar, can draw the eye away from problem areas, and the silhouette can be very slimming for the curvaceous providing you have the height. If you are tall and skinny this may not be the best choice for you unless it is waisted.

FABRICS

Fabric choice is important when you consider a sheath, as you want to minimize creasing when you sit. Good interlinings can help, and satin, crepe and twill fabrics are good. Silks like dupioni and taffeta will tend to crush so consider alternatives.

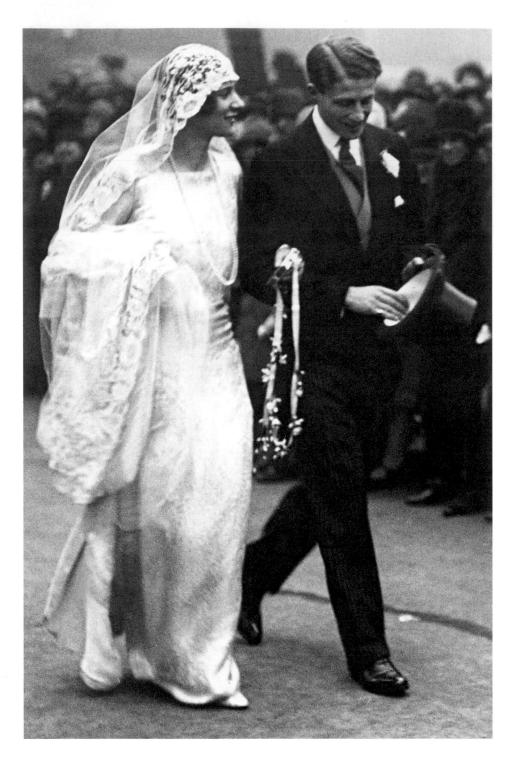

ABOVE Rachel Spenden-Clay marries David Bowes-Lyon in 1929. Her dress is strongly reminiscent of the dress worn by Elizabeth Bowes-Lyon (the Queen Mother) and reflects the fashionable silhouette of the time.

RIGHT Romantic off-the-shoulder sheath dress in cream, with silk roses trimming the neckline and hem of this SaraSusa design.

112

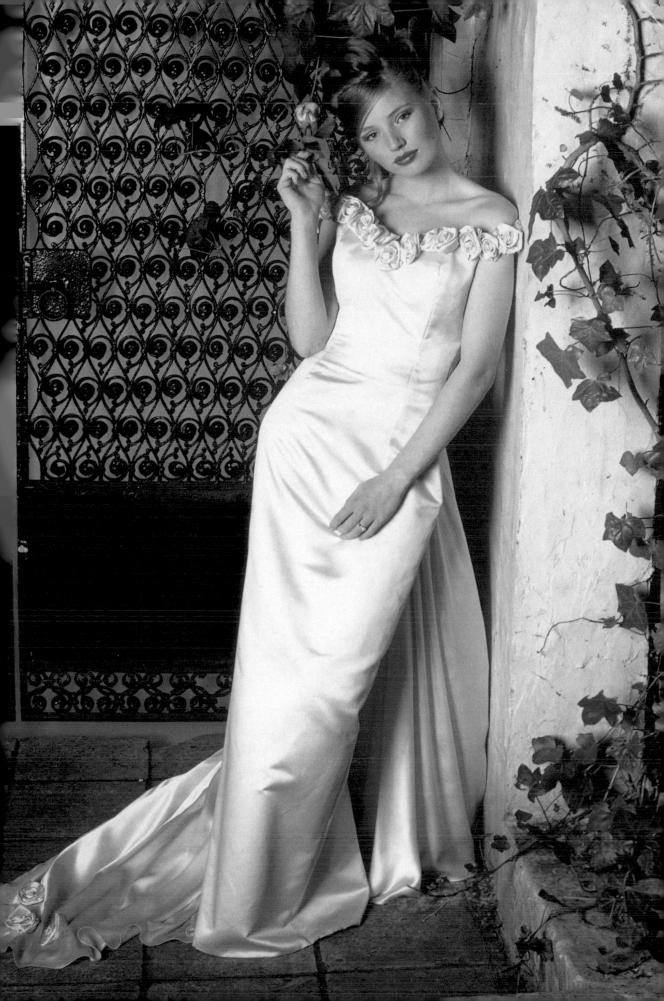

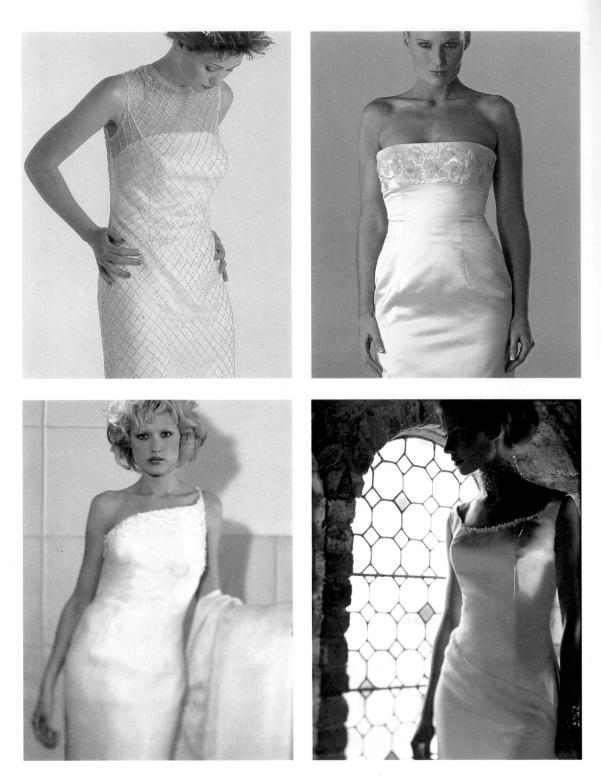

FAR RIGHT 1930s-inspired white gown with a clever twist and Watteau train in chiffon. ABOVE, CLOCKWISE FROM TOP LEFT Added sparkle—silver bugle-bead lattice on a simple sleeveless organza column over a strapless base; Stewart Parvin designed cream strapless column with sequinned and beaded floral border; draped skirt on a princess line column with beaded scoop neckline; an asymmetric neckline is scattered with beads on this modern dress style.

114

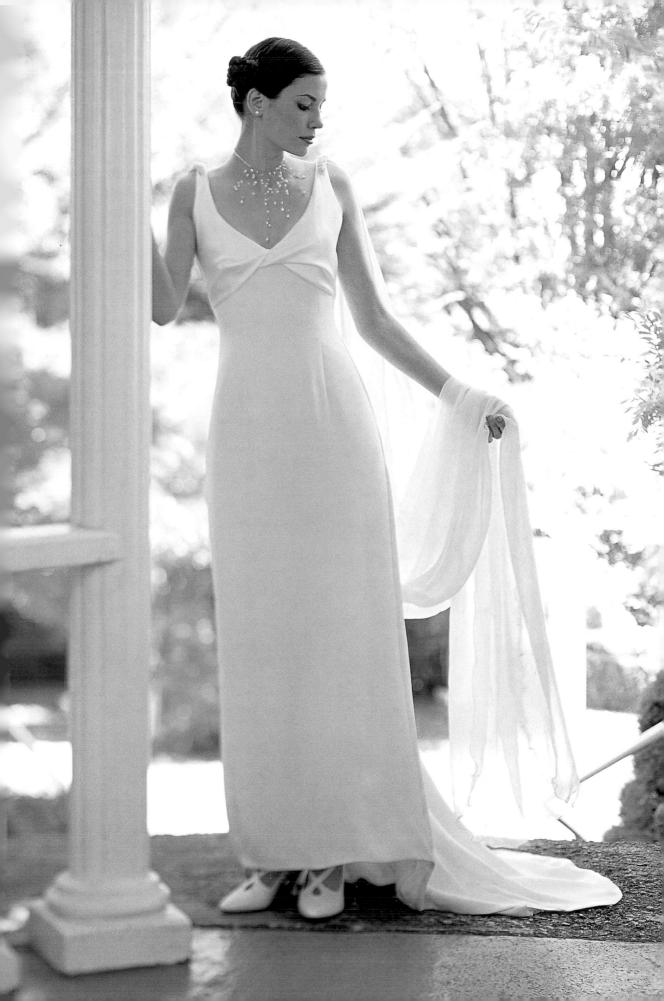

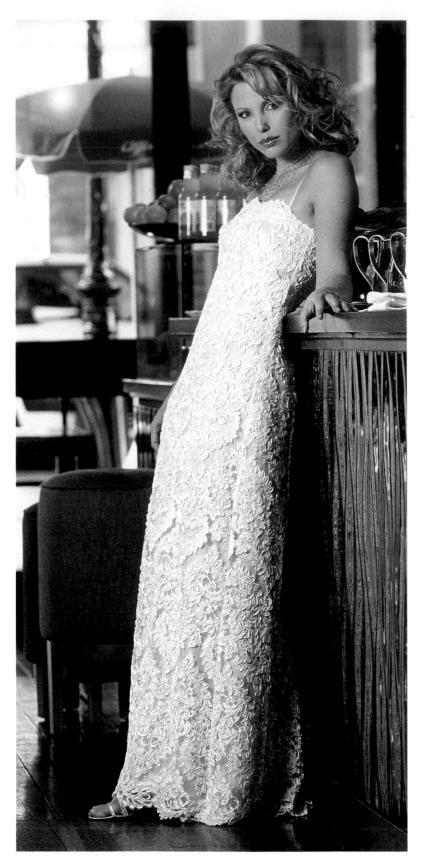

LEFT A simple sheath in dramatic ribbon lace with scalloped hem and satin straps.

RIGHT Antonia Pugh-Thomas design in lace over a white silk shantung underlay.

COLUMN

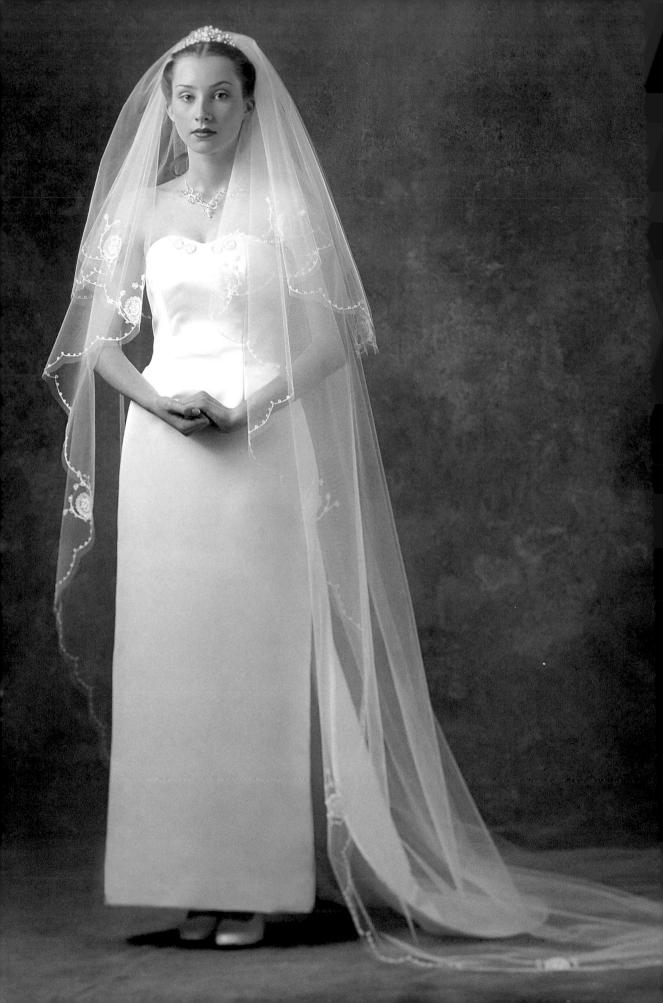

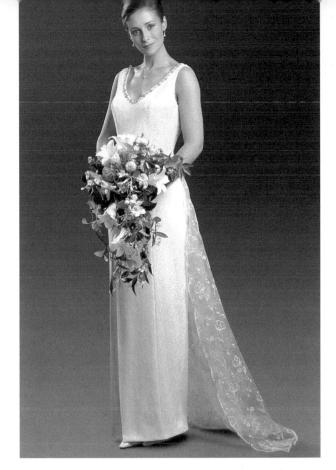

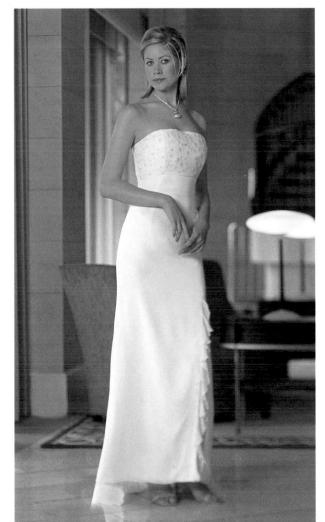

LEFT The beautiful decorative edge of this cascading veil sets off a simple ivory strapless column with motif at the bustline.

ABOVE RIGHT V-neck column in silk crepe with split skirt and floral trim, by Antonia Pugh-Thomas.

BELOW RIGHT This modern splitskirted design has ruffled edges and an empire-line embroidered bodice.

MINI AND MIDI

MINI AND MIDI

STYLE

The minidress denotes anything that falls above the knee, and so it can include many of the contemporary slip and shift dresses that are available today, as well as miniskirt suits and a few oddities like the puffball. While a mididress falls just below the knee.

HISTORY

The mini is a 1960s icon—free love and the sexual revolution were seen as a herald for personal expression, and with them came a new self-confident generation whose body image defined a generation gap. The development of more practical underwear as tights replaced stockings and suspenders may also have had a part to play.

Courrèges, Paco Rabanne and Pierre Cardin all experimented with shorter A-line styles in 1964 and 1965, but it was not until 1966 that the style really took off. Mary Quant raised hemlines high above the knee, and when combined with op-art graphics, the look became the definitive style for the 60s.

The 1980s revival of short added another dimension—tight. Azzedine Alaia's micro-mini stretch Lycra knits on leggy supermodels, and Vivienne Westwood's ironic mini-crinis and puffball-style skirts were sexy pastiches of the cumbersome 19th century creations. As the cult of youth prevails, the mini enjoys a perennial appeal; rather than shocking it is now a familiar part of our vocabulary of dress.

CLASSICS

A strapless mini-sheath can look stunning if you have the figure to carry it off. A minidress teamed with a suit jacket, like Mia Farrow's outfit to wed Sinatra, looks simple and stylish with her elfish crop, as does a slip or shift dress that falls just above the knee. Team with a sheer wrap or a cocoon coat for a covered up appearance.

WHO SHOULD WEAR IT

Only slim and athletic builds need apply for shorter styles. Ideal for petite figures, but not necessarily those who are very skinny. The knee-length shift styles are more flattering if you are more curvy. Remember that it needs to be an appropriate choice for the type and location of the ceremony. Some brides choose to have detachable panels that they can remove, transforming a full length into a mini or midi for the reception.

FABRICS

Just about anything goes for a mini style, it will just depend on the weight and construction you choose. If it is a stiffer A-line mini then choose heavier weights, like faille, gabardine or textured piqué. Damask, brocade and chunky lace give texture, while 60s dresses were often made from wool jerseys and softer overlaid fabrics.

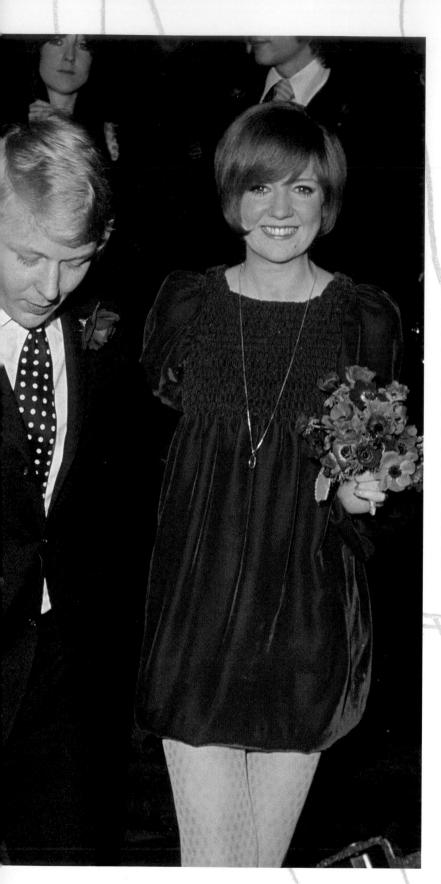

LEFT In a dress to match her hair color, British star Cilla Black (Priscilla White) at her 1969 wedding to her manager Bobby Willis, at Marylebone registry office in London, England.

RIGHT, CLOCKWISE FROM TOP LEFT Mini stars: second time around, Audrey Hepburn goes short in a space-age funnel-necked creation; Frank Sinatra's third wife, Mia Farrow, wears a pale silk cropped jacket over a minidress; Black (for her religious ceremony in Liverpool, 1969) chooses another minidress, this time in white with a belt and trimmed with maribou feathers; actress Sharon Tate wears a moiré puff-sleeved minidress with beaded trim as she cuts the cake with film director husband Roman Polanski.

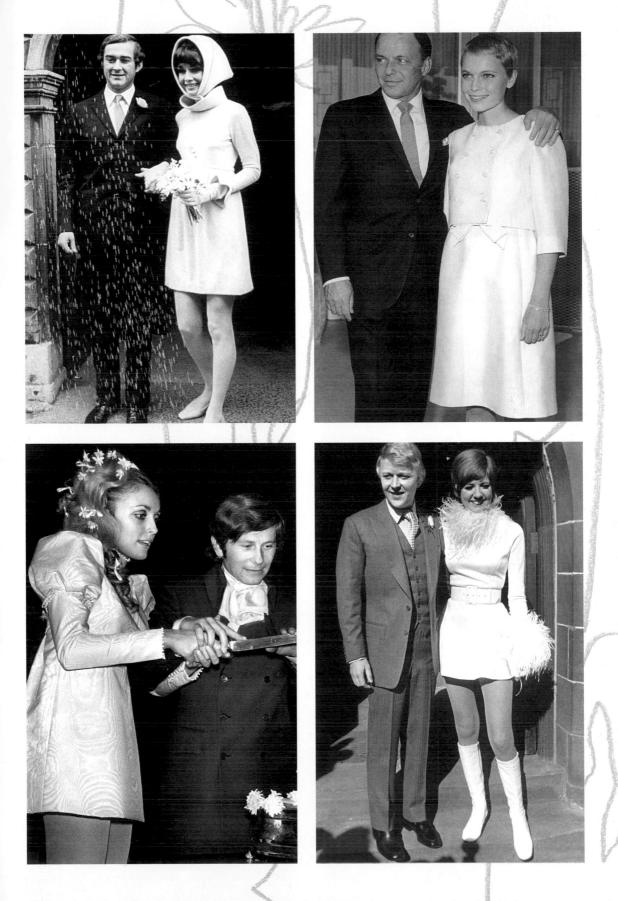

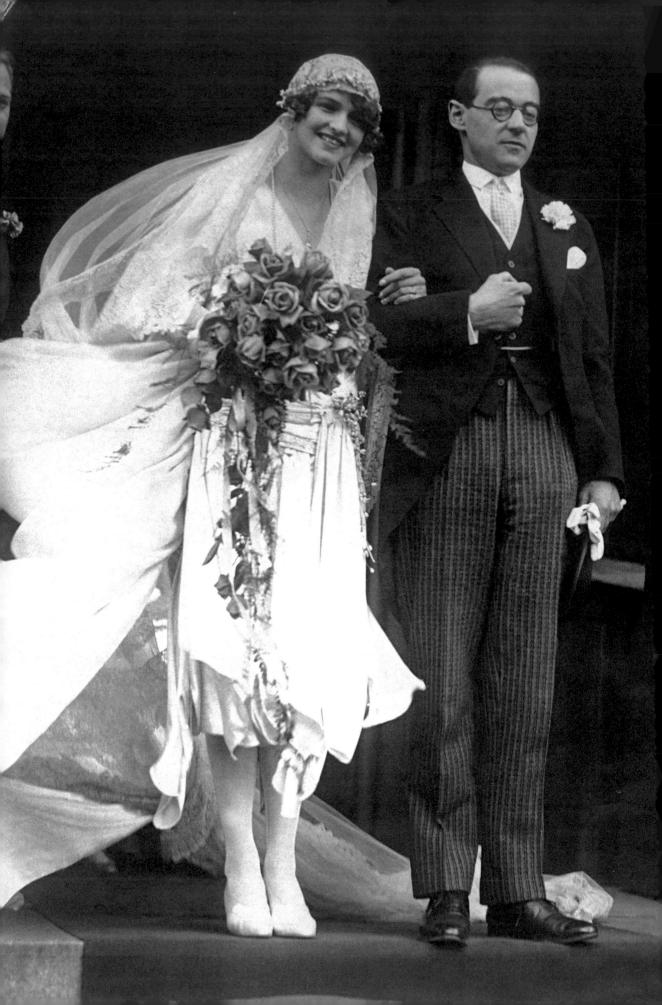

LEFT Chanel provided a lead for the new short lengths becoming fashionable for weddings in the 1920s. This dress is worn by Countess Von Bismarck, 1925.

Above RIGHT $\,$ Midi-length prom style with petticoats in this 1950s vintage dress.

LEFT Another 1950s-inspired dress in this modern champagne duchess satin midi-length shift with belt by Antonia Pugh-Thomas.

ABOVE RIGHT On the runway at Vera Wang, 2003, this strapless minidress with rich embroidery is given a pretty detail with its cream ribbon belt.

BELOW RIGHT Another Vera Wang creation, this modern dress features pearlescent sequins forming an oversized lace pattern on a sheer minidress worn over an ivory slip.

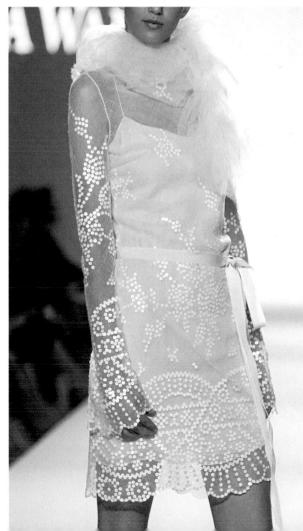

THE SUIT

THE SUIT

STYLE

The suit is a two-piece outfit consisting of a jacket and trousers or a skirt. Bianca's wedding to Mick Jagger in a white trouser suit is the archetypal image that comes to mind. But she wasn't actually wearing trousers, it was a skirt! So whether you wear the trousers or not is up to you, and there are a number of stylish variations on the two-piece outfit that can work well. Suits are more practical if you want to zoom in and out of a civil ceremony, or if you are the kind of person who doesn't want to wear a dress. They offer the freedom to dress up or down, with or without a train, veil or gloves. There is also an increase in the number of people who for ethical or practical reasons want wearability from what they choose, and do not want to consign their outfit to the attic once the big day is over. The advantage of wearing a two-piece outfit is that you can wear it again piecemeal, and it also offers a lot more off-the-rack choices.

HISTORY

Historically, only courtiers and royal brides would have specially created gowns for their wedding ceremony, and the majority of couples would simply wear their best outfit for their special day. It was not until the wartime era of the 1940s that many brides opted again, out of necessity, to simply wear their best suit to be married. Rationing of fabrics and scarcity of bridal materials added to the rarity of full wedding dresses, other than heirlooms and those borrowed from friends and family members. Post-war saw a return to romantic dressing up, but the more liberal post-war attitudes to dress and the increase in civil ceremonies and second marriages has contributed to the popularity of the suit as an alternative to the traditional dress. The cultural revolution of the 1960s also saw the suit take on a new role, either overtly sexual (mini, hot pants), or as an androgynous blurring of the gender roles, where couples wore "his and hers," matching suits *á la* Serge Gainsbourg and Jane Birkin.

Yves Saint Laurent's "Le Smoking," a cinch-waisted take on the tuxedo, never looked more predatory than on Charlotte Rampling or the women of Helmut Newton's fashion spreads of the 1970s. By the 1980s the suit became the exaggerated, wide-shouldered symbol of the power dressing working woman, typified by designers like Montana and Mugler. The style has moved away from those cartoon excesses now and is present in the collections of a myriad of designers who understand what women want from tailoring. Armani and Yamamoto are extremely skilled in soft, unstructured tailoring that retains a sense of femininity, while Jil Sander and Helmut Lang offer more modern architectural looks.

CLASSICS

The YSL white tux evening suit is the classic masculine take on the suit. A softer shawl-collared jacket worn with wider palazzo pants may be more forgiving, and a Chanel-style skirt suit is a feminine alternative. A strapless basque top and trousers can work with or without a jacket, and long line Edwardian jackets over full floor-length skirts or coatdresses offer more elegant solutions. There are lots of detail options, such as collar and sleeve types, peplums and trims. If you are getting married in a more exotic location, you might consider a more harmonious solution such as a kaftan top or crochet tunic with trousers—even a bikini. The birthday suit is the obvious choice for the naturist ceremony and will save many hours of deliberation!

WHO SHOULD WEAR IT

If you want to wear a suit then you will always be able to find one that will flatter your figure. It is more about your persona than your figure when it comes to wearing a suit. Just like a ball gown, the construction of a jacket is such that it can flatter and disguise any problem areas of your body. Short waist-length jackets can proportion petite figures. Long-line jackets, or a peplum style with nipped waist, can help shape a straight up and down silhouette. If you are curvy, then often a shorter style, like the ones shown on Liz Taylor and Marilyn Monroe (see pages 134–135) will draw emphasis to your waist. Full skirt and Edwardian, flared equestrian-style jackets will flatter the pear-shaped figure.

FABRICS

So many options here it will depend entirely on the type of suit you desire. Aside from the usual silks, there is much more choice available in a two-piece outfit—from crisp white linen to chunky wool bouclé and silk tweed for traditional suits, to cool cotton voile or habotai silk for a floaty kaftan style. Gaberdines and grosgrains have a twill or rib that adds texture, as do jacquards, damasks and other decorative weave structures, which can add another dimension to a simple cut.

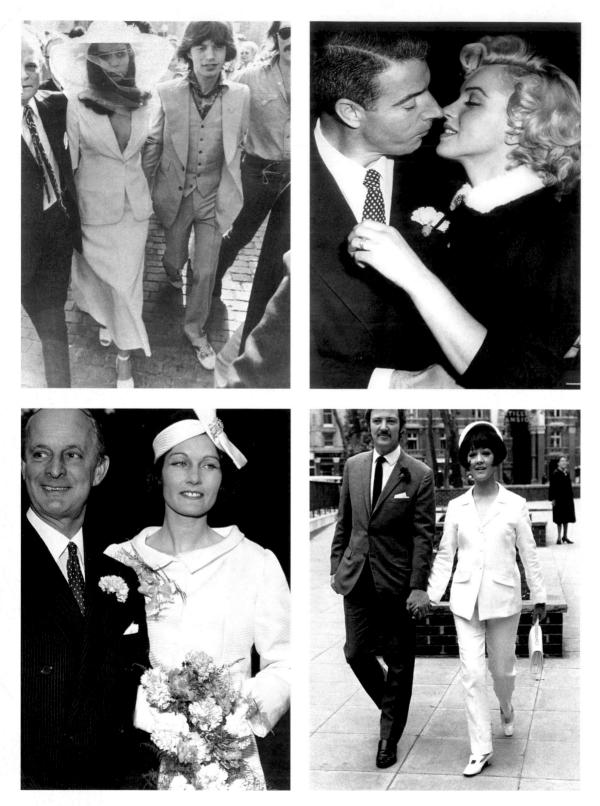

RIGHT Elizabeth Taylor in gray Dior-style full skirt and waisted jacket for her marriage to Michael Wilding, 1952. ABOVE, CLOCKWISE FROM TOP LEFT Bianca's infamous YSL skirt suit worn to wed Rolling Stones lead singer Mick Jagger, 1971; Marilyn Monroe wore a demure dark brown suit trimmed with ermine to marry Joe DiMaggio, 1954; actress Amanda Barry's pale trouser suit for her 1967 wedding; a headband adds the finishing touch to model Bronwen Pugh's outfit for her 1960 wedding to Lord Astor.

THE SUIT

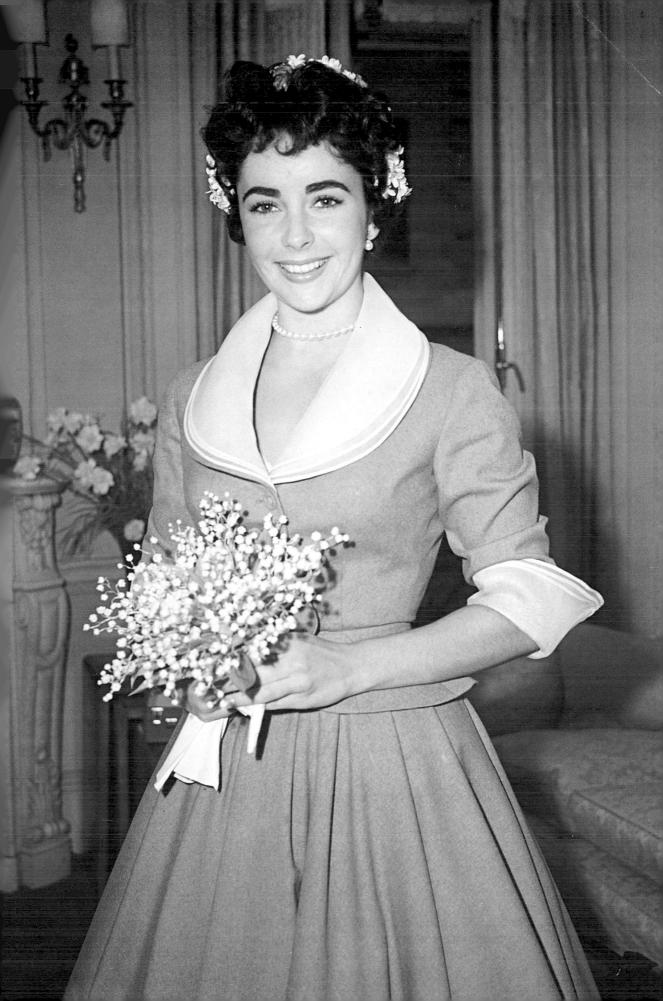

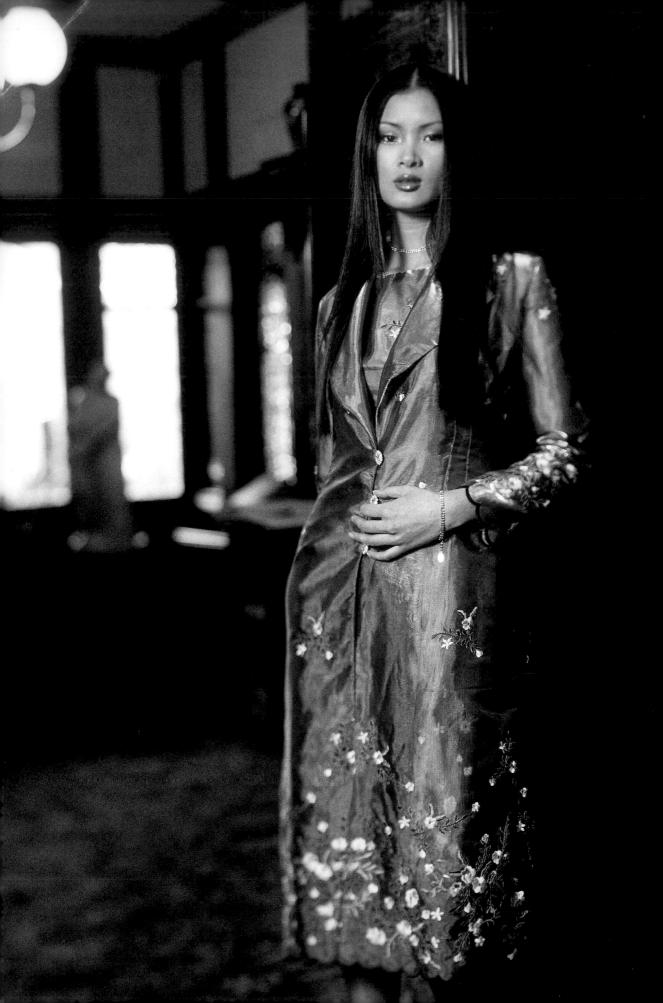

LEFT This long line gunmetal silk jacket with oriental embroidered organza overlay is more of a coatdress than a classic suit, but it's perfect for a civil ceremony or for the bride who doesn't feel that a huge white dress is appropriate.

ABOVE RIGHT His and Hers off-the-rack suits make for a practical alternative you can' wear again. Here the bride sets hers apart from day wear by wearing a statement vintage necklace.

BELOW RIGHT Strident style in this white satin 1970sinspired tuxedo jacket and trousers with beaded detail by Johanna Hehir. It is set off by a contemporary white feather hairpiece.

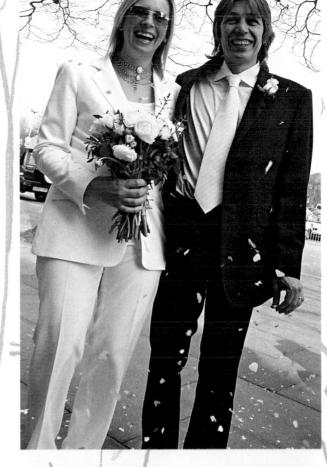

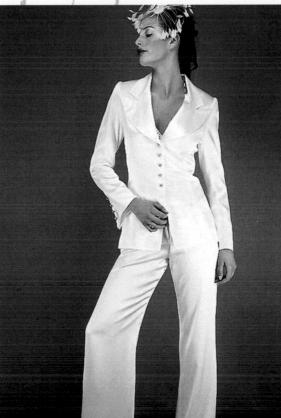

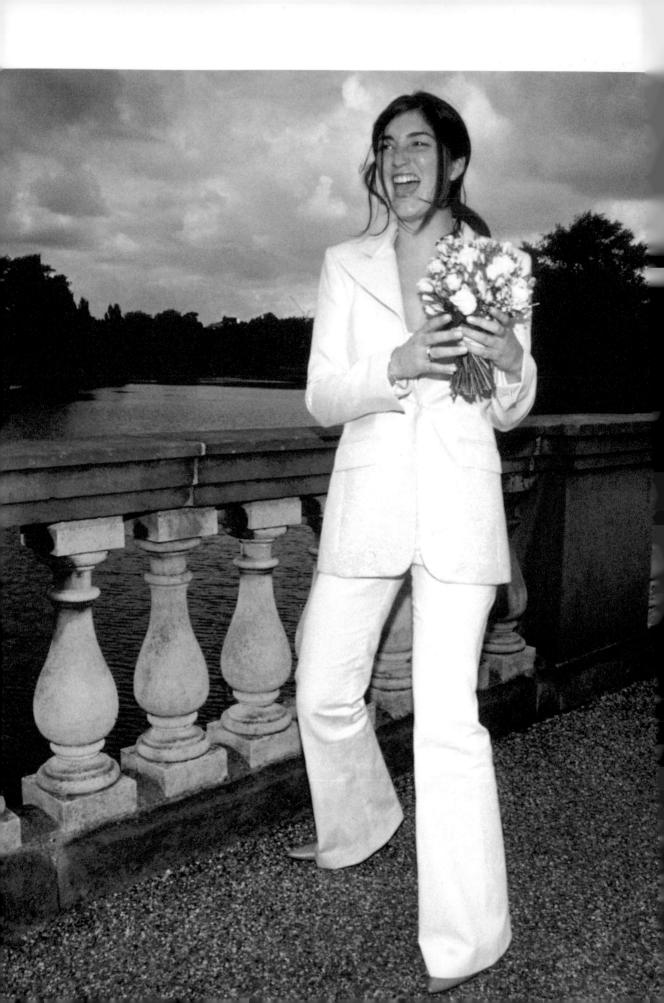

LEFT Clean and stylish in a 1970sinspired trouser suit with generous lapels and flared trousers, this is a fun look that is also timeless.

NECKLINES

NECKLINES

The silhouette of a dress and the impact it has on the viewer are as much dictated by the neckline as by any other detail on the dress. It is the focal point that helps to frame the face and should be harmonious with the physique of the wearer. As the neckline exposes or covers the neck and shoulders, and the amount of décolletage, it is important for details such as jewelry and accessories, as well as enhancing your own features. If you have great "coat hanger" shoulders and collarbone that you want to show, then a strapless style is a good option, but off-the-shoulder, halter or asymmetric styles could also be great alternatives. Here is a glossary of styles.

STRAPLESS

The strapless-style bodice cuts straight across the body at the underarm, although it may curve up or down as it passes across the bust. Often a two-layer or cut-away will suggest more than is revealed, and lace trim, ruffled or silk floral decorations are applied at the break. Good for strong athletic shoulders and arms, the simple style allows for ostentatious jewelry, gloves and big hair. Very flat-chested and heavier-set upper body shapes are best to avoid this style.

SWEETHEART

An alternative strapless style, as the name suggests this curves across the bust into a central V. While the straight cut is suitable for a smaller to medium bust, the sweetheart allows more room for corset construction and a larger bust for more Jayne Mansfield proportioned cleavage. Can be set into a sheer or lace fabric that rises to a high or simple round neck, giving the illusion of cleavage without putting it in anyone's face, and also giving additional support.

DROP SHOULDER

An off-the-shoulder line that sweeps across the body to bands on the upper arm. Bands can be simple or gathered and puffed like a sleeve. The effect is broadening and good for exposing neck and collarbone. If you already have broad shoulders you will not need the extra this style gives. A good style for balancing the pear-shaped silhouette, and consequently to avoid if you have no hips.

PORTRAIT COLLAR

An alternate version of the drop shoulder, it is reminiscent of the 1950s. The collar folds over itself to reveal the neck and shoulders. An elegant and useful style that at once reveals and conceals. Good to accentuate necks and collarbones, also to minimize a large bust and emphasize the waist.

HALTER NECK

Usually paired with backless or low-backed styles, the halter is a strap that passes from the front armhole or bust, around the back of the neck to the opposite front, like a bikini strap. This gives support to a dress front and is good for both maximizing a smaller bust and supporting a larger one. Not advisable if you require a bra.

COWL NECK

A draped style with swathed fabric that scoops across the bust. Often found in 1950sstyle and bias-cut dresses. Good for disguising a small bust and adding interest at the neckline. Not good for a large bust.

SPAGHETTI STRAP

Delicate straps, often in multiples, which may be just decorative on corset type bodices, or suspend bias and slip dresses. Good for small, but not advisable for large, busts.

BOAT NECK

Skims the collar bone to meet at the shoulder point, another style reminiscent of the 1950s and associated with the shift dress. Ideal for petite and flat-chested figures, but not suitable for anyone with much of a bust as the line is easily distorted.

ROUND NECK

T-shirt-style neckline that is good for those not so confident about exposing a lot of skin. A favorite with many modern designers, it can be imaginatively embellished. As with a T-shirt this style is better suited to a smaller bust.

SCOOP NECK

A more daring vest-style neckline that can dip as low as you dare. It is suitable for anyone who is happy with their chest and neck exposed.

V-NECK

Like the scoop but dipping to a point, the V elongates the neck and is flattering to a medium bust, but not so great for large or small busts.

SQUARE NECK

A deep square-scoop neckline usually associated with empire-line and corset styles. It can help minimize a large bust but is suitable for most shapes.

HIGH NECK

Various styles available, from stand collars like Nehru and Mandarin that abut at the throat, to high-button and shirt-collar types. Good for covering up the neck and chest and to elongate the silhouette. Suitable for all except where the neck would be a problem.

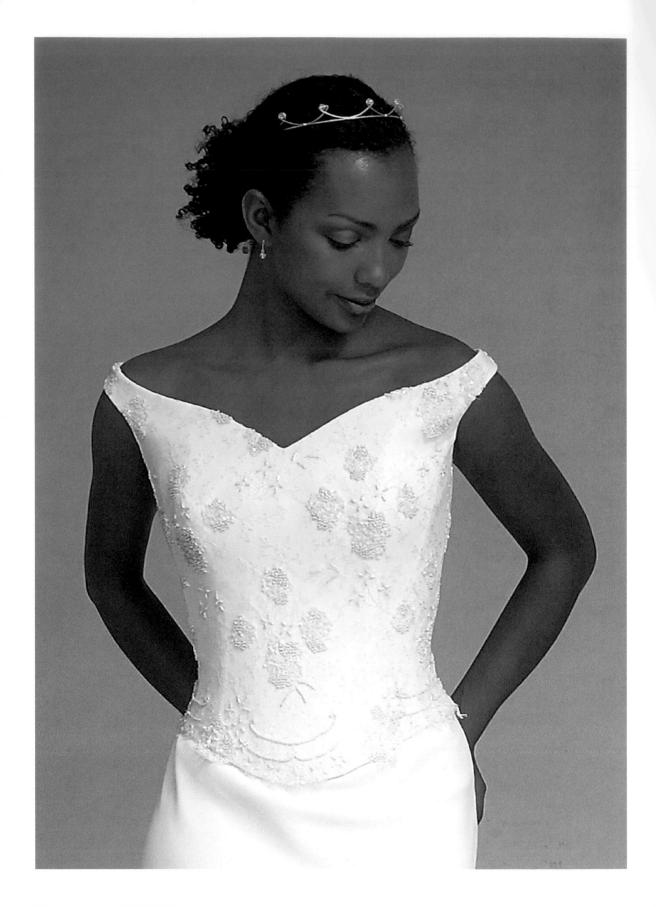

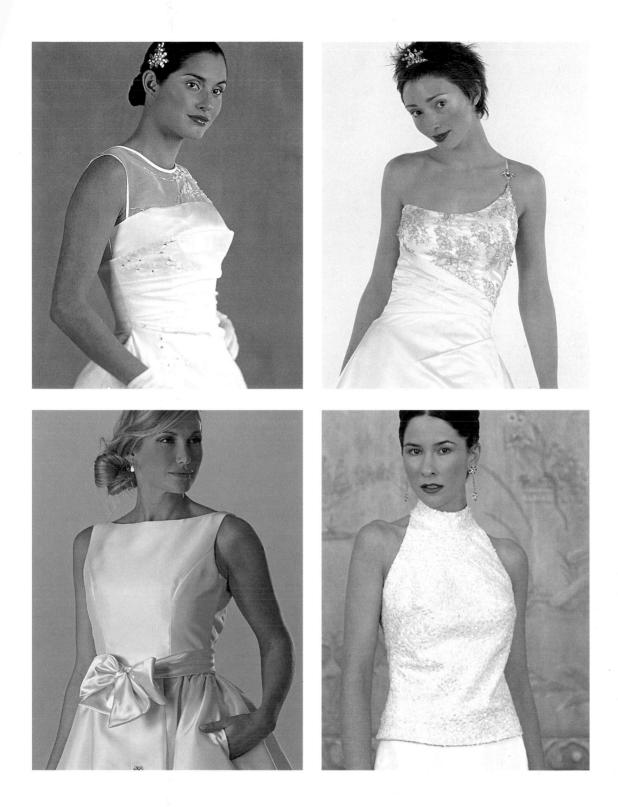

FAR LEFT A Caroline Parkes design with shoulder-point neckline on an ivory beaded-lace bodice. ABOVE, CLOCKWISE FROM TOP LEFT Sheer round neck over a strapless dress; asymmetric neckline on an interesting spiral-cut dress with silver lace and brooch motif at the strap; this halter neck collared dress with sequinned bodice shows off square shoulders; 1950s-style boat-neck dress in cream by Stewart Parvin.

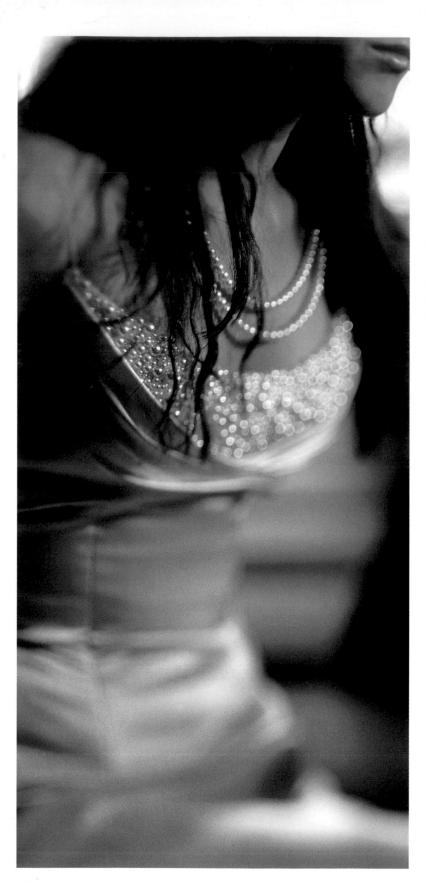

LEFT Cowl-neck champagne silk dress, with pearl bead-filled crumb catcher.

RIGHT Square-neck dress with shaped straps. The embroidered bodice is dotted with diamanté and crystal beads and stones to match the necklace.

NECKLINES

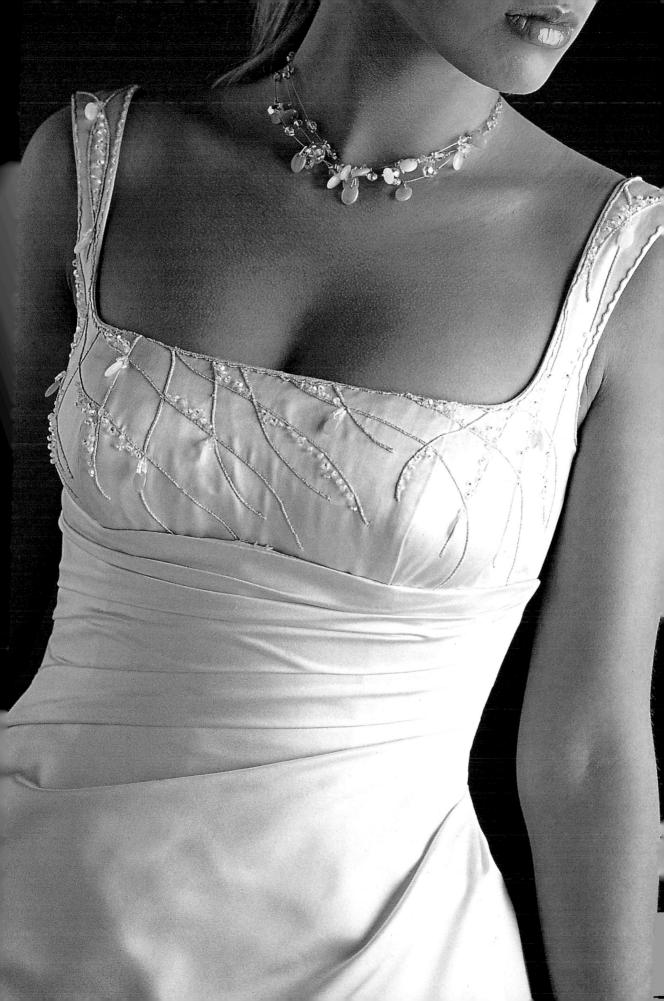

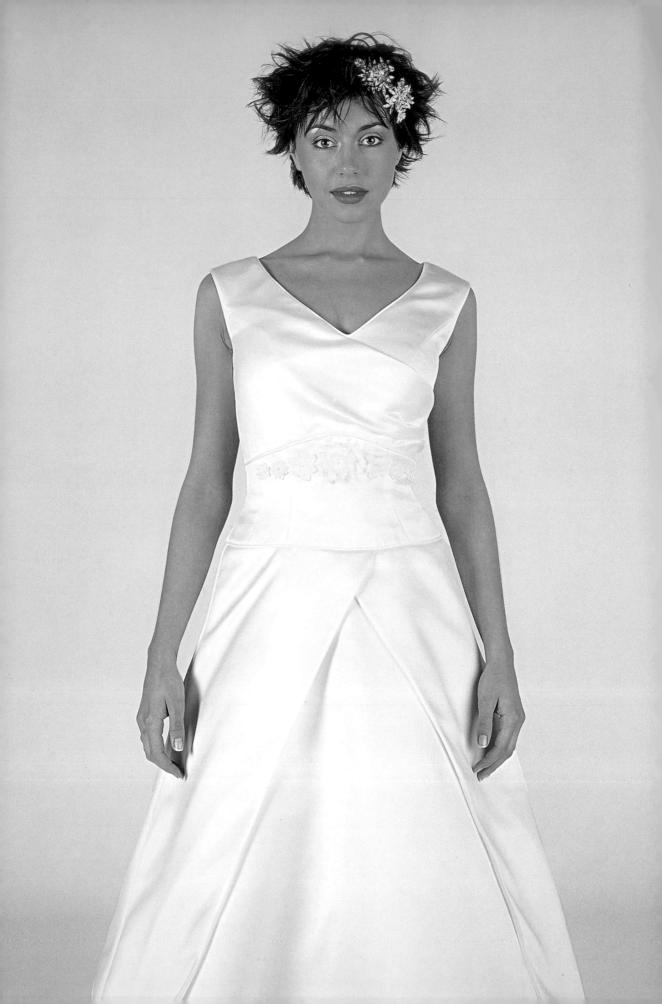

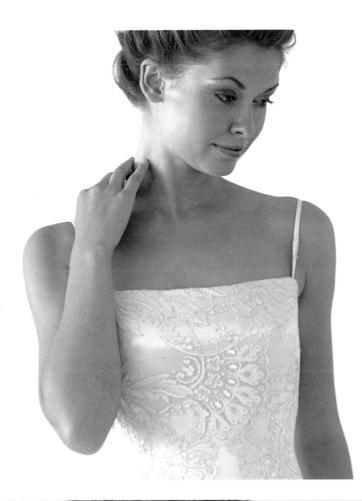

ABOVE LEFT Square neck with spaghetti straps overlaid with lace by Caroline Parkes.

BELOW LEFT Shallow scooped neckline to the shoulder point helps emphasize the collar bone in this Caroline Parkes design.

FAR LEFT A very simple V-neck design, which could be set off with a statement necklace.

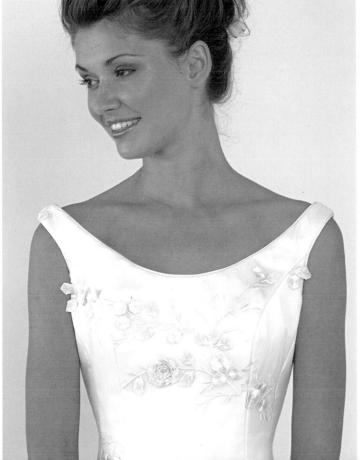

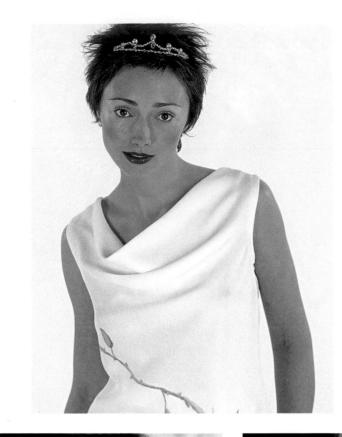

Above LEFT Draped cowl-neck dress with turquoise print.

BOTTOM LEFT Sweetheart neckline trimmed with silk roses on a corset bodice.

BOTTOM RIGHT Minimal style with a square strapless neckline.

FAR RIGHT Classic portrait collar on an off-the-shoulder dress by Stewart Parvin.

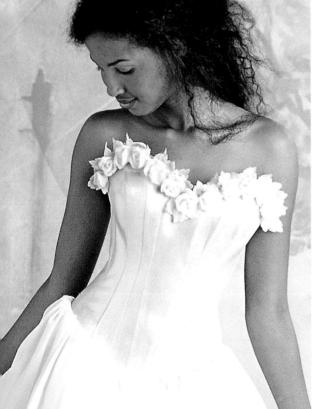

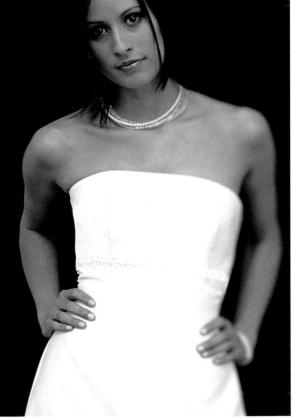

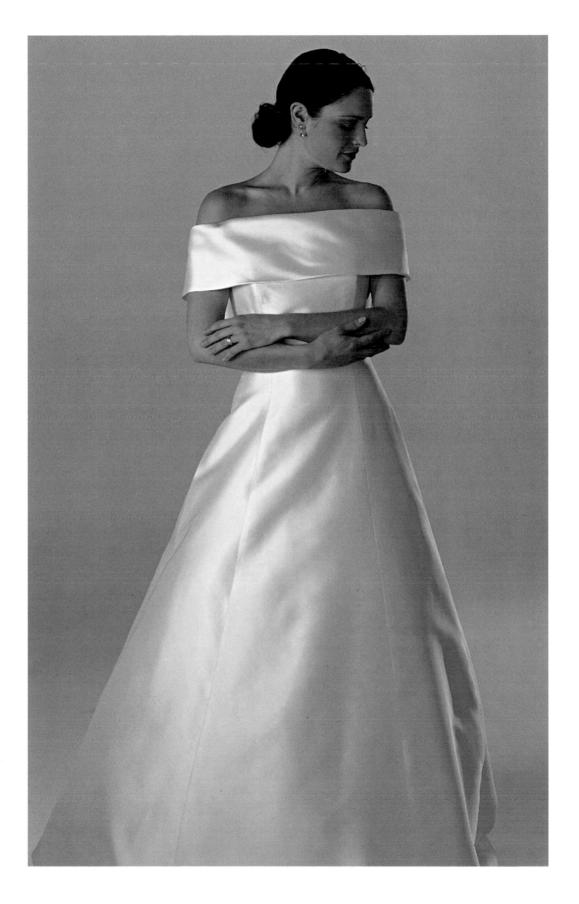

BACKS

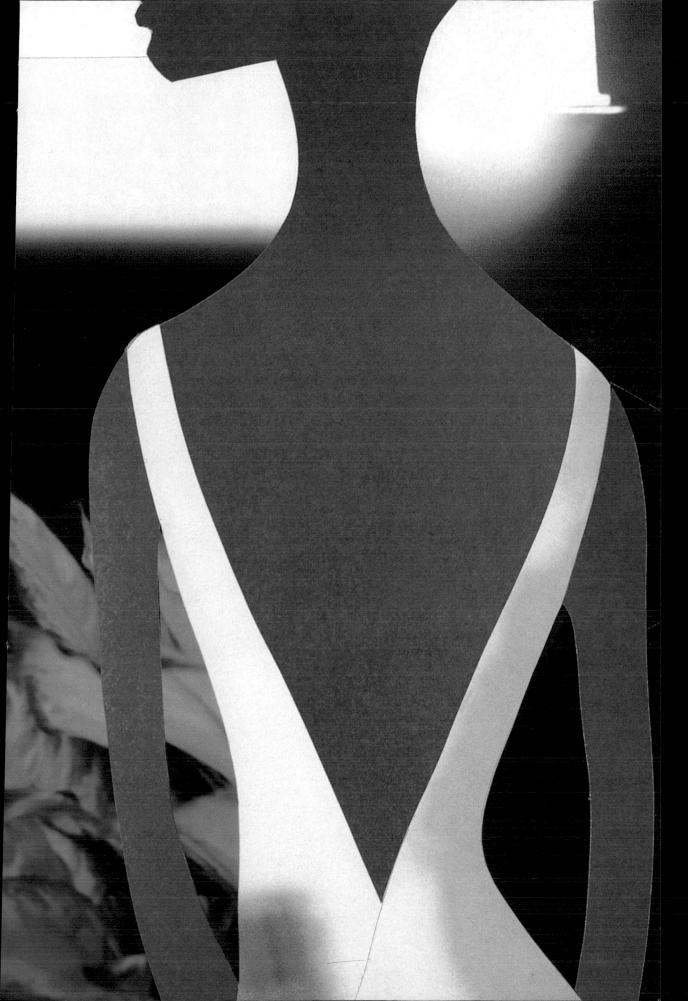

BACKS

The importance of the neckline continues to the back of the dress, particularly if you consider that it is the view that the wedding party will spend most time contemplating as you are conducted through the service. The back of the dress can give dramatic effect in the combination of dress, train and veil, which must be taken into account when you come to deciding upon the details. It could be a simple cut away to show off a bronzed and toned back, a cascade of silk roses, embroidery or beading, a simple row of covered buttons that trace a line from neck to hem, or a tightly laced and cinched waist. The details should be in keeping with the style of the dress, not fighting against it, and should flow naturally from the front to the back. Remember that one strong detail is enough—don't fall prey to Christmas habits for over decorating the tree.

V-BACK

Deep or shallow, the V-back cuts below the shoulder blade to the waist, or as low as you dare. Meeting at or above the waist, there may be a further button or laced detail below the point. Usually paired with halter-neck and strappy styles cut wide on the shoulder, deep V-backs are good for showing off well toned shoulders and back, and accentuate a slender waist. For the pear shaped, a shallow V can still enhance the slimming effects of a cinched or bound waist and will work with most styles.

X-BACK

Basically a V-back with additional straps that cross at the center back for support. These can vary from very fine spaghetti straps to delicately support a swathed biascut back, to wide, flat lace-ribbon styles. Multiple straps can be woven together as they intersect for interesting effects. Best with column, A-line and mermaid styles.

DRAPED

Like the cowl style neck, a low-draped back can be a dramatic counterpoint to a high or modest front style. The softening effect of the drape can also add contrast to other decorative touches like diamanté lacing. Best with column and A-line styles.

LACE INSERT

The illusion of a cut-away back can be given using lace or sheer fabric, either for striking details (see pages 162–163), or to give additional support. This flattering style is also good for camouflaging problem areas. Works well with trompe l'oeil strapless and sweetheart styles where the lace continues to a higher neckline.

COVERED BUTTONS

A very popular detail is the use of buttons and loops to close the back or simply for decoration. Often accompanies more traditional ball gowns and Victorian style dresses, which may have hundreds of tiny buttons from neck to hem. They tend to be used on covered-up styles (see page 157), but cut-away backs may also feature button details from the waist to hip (page 162).

CORSETRY

The art of constructing a corset bodice is a skilful practice. Boning and lacing enable a sometimes miraculous transformation of the figure by defining the waist and pushing up the bust. Typically the corset back will be strapless and laced at the center of the back, from just below the shoulder blades to waist or hip level. Sometimes there may be two shaped and laced panels in the back. Often the suggestion of corsetry will be given by a decorative lacing in ribbon as a back detail (see page 161, top left). Best with ball-gown, A-line and mermaid styles.

CORSAGE

More a detail than an actual style, but the use of floral corsages and ribbons or bows can form part of the neckline, drawing the eye in a cascade of flowers from the front to the back, the base of the neckline to the floor, or to a focal point at the waist, bound like a posy. Great for "wow" factor on simple dresses, they can introduce texture and color to a simple style. Be mindful that a large floral embellishment should be practical to sit in, and it should be harmonious with your bouquet, should you choose to have one. Will work best on full-skirted styles, but suitable for all.

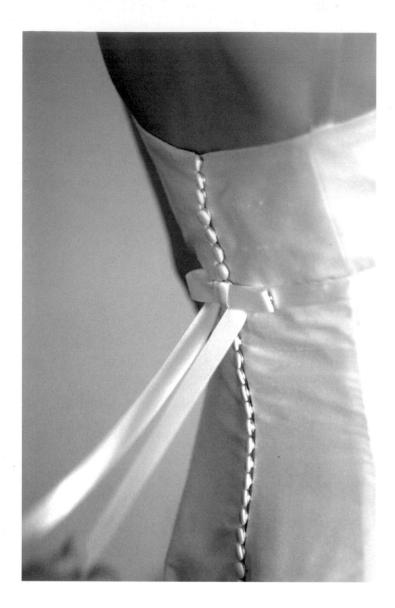

ABOVE An irresistible parcel—a row of pristine covered buttons is cut by a bow.

RIGHT These covered buttons add interest and draw the eye vertically through an otherwise unbroken silhouette.

BACKS

156

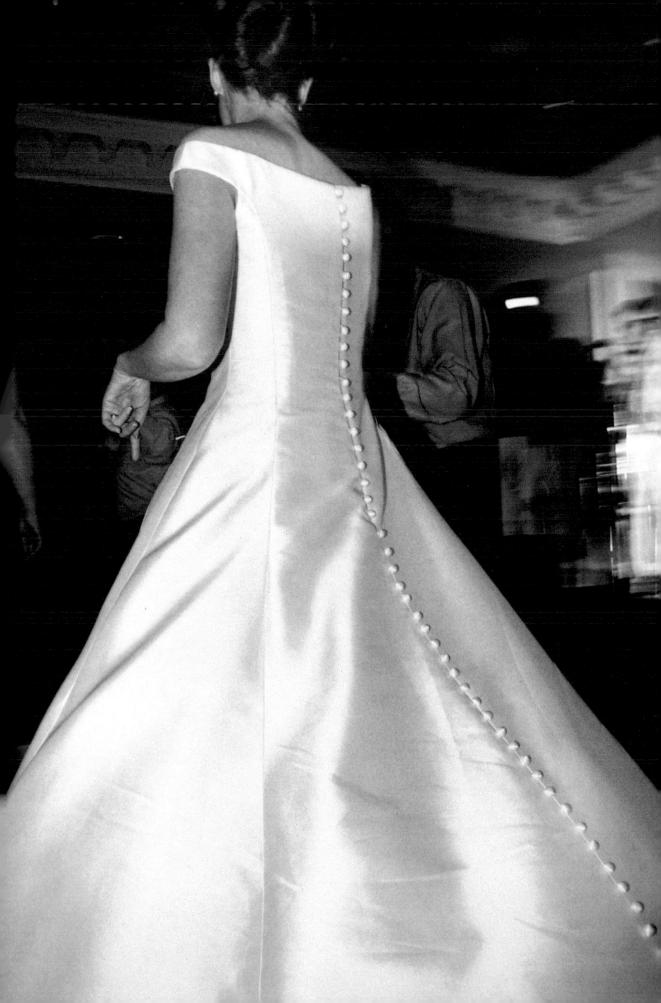

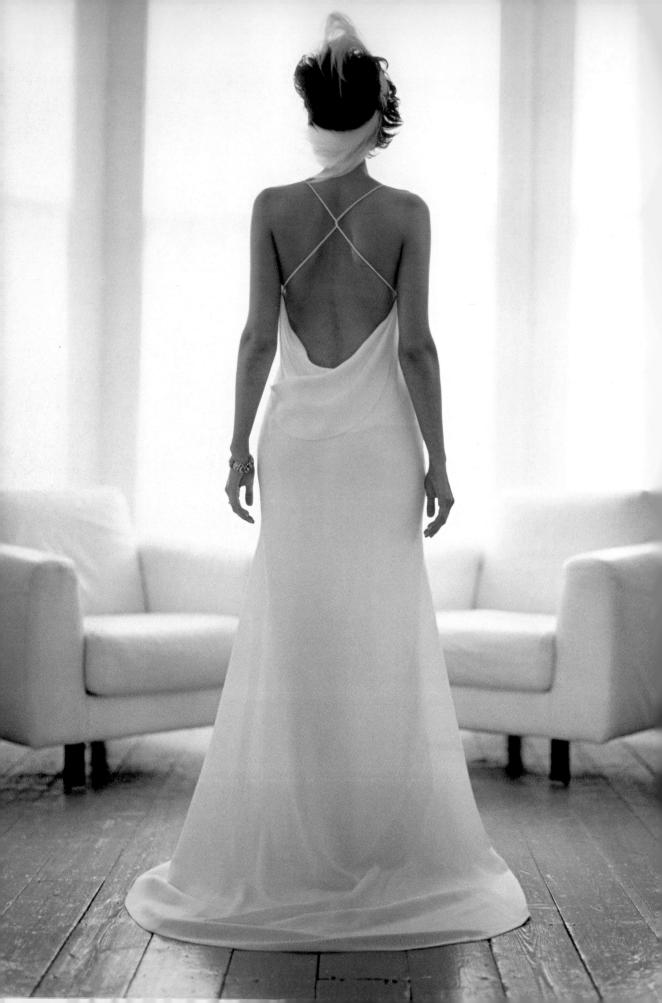

LEFT Bias-cut crepe dress with cowl back and cross-over spaghetti straps by designer Sarah Owen—a sophisticated design.

RIGHT Butterflies rest on the cross back of this nature-inspired dress.

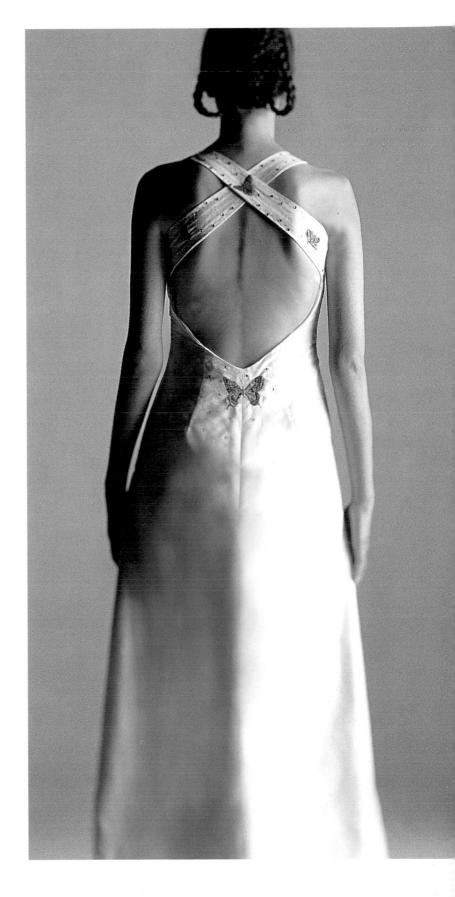

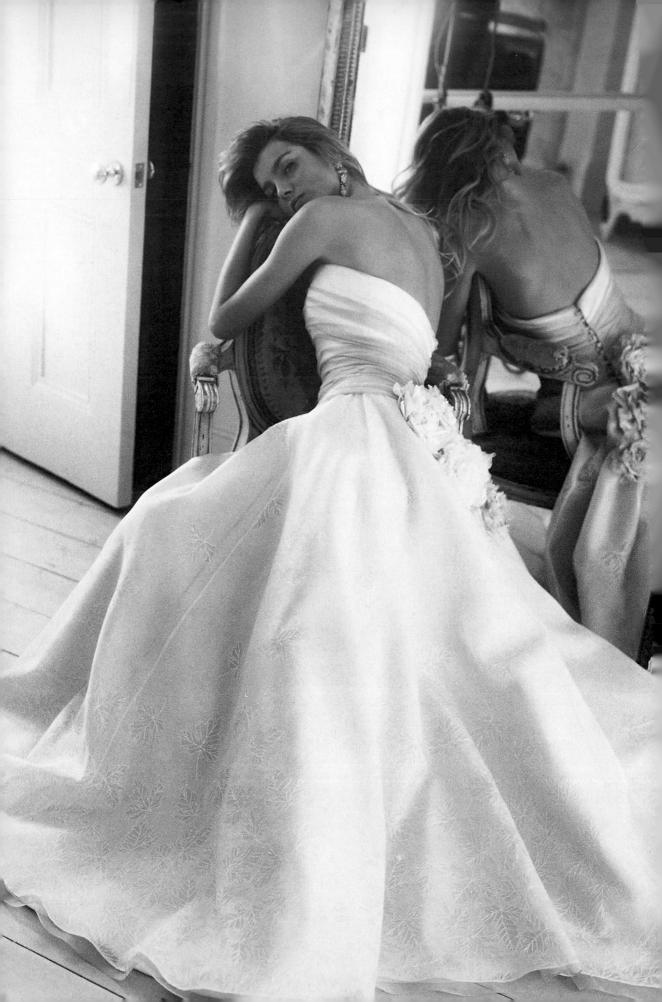

FAR LEFT This romantic leaf-patterened Phillipa Lepley design is crowned at the back with a large, cascading, organza flower corsage. BELOW, CLOCKWISE FROM TOP LEFT Caroline Parkes ribboned corsetry detail on the back of a strapless gown; diamanté laces crisscross and sparkle in a deep cowl-backed dress; lavender and ivory shades in this oriental-inspired floral obi are held with decorative chopsticks; white silk roses clasp the waist at the back of this dress.

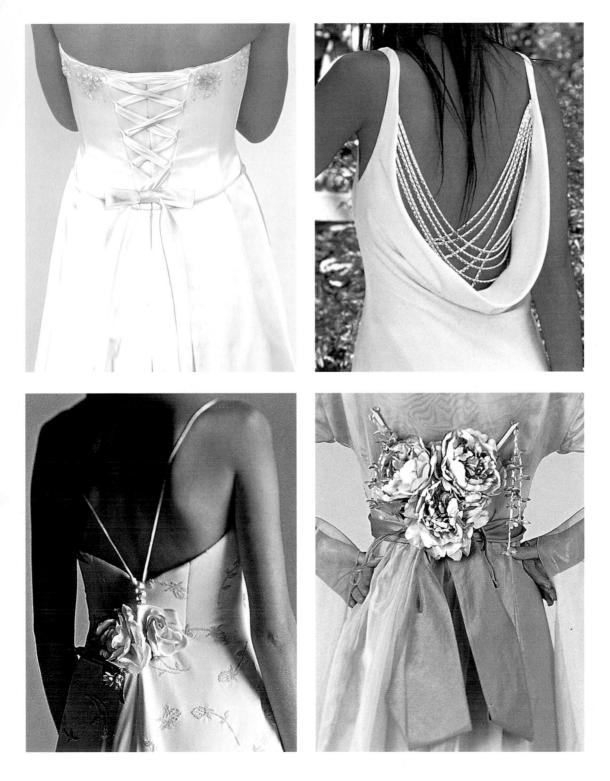

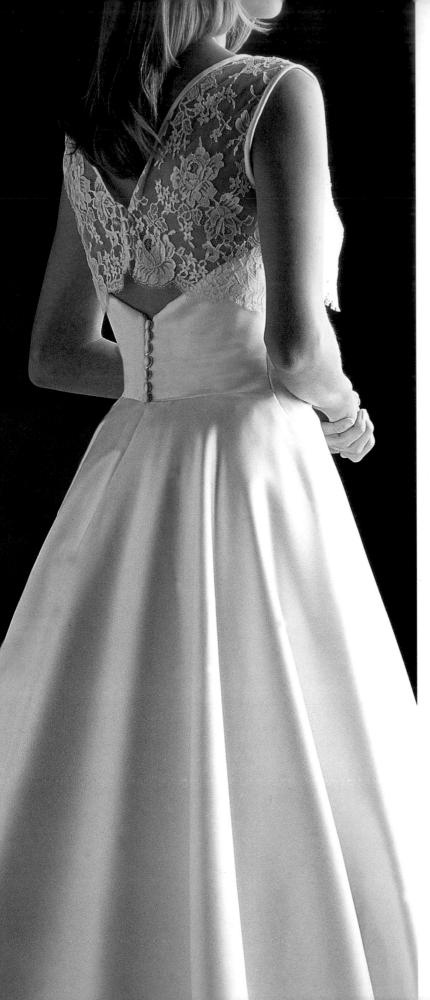

LEFT A delicate lace camisole top trimmed in satin, with covered buttons to match the dress, is cut away below the bust with a scalloped edge.

RIGHT A more dramatic approach with this antique-white ball gown, which has a cut away and appliqué beading to create a lace effect at the back.

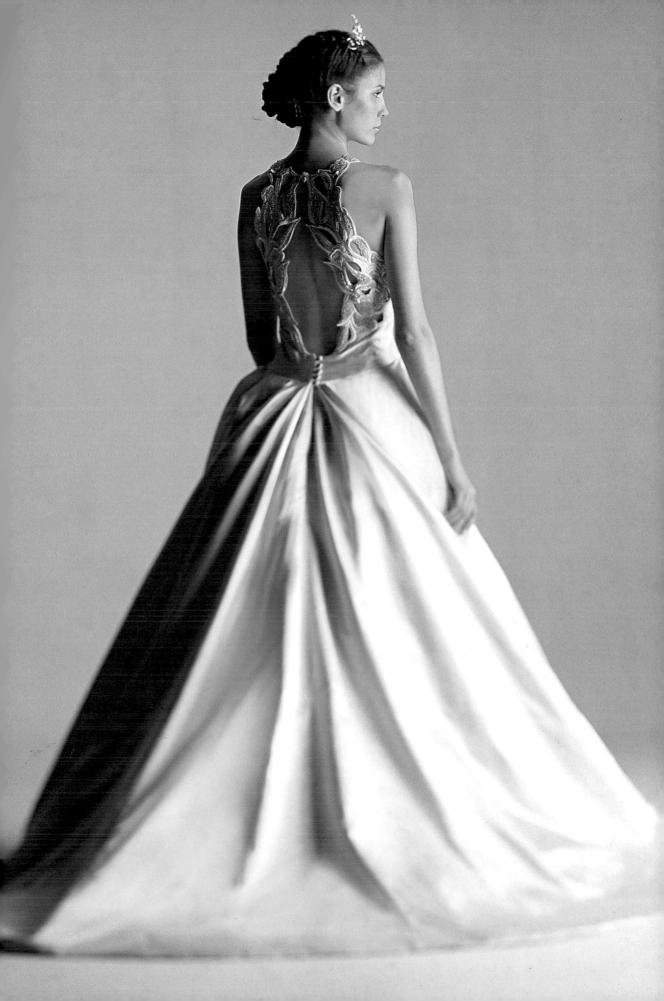

SLEEVES

SLEEVES

Whether you opt for sleeves or not will depend on the style of your dress, and how happy you are to be exposing your arms. Remember you can use gloves, a wrap and a veil to good effect too, particularly if you must cover up to satisfy the dictates of the ceremony. Sleeves can add dramatic counterpoint to your dress's style, and sheer or lace sleeves can camouflage, elongate and flatter your silhouette. While you may want to consider the season and location of your wedding, the inspiration should really be dictated by the dress. If you want to create maximum impact in your fairytale ball gown, then you will want to opt for an off-the-shoulder, balloon or leg-of-mutton style. An Empire dress will best suit capped and slim-fitted sleeves, while a minidress can be paired with bell and short styles. That is not to say that you cannot mix and match—the only rule should be if it looks right it is right. Think of what you usually wear—a tank top, a kaftan, a skinny, ribbed sweater—then you will know what suits you best.

OFF THE SHOULDER

More like broad straps or puffed bands, which are attached just at the underarm to give an alluring bare-shouldered silhouette. Best with a fitted bodice, but can add width so beware if you are very broad shouldered.

CAP

A close-fitting sleeve that caps the shoulder, often found on shift-style 1950s dresses. Softer versions can be gathered onto a band or in several sheer layers for Empire styles. Best for showing off well-toned arms or teamed with operalength gloves.

SHORT

Sleeves in a T-shirt style, which will suit most dresses. Good for camouflaging upper arms.

TULIP

Short sleeve comprising petal-shaped overlap. A more delicate short-sleeve style, usually in a sheer fabric.

ELBOW

An elbow-length sleeve that is usually slim fitting, but may have a cuff or band at the hem. Sometimes shaped or cut away.

THREE QUARTER

Cut between the elbow and the wrist, this length can be slimming if your arms are not so toned. It should finish at the narrowest point on the arm to give an elongate effect.

LONG

Long, slim sleeves are great for lace and sheer fabrics, giving the illusion of an exposed arm while keeping you covered. Scalloped edges in lace, cuffs and bound edges can give an added dimension.

PUFF

There are several variations on puffed sleeves, depending on the amount of volume in the sleeve and where it is cut. Juliet sleeves have a small puff at the shoulder and continue as a long, slim sleeve. Leg-of-mutton or balloon sleeves puff to the elbow and are slim to the wrist (see page 169), while the Poet sleeve is full from shoulder to wrist.

BELL

The opposite of the puff is the bell, which is slim to the elbow, flaring gently to the wrist.

KIMONO

Kimono sleeves are deep and wide Oriental-style rectangular sleeves, often cut into the body of the dress.

CAPE

Circular sleeves are usually in soft or sheer fabrics, which are gathered onto the shoulder and fall in a cascade to any length (see page 171).

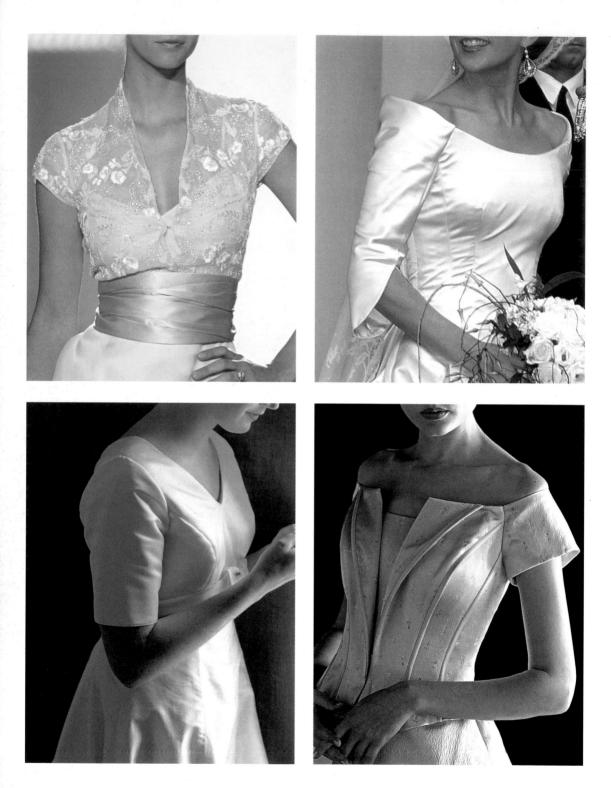

FAR RIGHT Audrey Hepburn's puff sleeves are tucked into skin-tight elbow-length gloves. ABOVE, CLOCKWISE FROM TOP LEFT Sheer capped sleeves on a dress at the Wedding March on Madison, New York, 2003; Crown Princess Mary of Denmark wears split elbow-length sleeves in her wedding gown by Danish designer Uffe Frank, 2004; cream crepe brocade dress with dropshoulder flared sleeves; short T-Shirt style sleeves in an off-white princess-line dress with bow.

SLEEVES

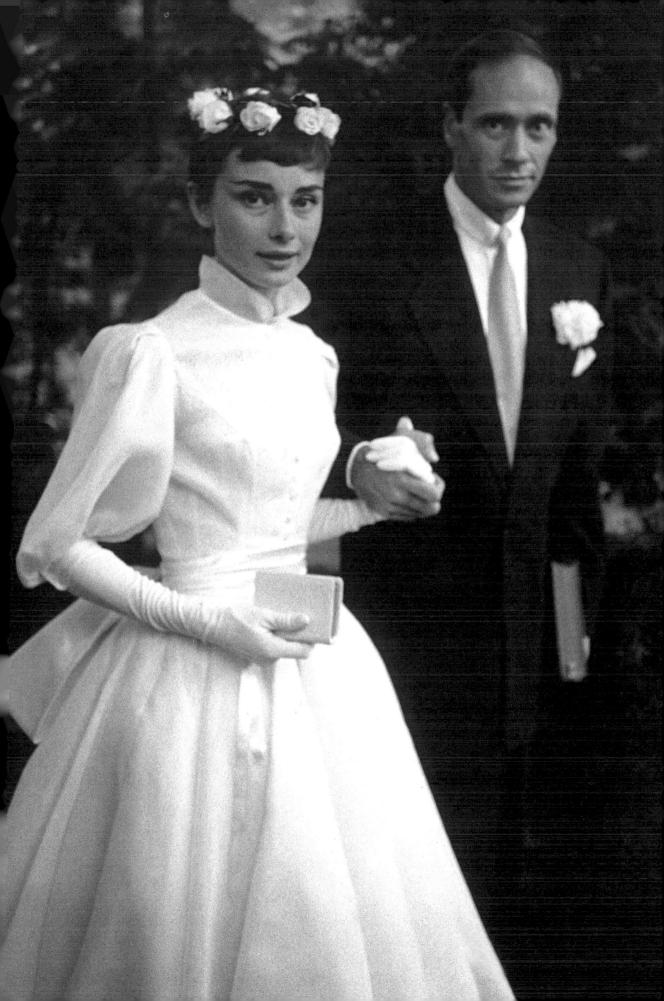

LEFT Pin-tucked and draped handkerchief sleeves on a dress by designer Sarah Owen.

BELOW Sheer, ruched cape sleeves on a pale empire-line dress, inspired by designer Zandra Rhodes.

Above RIGHT Beaded, detatchable capped sleeves on a dress by Australian designer Maggie Sottero.

BELOW RIGHT This straight "Charlotte" gown in satin by Phillipa Lepley is set apart by the silk tulle fluted bell-shaped sleeves, with appliquéd Chantilly-lace flowers.

FAR RIGHT Princess Grace kneels to show the exquisite detail of her rose point lace fitted sleeves, embroidered with tiny pearls.

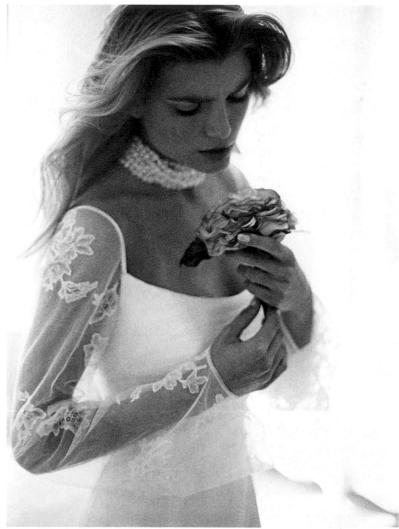

172

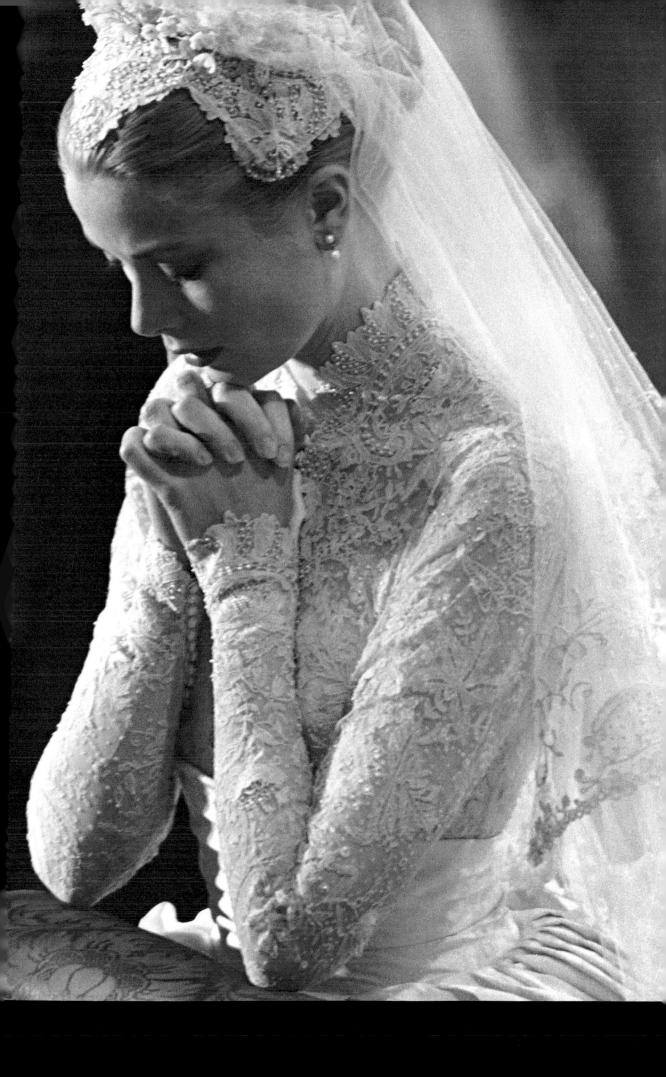

VEILS

Roman brides wore veils, known as *flammeum*, which were dyed a golden shade with saffron to represent the flame of Vesta, the domestic goddess and giver of life. The veil was to protect the bride from evil spirits and was a symbol of her betrothal for life.

The introduction of the veil into Europe seems to have come from the Middle East, brought back by knights from the crusades. In arranged marriages it was used to hide the bride's face from the groom, who would not yet have seen her. Once they were married, the groom was allowed to unveil his new wife's face, at which point it was too late for any second thoughts. This may be the reasoning behind the Jewish tradition of the groom checking to see if the bride is the girl of his choosing before placing the veil over her head.

Fashions for the veil have waxed and waned, and it was not until Queen Victoria's wedding that the fashion for veils was firmly cemented once again. The modern veil has evolved through the past century, as new materials and fashions have impacted on the styles. So when it comes to choosing there are a variety of styles and details to consider—traditional lace, soft sheer or stiff nylon tulle, multiple layers to the floor, short styles that can be worn with a number of headpieces or hats and many more.

You may have an heirloom veil that has been passed down through the generations, or you may choose to have a new veil, trimmed with your dress fabric. Whatever you decide, just remember that it must complement your dress in style and color, and comply with any stipulations there may be with a religious ceremony, should you have one. If you are wearing a veil that will cover your face during the ceremony, it is important to get the attachment right; practice with the headpiece before the big day. Otherwise have fun with it—it may be the only time in your life you wear one.

BLUSHER

A short, shoulder-length style that is fixed atop the head so it can easily be pushed back during the ceremony. Best for simple, modern dresses and suits. Will suit all face shapes.

ELBOW

As the name suggests, a simple veil that falls to the elbow. These include fountain styles, which may be multiple layers of fabric gathered at the crown, either softly cascading or in stiffer fabrics to create added height and shape. Good for a thin face as the height and width will help reproportion it.

FINGERTIP

A veil that reaches to the fingertips, it is a classic veil length, often trimmed in lace or satin ribbon. If you are not so slim, be careful that this style doesn't visually add width to your waist.

WALTZ

A calf- or ankle-length veil that will usually be a softer style. Good for rounder face shapes as it will help to slim and elongate.

CHAPEL

A more traditional style of veil, it is often worn with ball gowns. The chapel veil just sweeps the floor and may cascade in several layers. Often worn at the back of the head, it can help balance a long or thin face. May be worn with a blusher.

CATHEDRAL

The longest and most formal style, it is usually seen at royal weddings. This veil will fall as a train behind the wearer.

MANTILLA

Spanish-style lace veil that encases the wearer from top to toe and falls from the crown of the head. Will work beautifully with simple column or mermaid styles.

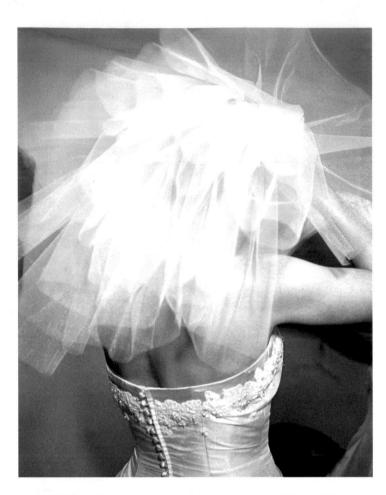

Above LEFT Caught in the moment—a bride adjusts her tiered fountain veil.

BELOW LEFT An elbow-length veil in white net is secured with a tiara.

RIGHT Mantilla-style lace-trimmed veil by Spanish designer Rosa Clará.

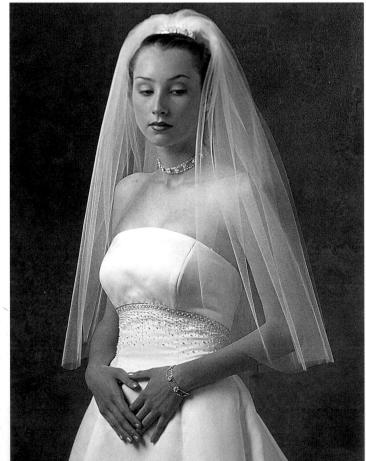

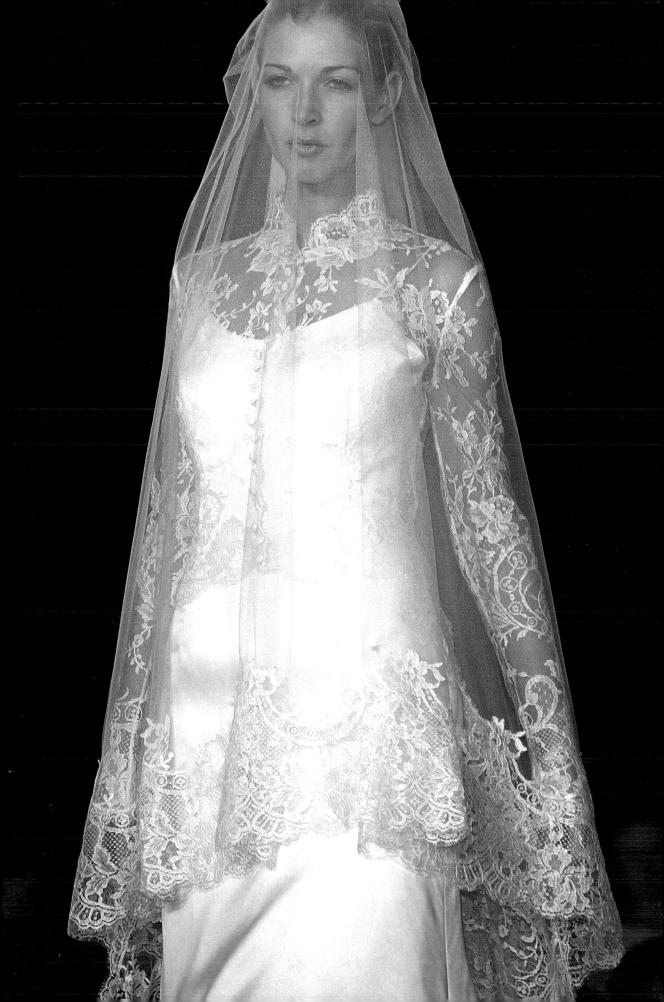

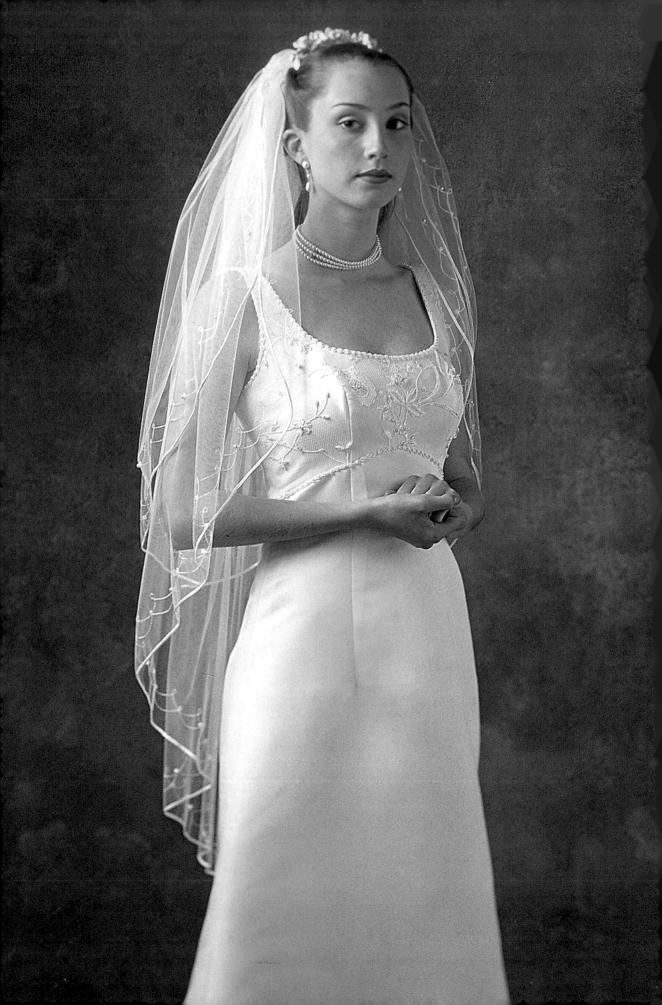

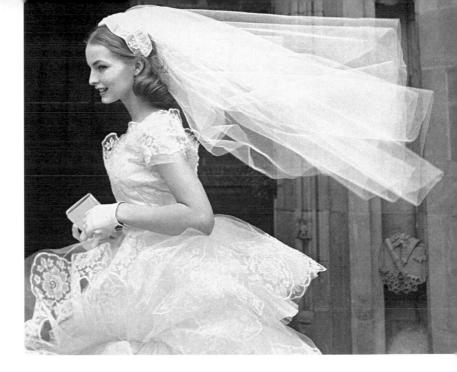

Above RIGHT Martha Boss, a top bridal model, wears a nylon tulle lace gown and veil.

BELOW RIGHT In contrast, this soft net chapel-length veil falls gently to the floor.

LEFT Fingertip veil with edge trim and embroidered border.

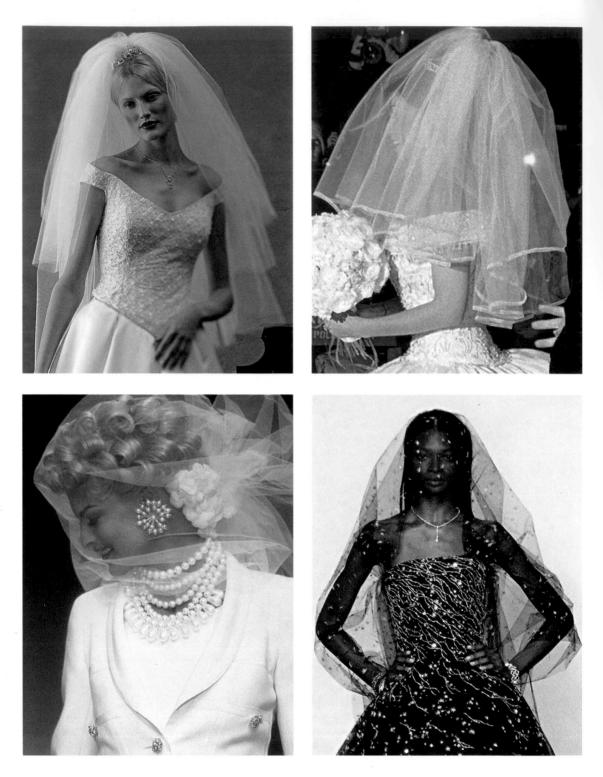

ABOVE, CLOCKWISE FROM TOP LEFT A fountain veil falls at the back of the head; blusher style with satin trim worn by Mexican actress and singer Thalia for her wedding to Tommy Mottola, 2000; black on black—a model wears an Oscar de la Renta wedding dress in black with a black beaded net veil; an alternative to the traditional veil is this wrapped-style veil that encases the head. OPPOSITE A cathedral-length veil trails behind a model showing a dress by Spanish designer Rosa Clará.

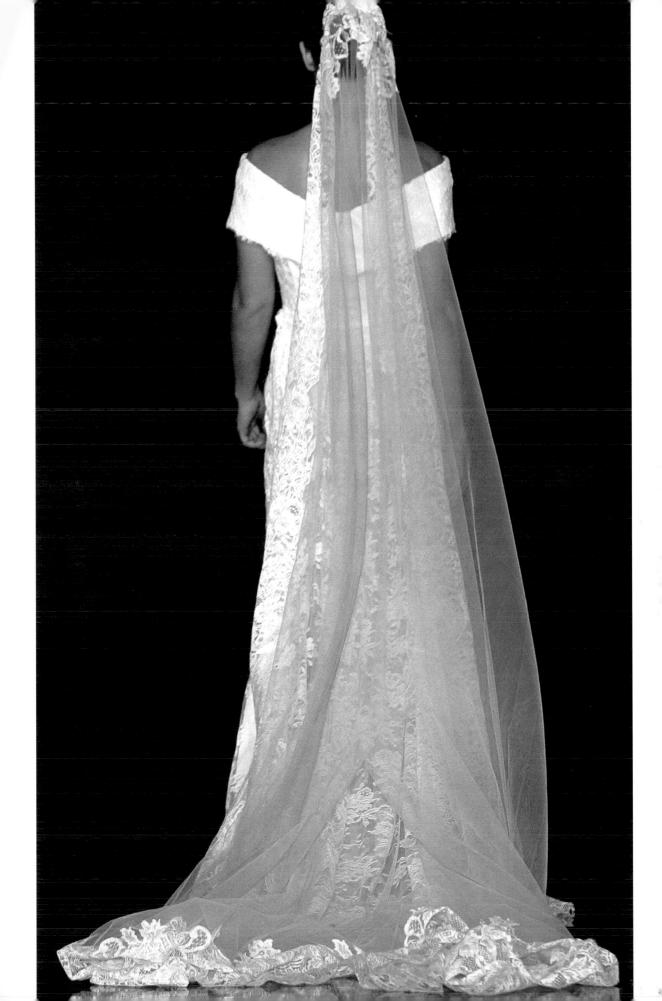

TRAINS

The train is fabric that sweeps the floor, either cut into the skirt of the dress or attached as a separate piece. Like the veil, the train is a romantic evocation of the bridal dress, with attendants carrying the acres of fabric into the church for that dramatic sweep down the aisle. It is a symbol of the occasion, and the grander the occasion the longer the train. Prior to the 20th century, many day dresses would have a train as a matter of course. In the 1920s, as hemlines began to rise, and again in the 1950s with the shorter A-line styles, the train was not such a popular option. Televised royal weddings, which always feature a spectacular train, may be responsible for reviving its fortunes, and it continues to be a popular feature today. Just like the other details that combine to make the dress a personal statement, there are no hard and fast rules when it comes to the train. It pays to look at the combination of details you will see from the back-the neckline, skirt, veil and train don't all want to be vying for attention or laying one over the other in a foaming trail behind you. Pick the detail you want to be the focus and work around it. Bear in mind the style of your dress if you are choosing a period design—look at the combination worn during that period to help you decide if you want to recreate an authentic look or an updating of it. The train can provide a clean and simple counterpoint to a frothy tulle skirt, or it can be a canvas for elaborate embellishment, beading and embroidery.

If you are having a church spectacular then you will probably want to go for the full train. Naturally, it follows that a cathedral train works best in a cathedral, and a chapel train in a chapel, so don't overdo it—you will want to get all of your dress into the venue. If you are marrying in another type of venue or having a civil ceremony, then you will at least need to be practical, which is not to say you need abandon the idea of a train altogether.

Modern dresses give you options, so you may have a detachable train, which can look spectacular for the ceremony but be removed for the reception so that your guests don't pin you to the dance floor. Many choose a more practical train, which can be gathered and tied or buttoned to form a bustle after the ceremony. If you choose a mermaid, empire or bias style, the skirts may be cut to sweep the floor, forming a small train as part of the dress. Alternatively, a long lace-trimmed or tiered veil can be just as beautiful as a train and will give the same visual impression. These are particularly popular with shorter styles and slender columns.

BRUSH

This is the shortest style and just brushes the floor, which has the effect of lengthening the silhouette slightly as it pulls the dress gently away from you as you walk. Good for column, slip and empire styles.

COURT

This is fuller than the brush train and falls from the waist. It was traditionally the length dictated for courtiers, and as wedding dresses were often worn again for presentation at court it became a much-demanded length. Good for princess and A-line styles.

CHAPEL

Extending about three feet (1 m) behind the wearer, a definite statement without being impractical. This is a very popular length and good for all styles.

CATHEDRAL

A more formal style of train that will be over six feet (1.8 m) in length for traditional ball gowns.

ROYAL

Lady Di proportions, good for cascading down the steps of large cathedrals. This will require assistance from bridesmaids.

WATTEAU

This style is attached at the shoulders and usually consists of a panel that falls to and brushes the floor, but it may extend further. Named after the Rococo painter who immortalized society women who sported such trains, which were fashionable at the time. These may be detachable and suit column and princess styles.

PANEL

Similar to Watteau but attached at the waist. Usually detachable, this train is a flat panel that may be chapel length or longer, and may be divided like oversized ribbons. Best with ball gown and A-line styles.

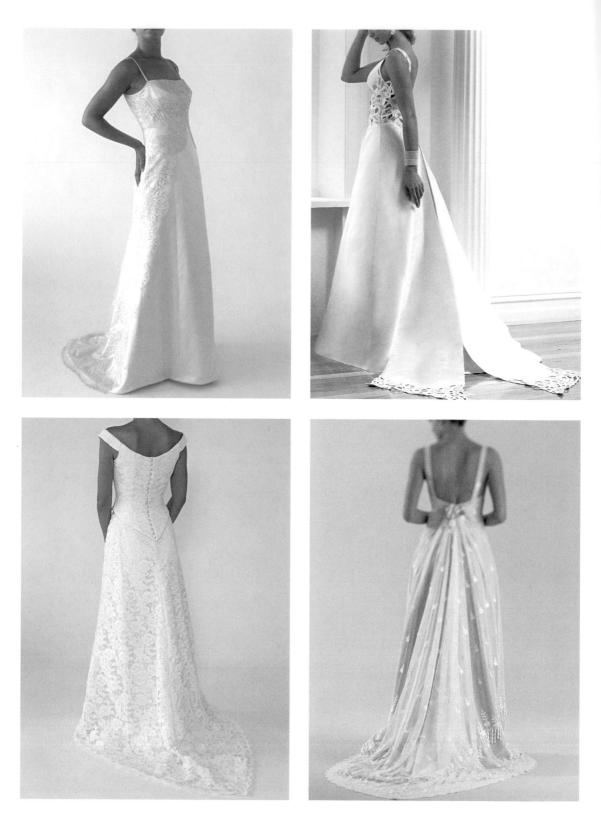

ABOVE, CLOCKWISE FROM TOP LEFT Brush-length lace train by Caroline Parkes; panel train with cut out and appliqué detail; a circular chapel-length train in lace falls from a corsage at the waist; chapel-length train shaped to a point in a Caroline Parkes design. OPPOSITE A panel train falls from the waist in a duchesse satin and tulle dress by Spanish designer Modesto Lomba.

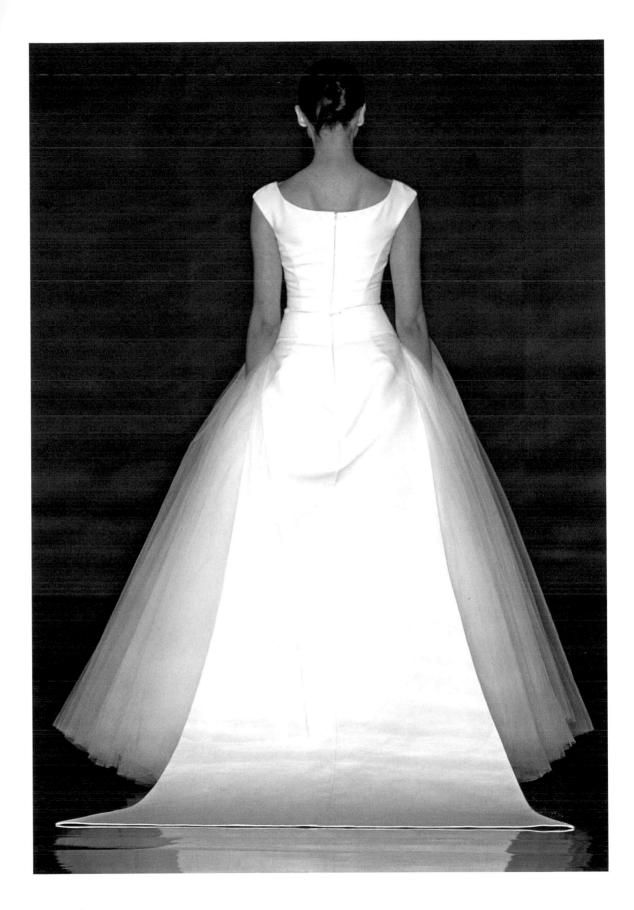

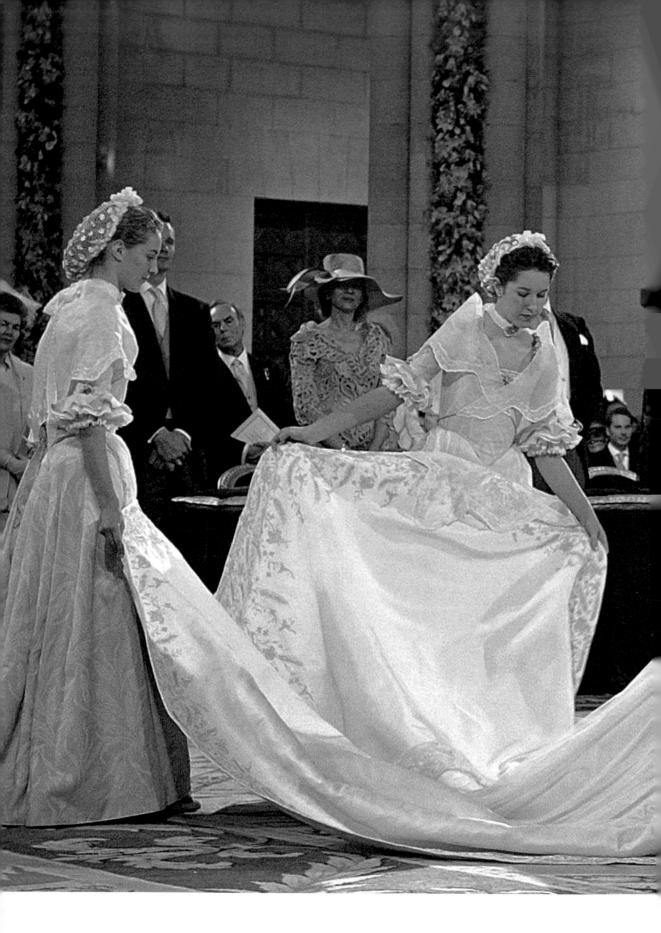

TRAIN

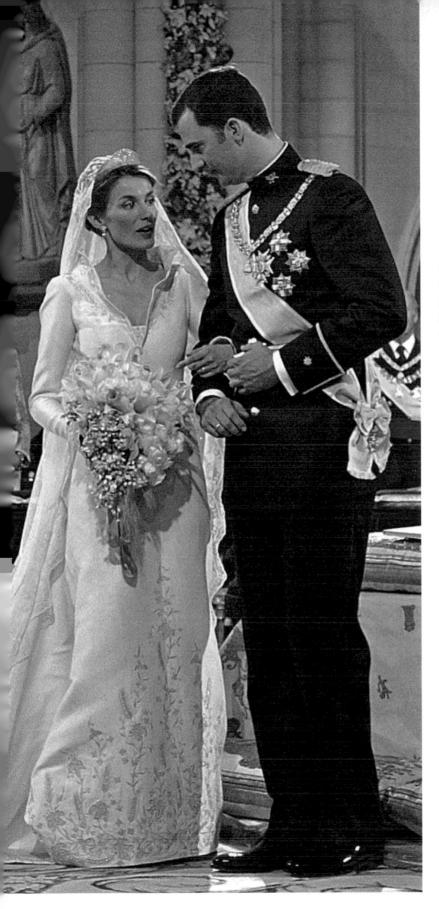

LEFT Letizia of Spain in a Manuel Pertegaz dress with a 15-foot (4.5 m) long royal train embroidered with heraldic symbols, at her wedding to Crown Prince Felipe of Spain, 2004.

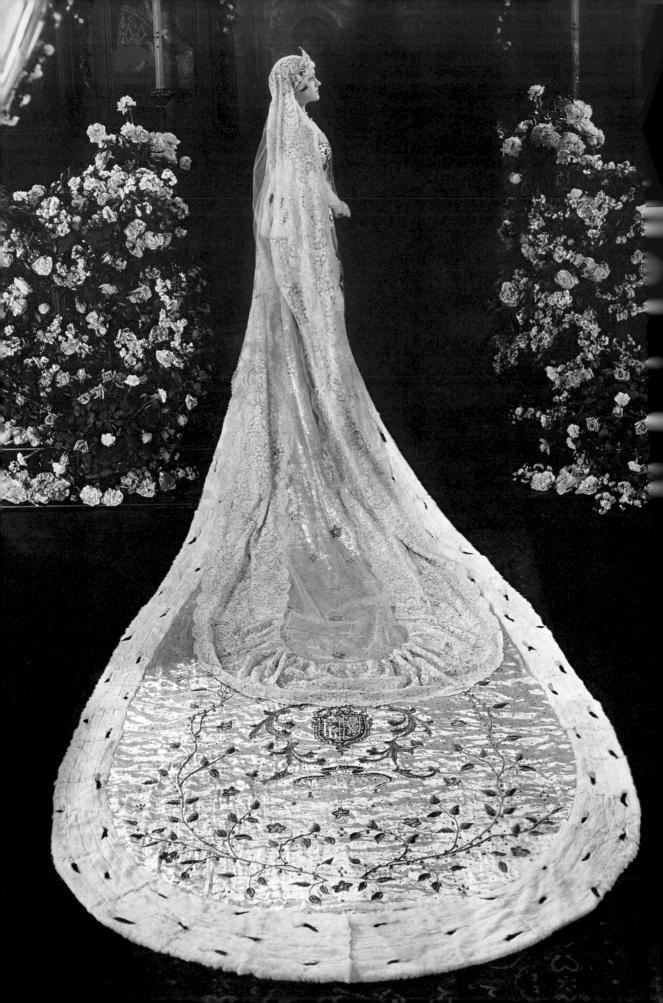

LEFT Gloria Swanson as Princess Marie in the 1924 film *Her Love Story*, wears a dress with a richly decorated royal train trimmed in ermine.

Above right Vintage 1960s wedding dress with panel train.

BELOW RIGHT An Antonia Pugh-Thomas design with circular cathedral train falling seven feet (2 m) from the waist.

DETAILS

HEADWEAR

If you are going to wear a veil you will need something to keep it in place on your head. This may be a simple band or comb or a floral garland. Orange blossom is traditionally associated with the bride and goes back to the Romans. Queen Victoria re-established the tradition by wearing a garland of orange blossom for her wedding—subsequently, real and imitation silk orange blossom has remained a popular tradition for brides. You might want to match your bouquet, dress fabric or corsage to a floral headpiece, or you may decide on an alternative statement piece or hat without a veil.

First, decide if you are a hair, a veil or a hat person. If you are wearing your veil to the front for the ceremony, your headpiece may have to be limited in size and type. If you are wearing a lace or decorated veil, you may not want to detract from it with any additional headwear. If you are wearing your veil to the back and your hair is the more important feature, then you may just want to keep it as the focus. Hair that is piled up on top of your head may benefit from a simple ribbon to match the dress, decorative hairpins or floral sprigs. If you have shorter hair you might want to wear a hat—wide-brimmed and top hats with veils wrapped or draped over them can look striking with the right dress or suit. Tiny pillbox hats with short veils that just cover the eyes can be a seductive partner to 1950s styles, while headbands and feather creations team well with shorter 1920s styles and modern columns. Make sure you look at the whole picture when deciding, so trying on a hat without the dress is not such a good idea.

OPPOSITE This dramatic pillbox hat with spiral feather quills looks like a miniature wedding cake. The lace matches the dress by designer Antonia Pugh-Thomas. The hat is by Katharine Goodison Millinery.

196

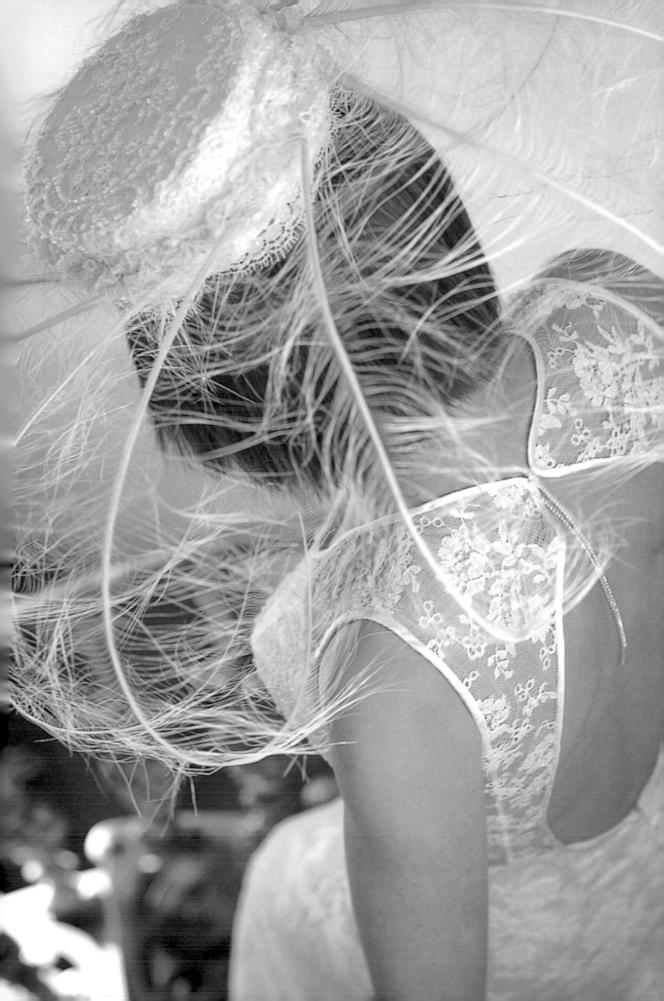

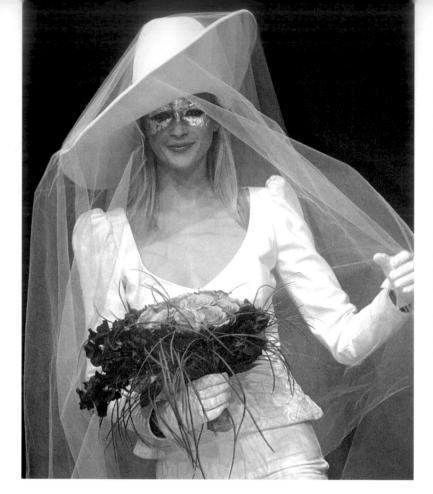

RIGHT A feather headdress frames a simple crop hairstyle and matches the waist detail.

ABOVE LEFT Only for the adventurous —a nylon tulle veil adorns a widebrimmed hat by Torrente Haute Couture, 2001.

BELOW LEFT Vintage finishing touches—a matching hat finishes the outfit as a bride steps from the car. Ideal for a civil ceremony.

BELOW RIGHT Decorative hairpins add the finishing detail to a basketweave hairstyle.

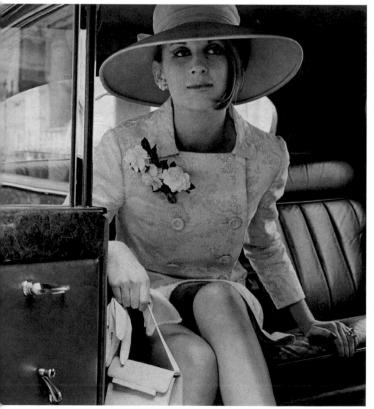

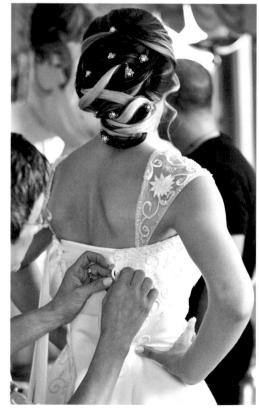

DETAILS

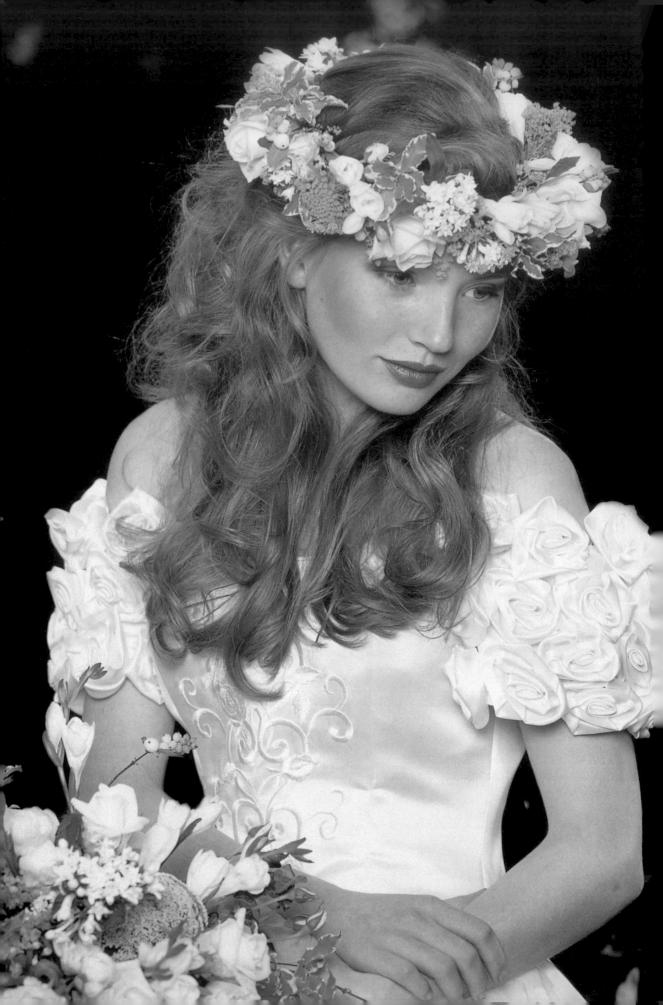

PREVIOUS PAGE, LEFT A statement headpiece is an alternative to a veil; this silk floral peony compliments the embroidery on the dress.

PREVIOUS PAGE, RIGHT The lattice net of this short "fascinator" veil is secured with a silk rose.

LEFT The natural look—a garland of real flowers is a pretty complement to the bridal bouquet in this SaraSusa design.

RIGHT The fresh green of a simple band of ivy sets of this romantic white ensemble.

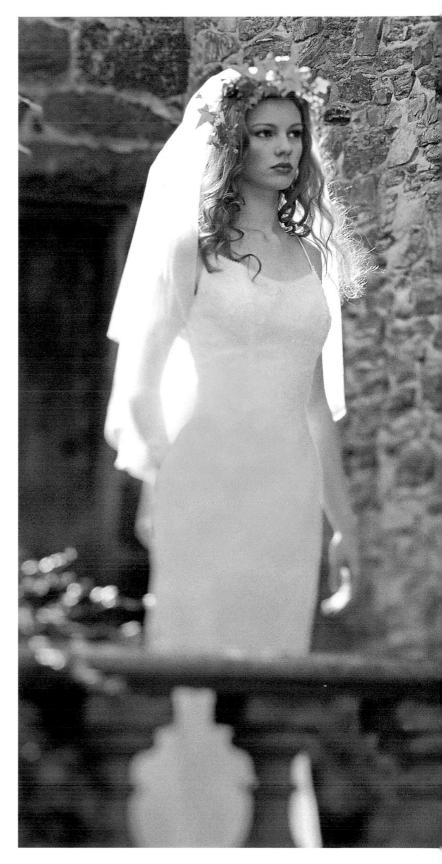

JEWELRY

An alternative to floral headpieces and hats is something more delicate and sparkly. Tiaras and crowns in particular play a part in some traditional wedding ceremonies. Aside from the royal connotations associated with crowns and brides, there are associations with Adam and Eve, the king and queen of creation, and in some Scandinavian and Russian Orthodox ceremonies a crown is placed on the bride's head. Half crowns and tiaras are more popular and more practical. They vary in size and complexity, from small barrette styles to regal arcs that work well with a bun, securing a veil with a little added glitter.

A strapless gown can be a foil for a stunning crystal choker, and if your dress is being scattered with pearls or beads, you might pick up these details with your accessories. If you are wearing an heirloom piece or something you have been given for your engagement, you might choose this as the starting point and develop your dress and accessories around it. Zodiac signs have symbolic colors, stones and metals that you might choose to link to your jewelry theme, as certain crystals and colors have associated powers and superstitions. If you are wearing a period style then the appropriate details, like the style of headband, bracelet or choker, can add an authentic touch. Keep it simple and don't overdo it—one strong piece with a simple column dress can look stunning, and you will reduce the effect with matching earrings, bracelet, anklet, belly chain and toe rings. Save this look for a beach wedding in the Caribbean.

OPPOSITE A delicate diamanté-studded tiara sets off a sleek hairstyle.

201

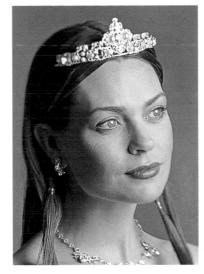

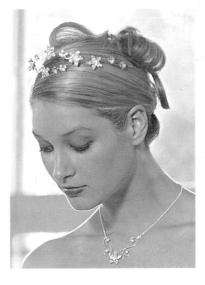

LEFT A tiara adds sparkle to a mass of curls, worn with a simple pearl bracelet.

RIGHT, CLOCKWISE FROM TOP LEFT Varying tiara styles: a half crown; a matching necklace and headband-style tiara; Pre-Raphaelite-style floral band; decorative hairpins hold long hair in place; a discreet barette-style tiara; an ornate decorative comb keeps hair in place for a swept-up style.

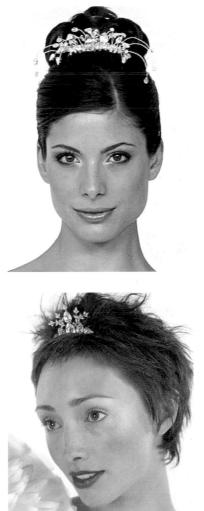

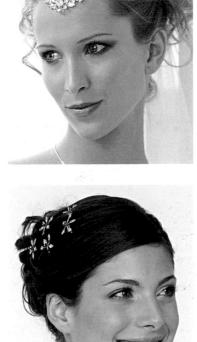

BELOW, CLOCKWISE FROM TOP LEFT Crystal beads and feathers make an interesting armlet cuff; matching amethyst necklace and earrings; crystal beading on the dress is picked up with a matching diamanté bracelet; a twinkling multistrand necklace complements a strapless gown. OPPOSITE A classic set of pearls is hard to beat for a demure, vintage look.

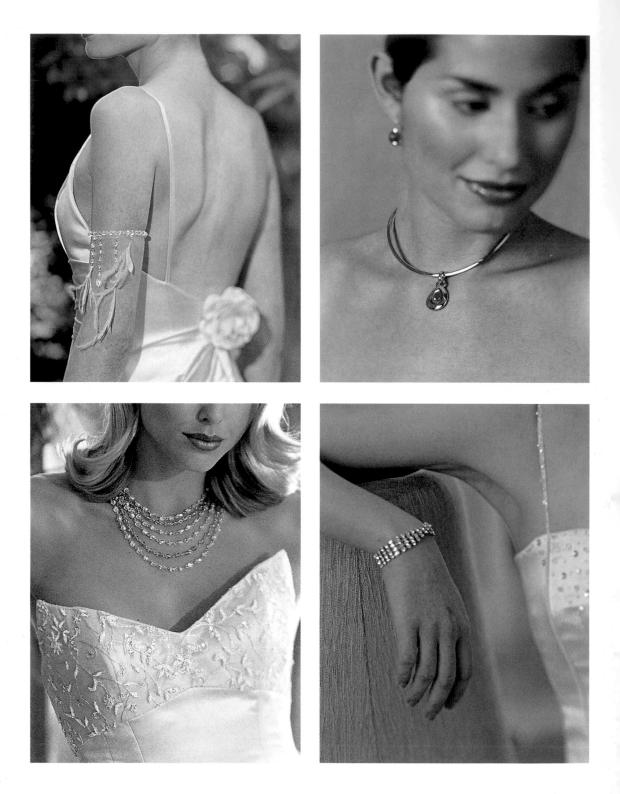

DETAILS

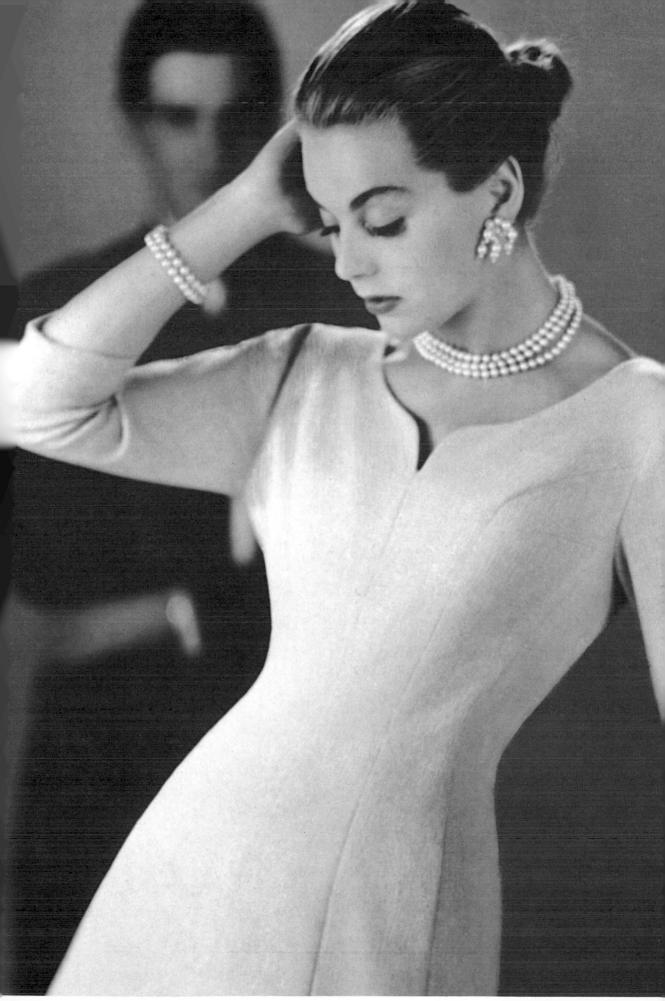

BEADING AND DECORATION

There are two schools when it comes to embellishing dresses—less is more and more is more. Traditionally, conspicuous consumption was the driving force behind much of the decoration of gowns, with precious metal threads, beads and furs used to trim the gown and signify the status of the wearer and her family. Today the addition of embroidery, face, appliqué, beading, sequins and fabric flowers, feathers and tassels is down to personal taste. These details are what can make your dress a personal statement, and it can be a great way to customize something you buy off the rack: many trims and motifs can be bought individually or on the roll and applied by machine or hand. Beading, embroidery and sequins, on the other hand, can be highly skilled crafts and take considerable time to apply, so if you are having a dress made seek advice from your maker at the start if you plan to have this kind of detail. Often the embellishment will have to be applied before construction of the dress is completed.

BORDERS/TRIM

Edge bindings, braiding or ribbons are used to give a decorative or contrasting edge. Lace, feathers or ruffles give softness, particularly on strapless bodices and hems.

MOTIFS

A placed design that may be small on a bodice or large as a feature on backs and trains. May be embroidered, beaded, appliquéd or use in combinations of effects.

SPRIG/SCATTER

Small motifs scattered evenly over the dress. Good for simpler column and slip styles

CASCADE

A large motif that appears to wrap or cascade down the body. May be asymmetrical and is good for all styles.

INSERT/CUT OUT

Usually lace or sheer motifs that are cut into the body of the dress. This also applies to larger panels, which may frame the bust or hem a sleeve or train. Good for all styles.

ALLOVER

Usually applied to the bodice of a dress, where beading or sequins give a striking contrast between the upper and lower parts. Good with ball gown and empire styles.

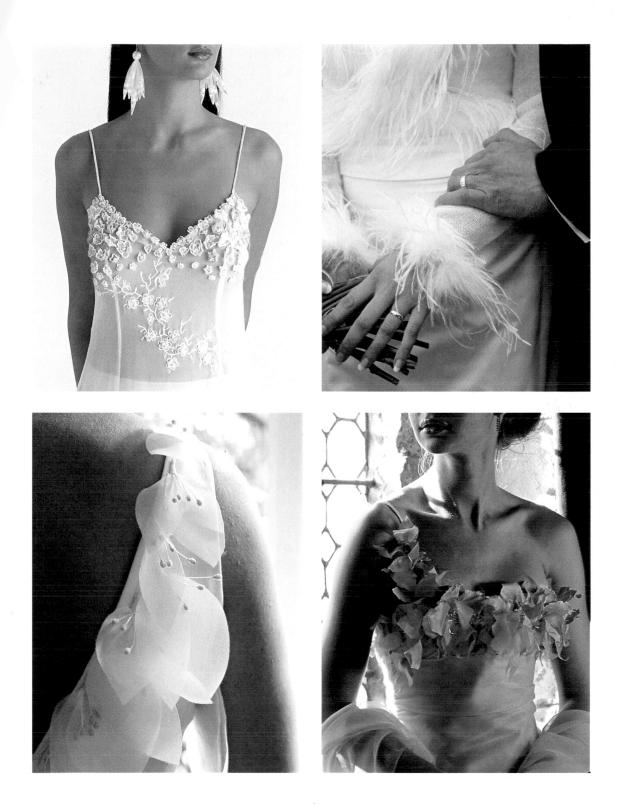

OPPOSITE Shimmering gauze flowers are scattered asymmetrically across this Caroline Parkes design. Above, CLOCKWISE FROM TOP LEFT Embroidery and appliqué add modesty to a revealing slip dress; fly-away feather collar and cuffs finish a sheer knit top; a mass of appliqué silk flowers adorn the neckline and strap of a striking blue dress; silk petals follow the line of a plunging back.

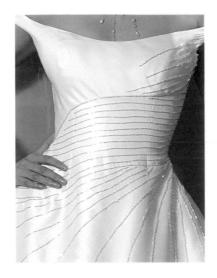

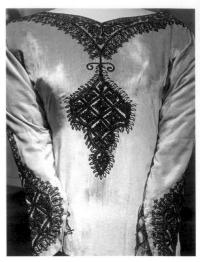

ABOVE LEFT Bugle beads trace lines across the bodice and skirt of this dress in a modern design.

ABOVE RIGHT Traditional eastern motifs are embroidered in black on this exquisite velvet dress, worn by actress Katherine Hepburn for her 1928 wedding to Ogden Smith.

LEFT A diamanté net is overlaid on the bodice of this sparkling dress by Lebanese designer Pierre Katra, 2004.

RIGHT Jewel encrusted—the heavily sequinned bodice of this dress contrasts with the simple wrapped silk skirt.

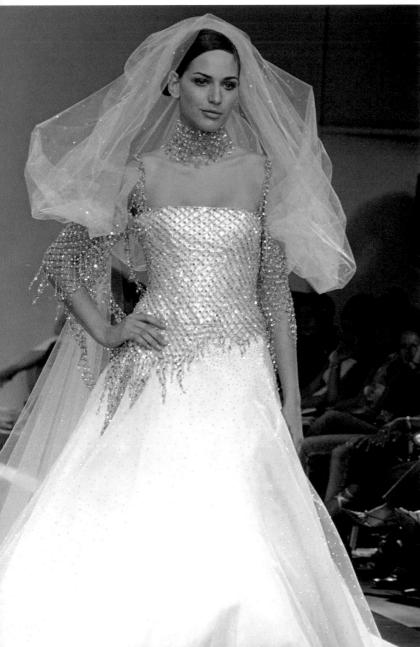

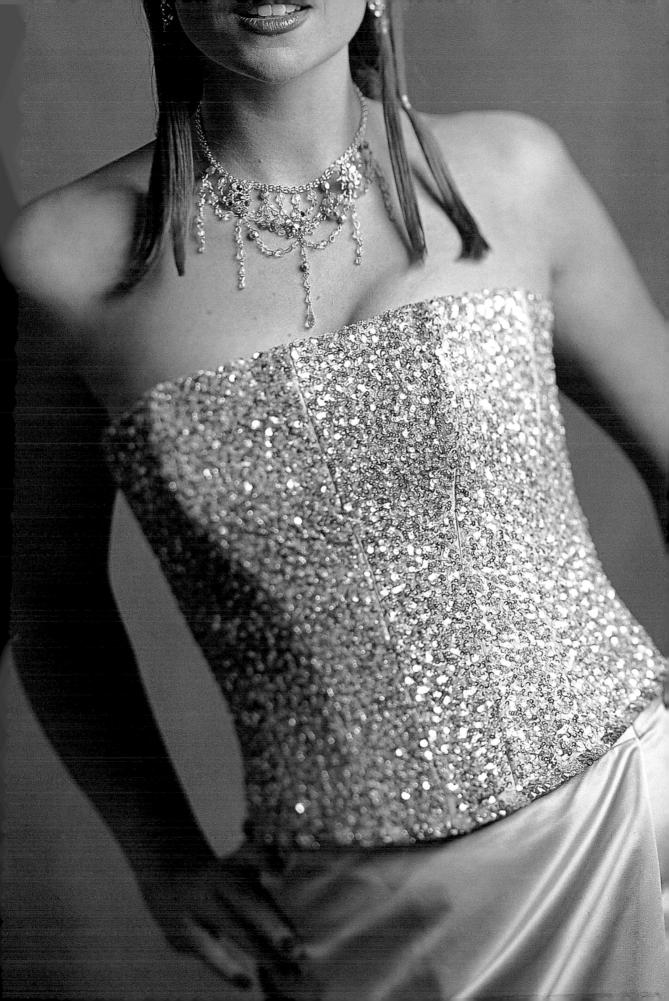

A FINAL WORD ON ACCESSORIES...

All those little personal details that take time and patience to finish your outfit, from the right gloves or shoes to the perfume you wear, can be so rewarding, making your day an intimate experience for you and your partner within the bigger picture of the wedding itself. It could be down to your entwined initials embroidered into the lining of the dress, a favorite color or a shared experience that you choose to reference. I remember making a dress for a bride whose partner had lost both his parents, and she asked for a pocket to be made in the interior of the dress so that she could carry a picture of them so that they wouldn't miss the big day. These finishing touches can be the most rewarding and enduring memories of your wedding day, so they are well worth the extra effort.

OPPOSITE Personal details—an antique purse and embroidered choker set off a stunning laser-cut organza skirt and chenille wrap by Robinson Valentine.

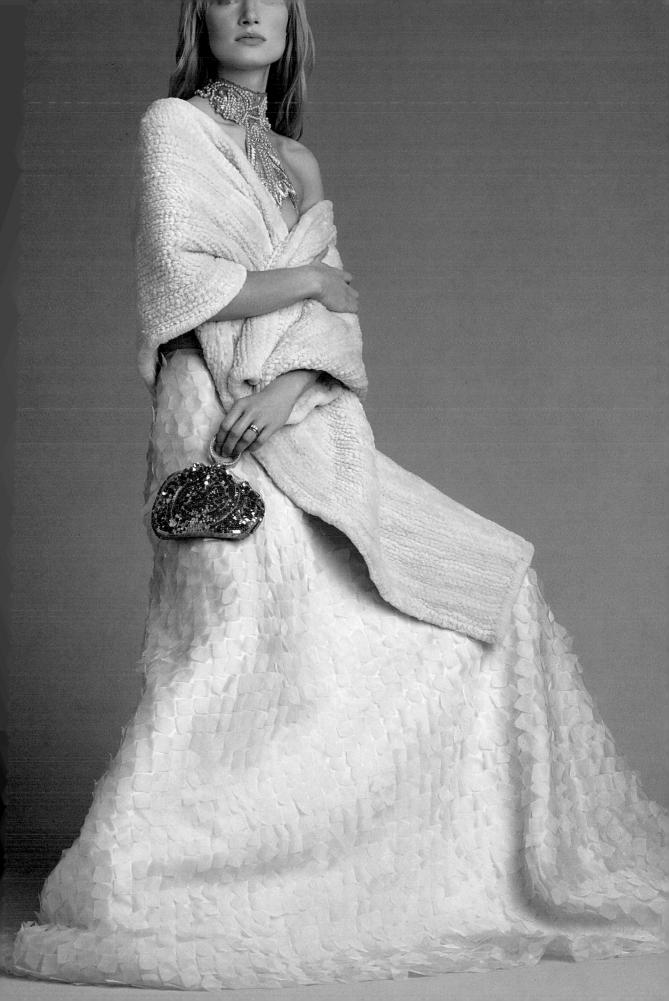

BELOW, CLOCKWISE FROM TOP LEFT Finishing touches—French actress Bridget Bardot finishes her outfit with a muff for her 1952 wedding; a capelet can offer warmth and modesty for a church; add interest, like this Vera Wang wrap in shredded tulle; add a sequinned and beaded bag that matches the dress to hold all the last minute essentials. OPPOSITE Getting it right for the day—this bride is taking no chances with the weather in an Antonia Pugh-Thomas dress and rubber boots.

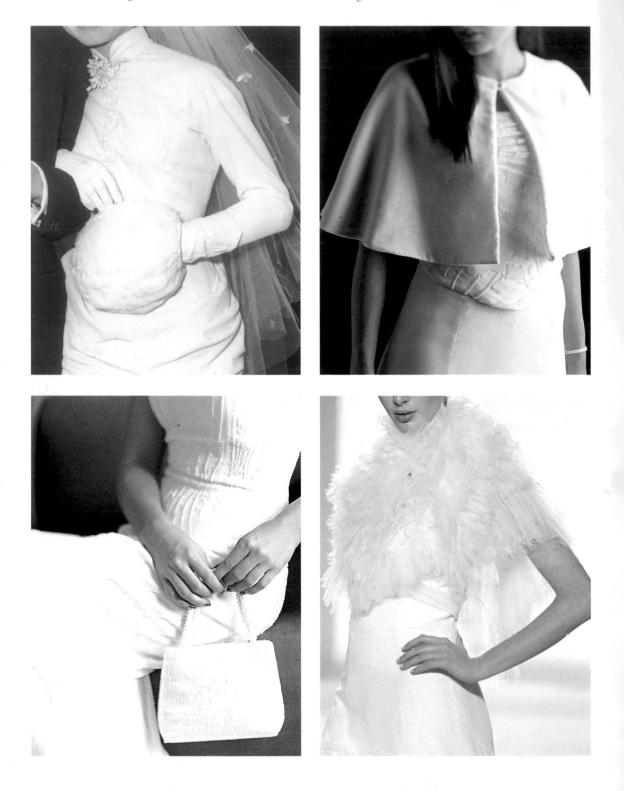

INDEX

accessories 216-219 Alaia, Azzedine 70, 122 a-line dresses 92–107 Amies, Hardy 26-27 Armani, Giorgio 72-73, 133 appliqués 15, 21, 45, 54, 60-61, 79, 83, 103, 163, 172, 188, 210-213 backs 89, 143, 152-163, 186, 213 corsage 155, 160-161, 188 corsetry 14, 15, 22-23, 34, 54, 98, 106, 110, 142, 143, 150, 155, 161 covered buttons 86-87, 154, 155, 156-157, 162 cowl 158, 161 draped 154, 161 lace insert 155, 162–163 V-back 86-87, 154 X-back 154, 158-159 Badgley Mischka 37 bags 218 ball gowns 12-31, 94-95, 133, 155, 163, empire-line dresses 52-67, 74, 78, 119, 166, 177, 187, 210 Balmain, Pierre 95, 96, 111, 169 Bardot, Bridget 218 beading 15, 18, 20, 40, 45, 46-47, 49, 51, 54, 55, 56, 62, 71, 74–75, 80, 88, 90-91, 95, 98, 102-103, 104-105, 106-107, 114, 125, 137, 144, 146-147, 154, 163, 172, 182, 186, 208, 210-211, 214-215, 218 bias-cut 66-67, 70-71, 79, 84-85, 143, 158 Black, Cilla 124-125 buttons, covered 86-87, 101, 154, 155, 156-157, 162 capes 218 Cardin, Pierre 34, 122 Castigliano, Caroline (Collection) 40-41 Chanel, Gabrielle "Coco" 110, 126-127, 133 Clará, Rosa 178-179, 182-183 Clarke, Ossie 94 coatdresses 25, 34, 71, 72-73, 133, 136 column dresses 26-27, 34, 70, 71, 86-87, 91, 108–119, 154, 177, 187, 196, 204, 210 corsages 18-19, 66, 155, 160-161 Courrèges, André 34, 94, 122

decorations 210-219 see also appliqués, beading, corsages, embroidery,

feathers, floral and lace de la Renta, Oscar 182 details 194-219 see also decorations, headwear and jewelry accessories 216-219 appliqués 15, 21, 45, 54, 60-61, 79, 83, 103, 163, 172, 188, 210-213 capes 218 Diana, Princess of Wales 15, 17, 187 Dior, Christian 70, 94, 95, 110, 134-135 draped styles 47, 48, 54, 57, 70-71, 81, 95, 106, 114, 143, 150, 161, 170

Electra, Carmen 37 Elizabeth II, Queen 35, 36-37 Emanuel 15, 17 embroidery 15, 20, 38-39, 42-43, 47, 48, 54, 55, 62, 65, 82, 91, 95, 107, 119, 129, 136, 147, 154, 173, 180, 186, 190-191, 200, 210, 213, 214, 216-217 143, 166, 171, 186, 210

fabrics chiffon 15, 55, 66, 67, 77, 85, 90, 95, 106, 115 cotton 55, 133 crepe 66, 67, 71, 78, 106, 111, 119, 158, 168 damask 35, 58, 95, 98, 122, 133 duchess satin 35, 66, 86-87, 91, 95, 98, 128, 188 dupioni 15, 111 gabardine 133 georgette 55, 71 grosgrain 95, 133 jacquard 133 linen 133 Lycra 70, 122 organza 28, 71, 91, 95, 101, 114, 136, 160, 216 satin 15, 16, 23, 29, 35, 36, 43, 44, 46, 71, 76–77, 83, 104–105, 106, 111, 116, 137, 172, 177, 182 shantung 95, 117 silk 35, 41, 71, 96-97, 98, 110, 133, 136, 142, 146, 172, 215 taffeta 15, 111 tulle 15, 22, 26-27, 172, 176, 181, 189, 198, 218 viscose 95 voile 15, 55, 59, 95

wool 95, 122, 133 zibeline 18, 74, 107 Farrow, Mia 122, 124-125 Fath, Jacques 111 feathers 18, 100, 124, 136, 196-197, 199, 208, 210, 213 fishtail dresses see mermaid dresses floral corsages 18-19, 66, 155, 160-161 decorations 21, 25, 28-29, 36-37, 43, 45, 48, 50, 58, 75, 100-101, 106, 113, 114, 119, 142, 172, 210, 212-213 headwear 19, 29, 48, 90, 105, 125, 169, 196, 200-203, 207 Fortuny, Mario 70, 110 Frank, Uffe 168 Galliano, John 55, 70, 110 Gaultier, Jean-Paul 34 Gigli, Romeo 55 Givenchy, Hubert de 94 Goodison, Katharine 196–197 hair 15, 142, 196, 198-199, 207 Hartnell, Norman 35, 36–37 hats 35, 59, 176, 196-197, 198 headwear 196-203 feathered 100, 136, 196-197, 199 floral 19, 29, 48, 90, 105, 125, 169, 196, 200-203, 207 hats 35, 59, 176, 196-197, 198 tiaras 22, 24, 26-27, 36, 39, 40, 51, 60, 63, 72, 75, 88, 102, 118, 144, 150, 178, 191, 192, 193, 204–207 Heche, Anne 72-73 Hehir, Johanna 137 Hepburn, Audrey 55, 95, 96, 124-125, 168-169 Hepburn, Katherine 214 Hulanicki, Barbara (for Biba) 55 Jagger, Bianca 132, 134 James, Charles 111 Jenks, Cozmo 80-81 jewelry 112, 201-209 bracelets 206, 208 brooches 47, 145 necklaces 137, 146, 148, 204, 206, 208,209 tiaras 22, 24, 26-27, 36, 39, 40, 51, 60, 63, 72, 75, 88, 102, 118, 144,

150, 178, 191, 192, 193, 204–207

220

Katra, Pierre 214 Katsura, Yumi 88–89 Kelly, Grace 15, 17, 172–173

lace 14, 15, 35, 40, 45, 71, 78, 84-85, 95, 122, 142, 145, 166, 167, 176, 177, 181, 188, 196 appliqués 54, 61, 79, 83 broderie anglais 55, 98 Chantilly 96-97, 172 cobweb 20 cutwork 79 eyelet 55, 98 inlays 110 inserts 25, 210 overlays 25, 44, 95, 105, 111, 116-117, 129, 149 rose point 17, 172 trims 15, 63, 76, 142, 177, 179, 187, 210 Lanvin, Jeanne 59 Lepley, Phillipa 18, 28, 66, 160–161, 172 Letizia of Spain 190–191 Lomba, Modesto 188-189 Lopez, Jennifer 95, 96-97 Mary of Denmark 168 McQueen, Alexander 56-57 mermaid dresses 68-91, 154, 155, 177, 186 mididresses 120-129 millinery see hats Milsom, Beth (Special Occasions) 101 minidresses 34, 94, 95, 120-129, 132, 166 miniskirts see minidresses Mischka, James see Badgley Mischka Miyake, Issey 70, 110 Monroe, Marilyn 111, 134 Montana, Claude 133 Mortimer, Emily 55, 57 Mugler, Thierry 133 Muir, Jean 94 necklines 140-151

boat 35, 89, 98, 143, 145 cowl 71, 78, 81, 143, 146, 150 drop shoulder 142 halter 79, 82, 95, 142, 143, 145, 154 high 14, 15, 35, 95, 143 lace 25, 35, 79, 110, 142, 145, 149, 173 portrait collar 14, 95, 111, 142, 151 round 143, 145 scoop 35, 57, 73, 95, 106, 114, 143, 149

spaghetti strap 20, 46, 61, 64, 84, 143, 149 square 38-39, 54, 75, 103, 110, 143, 147, 149, 150 strapless 14, 15, 18, 25, 28, 30, 35, 40-41, 50, 54, 62, 78, 95, 98-99, 102, 104-105, 106-107, 111, 114, 118-119, 122, 129, 133, 142, 150, 160-161, 204, 208, 210, 215 sweetheart 21, 37, 111, 142, 150 V-neck 80, 106, 119, 143, 148 Owen, Sarah 67, 90-91, 106-107, 158-159, 170-171 Parkes, Caroline 40, 44, 47, 50, 63, 98-99, 106, 144-145, 149, 161, 188 Parvin, Stewart 47, 78, 84, 114, 145, 150-151 Patou, Jean 110 Pertegaz, Manuel 190-191 petticoats 14, 15, 35, 63, 103, 127 Poiret, Paul 55

princess-line dresses 32–51, 71, 98, 114, 168, 187 Pugh-Thomas, Antonia 74, 106, 116–117, 119, 128–129, 193, 196– 197, 218–219

Quant, Mary 34, 110, 122

Rabanne, Paco 122 Rhodes, Zandra 171 Richards, Denise 71, 73 Rose, Helen 16–17

Saint Laurent, Yves 132, 133, 134 Sander, Jil 133 SaraSusa 29, 37, 112-113, 202-203 Shaw, Samantha 72-73 sleeves 164-173 bell 166, 167, 172 cap 54, 55, 57, 60, 73, 166, 168, 172 cape 167, 171 elbow 167, 168-169 handkerchief 170 kimono 167 lace 166, 167, 172–173 long 35, 54, 95, 167, 172-173 off the shoulder 14, 51, 63, 112, 151, 166, 168 puff 101, 125, 167, 169 short 166, 168 three quarter 167 tulip 167 Sophie, Countess of Wessex see Wessex, Sophie

Sottero, Maggie 172 suits 122, 130-139, 177, 196 Swanson, Gloria 192–193 Tate, Sharon 124-125 Taylor, Elizabeth 15, 16-17, 134-135 Thalia 182 tiaras 22, 24, 26-27, 36, 39, 40, 51, 60, 63, 72, 75, 88, 102, 118, 144, 150, 178, 191, 192, 193, 204-207 Todd, Elizabeth 22 Torrente Haute Couture 198 trains 14, 15, 19, 22, 44, 54, 58, 62, 65, 70, 71, 72, 74, 94, 95, 154, 184-193, 210 brush 187, 188 cathedral 89, 186, 187, 193 chapel 186, 187, 188, 189 court 187 detachable 111, 186 lace 188 panel 187, 188, 193 royal 17, 187, 190-191, 192 Watteau 115, 187 Tyler, Liv 55, 57 Ungaro, Emanuel 94 Valentine, Robinson 216–217 Valentino 95, 96-97 veils 154, 166, 174-183, 186, 187, 196, 198,201 blusher 177, 182 cathedral 177, 183 chapel 61, 177, 181 elbow 177, 178 fingertip 177, 180 fountain 178, 182

198, 201 blusher 177, 182 cathedral 177, 183 chapel 61, 177, 181 elbow 177, 178 fingertip 177, 180 fountain 178, 182 lace 176, 177, 179, 181, 196 mantilla 177, 179 waltz 177 wrapped 182 Vionnet, Madeleine 70–71 vintage 7–8, 16–17, 26–27, 36, 57, 58–59, 90, 96, 101, 112, 124–127, 134–135, 169, 181, 192–193, 198, 209

Walker, Catherine 35, 71 Wang, Vera 129, 218 Wessex, Sophie 71, 72 Winslet, Kate 55, 56–57 Worth, Charles 9, 34

YSL see Saint Laurent, Yves

DIRECTORY

Some of the designs featured in this book may be difficult, or even impossible, to find among your local retailers, but the following list contains some of the most popular designers available in North America. Most of the websites listed also provide store locations. The internet contains a wealth of information for the bride-to-be, but do be wary of offers that seem to good to be true. Many designers advise against buying their gowns from online retailers, as fakes are a common problem. A good source for information (and inspiration) is the *Modern Bride* website, which features a useful "dressfinder" tool, visit www.modernbride.com/dressfinder/bride

Amsale

625 Madison Avenue New York, NY 10022 Tel: (212) 583–1700 www.amsale.com Designers Amsale and Kenneth Pool, available nationwide.

David's Bridal

Toll-free: 1-888-480-BRIDE or 1-877-923-BRIDE www.davidsbridal.com Bridal retailer with 240 locations nationwide.

Eden Bridals, Inc.

145 East Walnut Avenue Monrovia, CA 91016 Tel: (626) 358–9281 Toll-free: 1-800–828–8831 Email: sales@edenbridals.com www.edenbridals.com Affordable bridal wear available nationwide.

Kleinfeld Bridal

8202 Fifth Avenue Brooklyn, NY 11209 Tel: (718) 765–8500 www.kleinfeldbridal.com Bridal retailer whose website includes information on designers, dresses and more.

Lazaro

525 Seventh Avenue, Suite 1703 New York, NY 10018 www.lazarobridal.com Designer of bride's and bridesmaid's dresses available nationwide.

Justina McCaffrey Haute Couture

465 Sussex Drive Ottawa, ON K1N 6Z4 Tel: (613) 789–4336 Toll-free: 1-888-874–4696 www.jmhc.com *Couture wedding gowns available nationwide*.

Caroline Parkes

Email: info@carolineparkes.com www.carolineparkes.com Designer bridal wear.

Stewart Parvin

Tel: +44 20 7235 1125 Email: sarah (\tilde{a}) spbride.demon.co.uk www.stewartparvin.com British bridal wear designer available at select U.S. stores.

PC Mary's Inc.

Tel: (281) 933–9678 Email: mbridal@marysbridal.com www.marysbridal.com Designers of gowns, veils and headpieces available nationwide.

Maggie Sottero

www.maggiesottero.com Bridal wear designer available nationwide.

Alfred Sung

Tel: (416) 247–4628 Toll free: 1-866–298–2100 E-Mail: info@alfredsungbridals.com www.alfredsungbridals.com *Canadian designer available across North America.*

Vera Wang

Flagship Salon 991 Madison Avenue New York, NY 10021 Tel: (212) 628-3400 Toll-free: 1-800-VEW-VERA Email: inquiries@verawang.com www.verawang.com Couture and ready-to-wear designs, as well as footwear and fragrances, available worldwide.

ACKNOWLEDGMENTS

The publishers are committed to respecting the intellectual property rights of others. We have therefore taken all reasonable efforts to ensure that the reproduction of all content on these pages is done with the full consent of copyright owners. If you are aware of any unintentional omissions please contact Chrysalis Books Group Plc directly so that any necessary corrections may be made for future editions.

1 ©Robin Lowe-Abstract Creative; 2 SaraSusa/Virgin Bride; 6 James Gilberd/ Photospace; 7 Collection of Sarah Hunnings; 8 ©Amanda Lockhart; 9 Collection of Ian & Betty Gillan; 10 Collection of Amanda Saborn Hutt; 11 Collection of Antonia Pugh-Thomas; 16 ©SNAP/Rex Features; 17TL ©Bettman/CORBIS; 17TR ©Sipa Press/Rex Features; 17B ©Quadrillion/CORBIS; 18 ©Tony McGee Photography/ www.tonymcgee.co.uk; 18/19, 20TL, 20TR, 20BL, 20BR, 21, 22T ©Robin Lowe-Abstract Creative; 22B Collection of Elizabeth Todd Designs; 23, 24, 25TL, 25TR, 25BL, 25BR ©Robin Lowe-Abstract Creative; 26/27 ©Hulton Archive/Getty Images; 27T, 27C ©Robin Lowe-Abstract Creative; 28T ©Tony McGee Photography/ www.tonymcgee.co.uk; 28B ©Robin Lowe-Abstract Creative; 29T ©SaraSusa/Virgin Bride; 29BL ©Robin Lowe-Abstract Creative; 29BR ©SaraSusa/Virgin Bride; 30, 31 ©Robin Lowe-Abstract Creative; 36 ©Hulton Archive/Getty Images; 37L ©Simon/Ferreira/Rex Features; 37R ©SaraSusa/Virgin Bride; 38/39, 40T ©Robin Lowe-Abstract Creative; 40B Collection of Caroline Parkes; 41 Collection of Laura Wilson; 42, 43 ©Robin Lowe-Abstract Creative; 44 Collection of Caroline Parkes; 45, 46, 47TL, 47TR; ©Robin Lowe-Abstract Creative; 47BR Collection of Caroline Parkes, 47BR Collection of Stewart Parvin; 48, 49T, 49B ©Robin Lowe-Abstract Creative; 50 Collection of Caroline Parkes; 51 ©Robin Lowe-Abstract Creative; 56 ©Stewart Turkington/Rex Features; 57T ©David Hartley/Rex Features; 57B ©Albert Ferreira/Rex Features; 58 Collection of Lois Oldfield; 59 ©Hulton Archive/Getty Images; 60, 61, 62 ©Robin Lowe-Abstract Creative; 63 Collection of Caroline Parkes; 64, 65 ©Robin Lowe-Abstract Creative; 66 ©Tony McGee Photography/www.tonymcgee.co.uk; 67 Collection of Sarah Owen London; 72/73 ©Tim Graham/Getty Images; 73T ©Getty Images; 73B ©Charbonneau/BEI/Rex Features;74T ©Charlotte Rushton; 74B Collection of Antonia Pugh-Thomas; 75, 76, 77, 78L ©Robin Lowe-Abstract Creative; 78R Collection of Stewart Parvin; 79, 80 ©Robin Lowe-Abstract Creative; 81 Collection of Sarah Hunnings; 82, 83T, 83B ©Robin Lowe-Abstract Creative; 84 Collection of Stewart Parvin; 85 ©Robin Lowe-Abstract Creative; 86/87 ©James Gilberd/Photospace; 88 ©Getty Images; 89 ©Robin Lowe-Abstract Creative; 90 Gilles Piel/Image Décisive/Patricia Hopkins; 91 ©Marie-Line Denis, 2004; 96T ©Bettman/CORBIS; 96B ©Reuters/CORBIS; 97 ©rien/CORBIS SYGMA; 98TL, 98TR, 98BL, 98BR ©Robin Lowe-Abstract Creative; 99 Collection of Caroline Parkes; 100 ©Robin Lowe-Abstract Creative; 101TL ©Tom Bader/www.tombaderphotography.com; 101TR Collection of Emily Preece-Morrison; 101B ©Studio Images UK/www.studioimages.co.uk; 102, 103T, 103C, 103B, 104/5, 105, 106TL ©Robin Lowe-Abstract Creative; 106TR Collection of Caroline Parkes; 106CL ©Martin Rice/ Collection of Antonia Pugh Thomas; 106CR Collection of Caroline Parkes; 106BL, 106BR ©Robin Lowe-Abstract Creative;

107 Collection of Sarah Owen London; 112 ©Hulton Archive/Getty Images; 113 ©SaraSusa/Virgin Bride; 114TL ©Robin Lowe-Abstract Creative; 114TR Collection of Stewart Parvin; 114BL, 114BR, 115, 116 ©Robin Lowe-Abstract Creative; 117 Collection of Antonia Pugh-Thomas; 118 ©Robin Lowe-Abstract Creative; 119T ©Robert Daly/Collection of Antonia Pugh-Thomas; 119B ©Robin Lowe-Abstract Creative; 123 ©William Robert/Photolibrary.com; 124 ©Hulton Archive/Getty Images; 125TL ©Rex Features; 125TR ©Hulton Archive/Getty Images; 125BL ©Everett Collection/Rex Features; 125BR ©TopFoto.co.uk; 126 ©Hulton Archive/Getty Images; 127 Collection of Bill & Alison Cassanos; 128 Collection of Antonia Pugh-Thomas; 129T, 129B ©Getty Images; 134TL ©Hulton Archive/Getty Images; 134TR ©POPPERFOTO/Alamy; 134BL ©POPPERFOTO/Alamy; 134BR ©POPPERFOTO/Alamy; 135 ©Hulton Archive/Getty Images; 136 ©Robin Lowe-Abstract Creative; 137T © Justin Whillock, 137B © Andrew O'Toole Photography/ Collection of Johanna Hehir; 137B ©Robin Lowe-Abstract Creative; 138/9 ©Amanda Lockhart; 144 Collection of Caroline Parkes; 145TL, 145TR ©Robin Lowe-Abstract Creative; 145BL Collection of Stewart Parvin; 145BR, 146, 147, 148 ©Robin Lowe-Abstract Creative; 149T, 149B Collection of Caroline Parkes; 150T, 150BL, 150BR ©Robin Lowe-Abstract Creative; 151 Collection of Stewart Parvin; 156 ©Warren Diggles/Alamy; 157 ©Amanda Lockhart; 158 Collection of Sarah Owen London; 159 ©Robin Lowe-Abstract Creative; 160 ©Tony McGee Photography/ www.tonymcgee.co.uk; 161TL Collection of Caroline Parkes; 161TR, 161BL, 161BR, 162, 163 ©Robin Lowe-Abstract Creative; 168TL ©Getty Images; 168TR ©Tim Graham/Getty Images; 168BL ©Ray McMahan/Corbis; 168BR ©Robin Lowe-Abstract Creative; 169 ©Hulton Archive/Getty Images; 170 Collection of Sarah Owen London; 171 ©Andrew Montgomery; 172T ©Leigh Goodsell Photography/www.goodsell.ws; 172B ©Tony McGee Photography/www.tonymcgee.co.uk; 173 ©Bettman/Corbis; 178T ©Harley Aisha/Photolibrary.com; 178B ©Robin Lowe-Abstract Creative; 179 ©Omar Torres/AFP/Getty; 180 ©Robin Lowe-Abstract Creative; 181T ©Timelife Pictures/Getty Images; 181B, 182TL ©Robin Lowe-Abstract Creative; 182TR ©Getty Images; 182BL ©Julio Donosa/Corbis Sygma; 182BR, 183 ©AFP/Getty Images; 188TL Collection of Caroline Parkes; 188TR ©Robin Lowe-Abstract Creative; 188BL Collection of Caroline Parkes; 188BR ©Robin Lowe-Abstract Creative; 189 ©Omar Torres/AFP/Getty Images; 190/191 ©COVER/CORBIS; 192 ©Bettman/ CORBIS; 193T Collection of Emily Preece-Morrison; 193B Collection of Antonia Pugh-Thomas; 197 Collection of Antonia Pugh-Thomas/Katherine Goodison Millinery; 198T ©Francis Petit/Prestige/Getty Images; 198BL © Hulton Archive/Getty Images; 198BR ©Leigh Goodsell Photography/www.goodsell.ws; 199, 200, 201 ©Robin Lowe-Abstract Creative; 202 ©SaraSusa/Virgin Brides; 203, 205 ©Robin Lowe-Abstract Creative; 206 ©Amanda Lockhart; 207TL, 207TR ©Robin Lowe-Abstract Creative; 207CL Collection of Caroline Parkes; 207CR, 207BL ©Robin Lowe-Abstract Creative; 207BR Collection of Caroline Parkes; 208TL, 208TR, 208BL, 208BR ©Robin Lowe-Abstract Creative; 209 ©Hulton Archive/ Getty Images, 211 ©Robin Lowe-Abstract Creative; 212 Collection of Caroline Parkes; 213TL ©Robin Lowe-Abstract Creative; 213TR ©Slick Shoots/Alamy; 213BL ©Sarah Cameron/Collection of Robinson Valentine, 213BR, 214TL ©Robin Lowe-Abstract Creative; 214TR ©Spencer Platt/Getty Images; 214B ©Ramzi Haidar/AFP/Getty Images; 215 ©Robin Lowe-Abstract Creative; 217 ©Grey Zisser/Collection of Robinson Valentine; 218TL ©Getty Images; 218TR, 218BL ©Robin Lowe-Abstract creative; 218BR © Getty Images; 219 Collection of Antonia Pugh-Thomas.

ACKNOWLEDGMENTS